THE
Symbols
OF THE
Church

Maurice Dilasser

Translated by
Mary Cabrini Durkin, O.S.U.,
Madeleine Beaumont
and Caroline Morson

A Liturgical Press Book
The Liturgical Press
Collegeville Minnesota

Author
Maurice Dilasser

Design and layout
Juliette Roussel - Daniel Muller

Picture editor
Sandrine Winter

Photo credits

© Alinari-Giraudon : pages 17, 29d, 92, 94

© Alsace Média : page 37h

© Bibliothèque Nationale : page 126

© Bridgeman-Giraudon : page 13

© Ciric : pages 136h, 143
Brigitte Cavanagh : page 149
Marcel Crozet : page 141
Stréphane Lehr : pages 150, 152h
Philippe Lissac : page 152b
Régis Martin : page 145
J.M. Mazerolle : pages 147, 153
Alain. Pinoges : pages 144, 151
J.P. Pouteau : page 137

© Chrétien Média : pages 9b, 9m, 11h, 39

© Maurice Dilaser : pages 9, 21, 22h, 27g, 31hg,32h, 64, 66, 67, 77, 81, 85, 87, 95, 98, 99, 106, 112, 114, 123, 124, 132, 134, 143, 148

© Editions du Signe : page 29g

© Galerie Plessis, Nantes, France : page 105h

© Giraudon : pages 12, 24, 32b, 35bd, 83, 150
Louvain, Belgique : page 80
Musée des Beaux-Arts de Rennes, France : page 27b
Musée de la Chartreuse, Douai, France : page 41
Musée de Condé, Chantilly, France : pages 14, 16, 31hd, 33, 48b, 55
Musée du Prado, Barcelone, Espagne : page 19
Musée Unterlinden, Colmar, France : page 89
Nationale Galerie des Arts de Washington, Etats Unis : page 35h

© Gustave Hervé : pages 31b, 34, 36, 46, 48m, 99, 101, 102, 105b, 108, 110, 113, 117, 118, 119, 120, 122, 123, 127, 128, 130, 134, 135, 136, 138, 140, 149, 154

© Lauros-Giraudon : pages 71, 76, 78, 79, 84, 86, 88

Musée de l'Oeuvre Notre-Dame, Strasbourg, France : page 87b
Musée du Louvre, Paris, France : page 51m

© Ariane de la Marcq : page 12b

© Musée de l'Oeuvre Notre-Dame, Strasbourg, France : page 3

© PC : page 63

© PIX
V. d'Amboise : page 94
J.P Lescourret : page 90

© RMN :
Musée du Louvre, Paris, France : pages 20, 22, 90, 131

© Scala :
Cathédrale Monreale, Sicile, Italie : page 38
© Musée de l'Oeuvre Métropolitaine, Sienne, Italie : page 57
© Catacombe di Priscilla, Rome, Italie : page 70
©Musée de Pio Cristiano, Italie : page 73

© Patrice Thébault : pages 115, 125

© Zvardon : pages 5, 8, 10, 11b, 15, 20, 23, 25, 26, 28, 33, 35bg, 37b, 41g, 43, 44h, 45, 47, 49, 50, 51, 52, 53, 56, 59, 61, 62, 63, 65, 69, 71h, 73h, 74, 75, 78, 82, 91, 92, 103, 104, 106, 107, 108, 109, 110, 111, 112, 116, 117, 121, 128, 129, 132, 139, 144

Translated by Mary Cabrini Durkin, O.S.U., Madeleine Beaumont and Caroline Morson

English text edited by Aaron Raverty, O.S.B.

© 1999 by Editions du Signe, Strasbourg, France.
All rights reserved.
This edition in English is published by The Liturgical Press, Collegeville, Minnesota, United States of America, for distribution throughout the world.

Library of Congress Cataloging-in-Publication Data

Dilasser, Maurice.
[Symbolique des églises. English]
The Symbols of the Church / Maurice Dilasser ;
translated by Mary Cabrini Durkin, Madeleine Beaumont and Caroline Morson
Includes Index.
ISBN 0-8146-2538-X (alk. paper)
1. Christian art and symbolism--History. 2. Catholic Church--Liturgy. I. Title.
BV 150.D46513 1999
246'.55--DC21
99-31073
CIP

ILLUSTRATION ON THE COVER
THE REVELATION OF JESUS CHRIST AND HIS CHURCH ACCORDING TO JOHN
The heavenly Jerusalem, with its doors and its rampart foursquare, is measured, according to John, by an angel with a measuring rod of gold. The Holy City, fortified with this rampart, opens itself by means of twelve doors to all the tribes. Each one shrines with the presence of the twelve apostles, like precious stones. God is its temple and its light; it can outshine the brilliance of the sun and the moon, because the glory of God has illuminated it; and the Lamb, victor by means of the cross, takes the place of its lamp.

Foreword

© Nicolas de Leyde,
Bust of a man leaning
on his elbows,
Museum of the Œuvre Notre-Dame,
Strasbourg, France

*Nature is a temple in which living pillars
sometimes let out muddled words.
Amidst them man passes through forests of symbols
which observe him with familiar faces.*

Baudelaire

The Language of Symbols

*"Figure includes absence and presence, pleasant and unpleasant.
- Cipher with a double meaning, of which one is clear and says that the meaning is hidden."*
Pascal, Pensées, 565

Science has its own language; the arts have another. Religion uses especially the language of the arts, for it uses signs and symbols, like bridges from the visible to the invisible, from the depths to the heights, from the earthly world to the heavenly one, from humanity to God. The symbol is not an object of worship, but invites to worship. It leads to the encounter with the divine. Its language takes an object or an action and from it evokes something other, which is often inexpressible, by virtue of some correspondence, natural association, or convention.

Symbols are often ambiguous. They can refer to a reality and also to its opposite, as for example in the case of the waters of the Flood or the Red Sea, which both engulfed and saved. A dictionary of sacred symbols cannot guarantee a correct interpretation. If it did, the interpretation would not be sufficient to penetrate beyond the sign any more than treatises of prosody, or pictorial or musical technique can replace knowledge [In the original French, knowledge, *connaissance*, literally means a *'co-birth'*], the birth of the other, or as Claudel calls it, 'birth to others.' The art historian who is able to decipher symbols and demonstrate their evolution in time can remain impervious to their ineffable meaning. The science of the religious world and its language are less important than an inner disposition to receive signs.

Jesus, the Word of God, spoke in parables and used symbols. He chose this language in order to proclaim the kingdom of God, not to an initiated elite, but to everyone, especially to the simple-hearted.

Like the sown seed falling on the path, on the stony ground, or into the good soil, the word has the same fate. Those who are not open to receiving the life-giving word and its author hear without hearing, see without seeing; they know without knowing. Yet this word can bear fruit a hundredfold in those who welcome it.

3

Religions and Symbols

The language of symbols is more universal than the language of words. All religions have one thing in common: the capacity of seeing in elementary forms and movements of life a symbolic expression of the beyond.

In this common language each civilization has recapitulated its concept of the cosmos in a symbolic image, the temple: a place in which the deity dwells, speaks and shows its pleasure or displeasure.

Even Judaism uses the symbolic language of the "nations" (non-Jewish) in order to express its belief in a unique God. It does this, knowing well that neither places, nor images, nor even a temple constructed by human beings can contain this God of the Covenant who accompanies God's people in the desert just as much as God does in Babylon. Without embodying God, the ark and then the Temple in Jerusalem rendered tangible the presence of the One who is at once totally "other" and yet close to this people.

With the birth of Jesus, the Emmanuel, God in our midst became visible without the medium of symbols: "The Word has made his dwelling among us." And yet God still has to be recognized.

Christ perpetuated his presence in the world through the institution of the Church, which is his body. Any Christian assembly gathered in his name in any part of the world is a sign of his presence. Still more explicitly, he instituted signs, the sacraments, through which the Church actualizes and celebrates this presence.

Thus the places of worship are not indispensable for God to dwell among God's own. However, the Church makes use of such edifices because the language of the monument in which it gathers expresses in time and space the living bonds which unite the Church to its God. The Church does not intentionally connect the biblical epiphanies which occurred in the course of history, and their celebration, to the accounts of "pagan" myths. The Church is afraid to recognize in the great religious symbols a preparation for the actions of the Savior, yet it turns to the more widely used symbols of religious language to express its faith and dispose each person to receive its vision of the world.

This language has evolved through the ages and with different mentalities. For example, in order to evoke the transcendence to which the Romanesque era was particularly sensitive, symbolic language is rich and subtle. The ensuing few hundred years, which were more humanist, focused more attention on the face of the incarnate God, so close to humanity, and used images as much as symbols.

Interpretation of the Symbols

Churches are compendia of symbols. Their walls, their furnishings, are covered with them; the celebrations which take place in them enact these symbols. They are a great book of signs to be translated. Most of them come from the Bible, from the history of salvation, the prophetic figures, or the mysteries of Jesus. Their interpretation cannot be improvised but is a product of the interpretation given by the Church throughout its history and in its teaching and liturgy. To these signs which found a Christian symbolism, others were added, drawn from the free expositions of the Fathers, from universal symbolism, and (by way of an approach) even from mythology.

These diverse sources inspired the architectural forms and the iconographic riches of the churches. This dictionary offers introductory elements for their interpretation, which is infinite.

*S*ymbols
of the Christian World

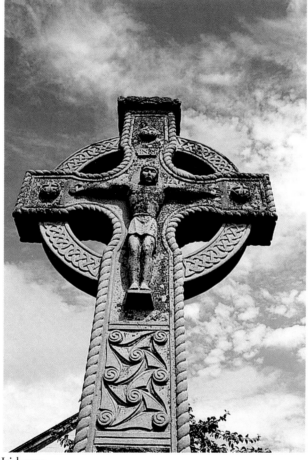
Irish cross

This first part recalls those principal sacred symbols which various cultures have made into a permanent and universal religious language, and which were known to Judeo-Christianity.

Abandoning esoteric interpretations, the text presents the interpretations of the Bible, the Church Fathers, the liturgy of the Church, and the artists inspired by it. Signs, figures, and emblems proper to the Christian world are added to these universal symbols.

They are not presented in alphabetical order, but in sections according to their affinities and the topics in question:

> *I - The world and its image,*
> *II - The celestial and terrestrial inhabitants of the world,*
> *III - The world dominated by humanity,*
> *IV - The elements, space, and time.*

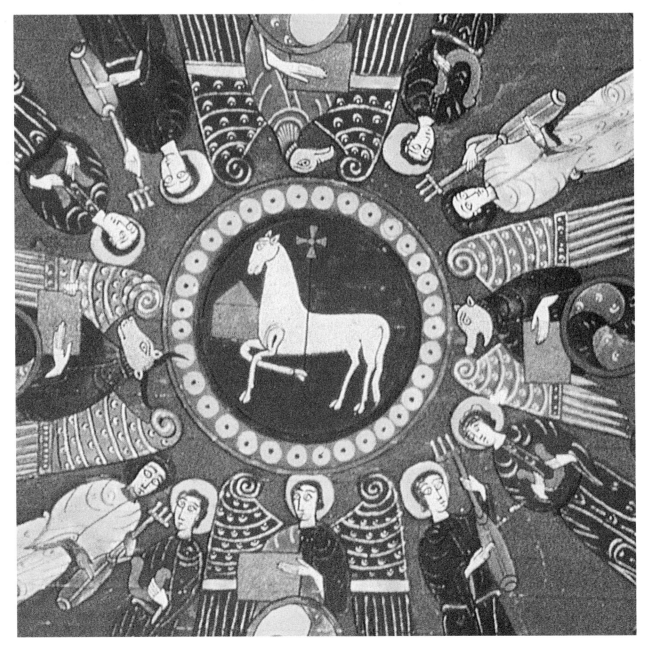

The World and Its Image

In the beginning God created the heavens and the earth.
Gen 1:1

Ancient communities imagined the center of the world to start at their hut, village, temple, or the tent pole pointing to the sky. Beyond, there was chaos, the formidable powers of the night and of death, from which one had to protect oneself. Each community discovered in the primeval myth the truth about the world and the significance of its three spaces: heavenly, terrestrial and infernal, along with the cosmic pillar linking them. From there it drew the symbolic image of a plateau, the square of the earth, surrounded by the oceans and framed by the gates of the four winds. The world was borne up by the pillars of the abyss, that mysterious domain of the great waters and of the kingdom of the dead, the Hebrew Sheol. Its axial ladder reached the canopy of heaven, where concentric circles guided the movement of the stars, maintaining the sequence of day and night and the cycle of the seasons, and causing the life-giving clouds to rain down. Above all this was the throne of God.

■ Source of the Symbolism of the Universe

The people of the Bible drew this symbolic image of the universe from the first two chapters of Genesis. Taking place in the space of a week, this double narrative attributes the creation of the cosmos to a unique God, who hovers above the nocturnal chaos of the watery abyss. God's breath (= spirit) begins by separating light and darkness; then God interposes the canopy of the firmament between the waters; and, below, God separates the sea from the land. Then God covers the ground with vegetation and decks the celestial vault with luminous stars, marking time. God peoples the waters and the firmament with birds and fish and the earth with animals. God completes this work by creating humanity in the divine image.

Different myths, such as the Babylonian poem of Marduk, or certain Egyptian mythological narratives, illustrate the same cosmogony: original chaos and the separation of the elements born of the primitive waters; the sky and the earth; the darkness, the light and the stars; and the creation of humanity. They differ from the biblical narrative in their polytheism and the struggle between deities of good and evil.

In several of these mythologies, original sin hampers communication between the world above and the world below, forbidding human access to the deity and fostering nostalgia for a lost paradise.

■ Initial Point and Center

This image of the world of the heavens, the earth and the depths, is generated by an immaterial point. It is the original node of the world, its foundation, summit and center, its navel, represented by a stone. It is the omphalos of Delphi, the standing stone of Beth-El, "house of God" (Gen 35:1) or the umbilical rock of the temple. Everything stems from this and converges toward it as to the hub of a wheel. From this originating point, the throne of God, at the center of the cosmos and of time and space, the creative energy radiates.

The Creator's compass and square trace out the heavenly circle, the square of the earth, the cross and the four compass points of space and, in the third dimension, the polar axis of the celestial vault which links heaven, earth and abyss.

Space and time are defined in reference to the initial point. Determined by the cross, the circle and the square – and, in the third dimension, the polar axis of the celestial vault – space has a meaning:

- The top signifies the spirit, heaven, divinity.
- The bottom signifies the carnal, hell, the demons.
- The right, or dexter, signifies the day star (the sun), salvation, holiness, the side of the cross and of the altar in the church. Christ in majesty, and in his name the priest, bless with the right hand. It is at his right hand that Christ the Judge places those blessed by his Father. Pilgrims walk around the sacred edifice to the right (clockwise).

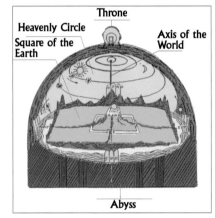

Throne
Heavenly Circle
Square of the Earth
Axis of the World
Abyss

- The left, or sinister, whence is derived the word sinister, is the direction of the shadows, of death and of sin. It is also the side of the church on which the Last Judgment is depicted. The damned are thrown out to the left.

Thus the universe proceeds from the immaterial center. It is a sacred place, or temple, in which God, who is both Creator and Providence, is manifested.

This center is not unique. Each people and each community have acknowledged it in their home, on their mountain, in Garizim (navel of the earth), in Jerusalem (city of peace), on Golgotha (place of the skull of Adam).

Everywhere, the association of the square of the earth, the heavenly circle and the column (which links them) evokes the cosmos, the heavens and the earth. The language of these figures concerns equally the three-dimensional entities which arise from them (the cube and the sphere) and even the linear entities which generate them: the curve and the right angle of the square or rectangle. The meaning of these forms remains the same whether they are combined vertically or horizontally, as for example in a church, the floor of the nave and its vault, its rectangular surface and the semicircular choir.

Their relationship symbolizes at the same time the relationship between time and eternity and that between transcendence and immanence.

Omphalos of Delphi in Greece

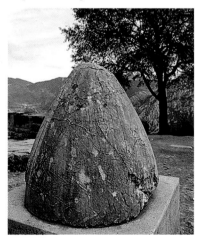

O Lord, my God, you are so great! Clothed with splendor and majesty, he wraps himself in light as with a garment, he stretches out the heavens like a tent.

Ps 104

1. Heavenly Circle

The circle, the dynamic extension of the point, is the perfect form engendered by the divine compass. It guides the movements of the stars. *"The poles of the spheres coincide with the center which is God.... He is circumference and center for he is everywhere and nowhere"* (Nicholas of Cusa 1401-1464). After the Copernican revolution, Kepler saw the world as structured by the Trinity, the Father being the center around which the Spirit radiated and the Son being the surface engendered.

■ **Heaven, the Dwelling of God**
The canopy of heaven is the symbolic residence of the deity, but the heavenly spaces in which the astral bodies gravitate are differentiated from the whole. If, in order to avoid pronouncing the divine name, biblical language uses the word heaven as a substitute, it does not confuse it with the One who reigns there: *"the highest heavens"* are not capable of containing God (1 Kgs 8:27). Heaven or heavens designate the dwelling of the Creator, the tent, the palace (Ps 104), whence the Creator's voice resounds in the roar of the thunderstorm (Ps 19).

Christ taught the prayer "Our Father who art in heaven." He preached the advent of the kingdom of heaven.

■ **Paradise**
The earthly paradise, *the Eden in which God was walking in the cool of the day,* was the initial dwelling of humanity with God, depicted as an oasis in the desert. The town surrounded by walls, the heavenly Jerusalem, will be the definitive residence, the heavenly par-

adise in which God will assemble the elect. The heavenly forms of the *vault* and the *conch,* and the *canopy* or the *baldachin,* symbolize the divine world and the spiritual ascension of the elect toward God.

The *heavenly light* consists of the sun, the moon, and the stars.

UN

The sun represents the celestial, invigorating power which enriches, burns and purifies. Many ancient gods were heroes

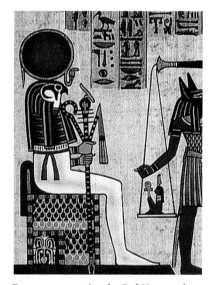

Papyrus representing the God Horus and the Weighing of Souls, Cairo, Egypt

of solar myths: the Egyptian Gods, notably *Aton,* the solar disk; *Horus,* the god of the horizon; *Amon-Re* and *Osiris,* masters of life and death; and the Greek gods such as *Helios* (with golden hair, carried off through the sky in his chariot of fire, and bathing his tired horses in the ocean in the evening while he himself rested in a golden palace); and, in his footsteps, *Apollo,* the God carrying

a bow and a lyre who saw very clearly and very far. The Persian *Mithra,* a triumphant star, announced the lengthening of the days.

With its light the sun gives understanding of things above. Therefore it symbolizes the Word-Light who brings light into the darkness. The rising of this star in its orbit at the winter solstice announces the nativity of Christ who drives back the shadows of death, whence the names *Sol Salutis, Sol Invictus, Sol Justitiae* (Sun of Salvation, Unvanquished Sun, Sun of Justice).

> *I am the light of the world. Whoever follows me will never walk in darkness, but will have the light of life.*
>
> John 8:12

■ Rainbow, Ring

The iridescent arch which stands out against the heavenly vault controls the waters from above. Beneath it, Noah's Ark gives protection from the waters below, reestablishing the normal state of affairs after the flood. God outlines in the sky the sign of a covenant with saved humanity. Seated on the arch of the new universe, Christ announces his advent as Supreme Judge.

Both circle and celestial emblem, the ring was worn on the finger of the priests who served and represented Jupiter. With Peter, responsible for casting the apostolic net, it becomes the fisherman's ring, whose seal depicts a fish, and then the bishop's ring, symbol of the union of Christ and his Church.

The closed ring is also the symbol of the sacred covenants of marriage and of religious vows.

■ Crown

The human skull, the seat of the spirit, is dome-shaped. The head of a ruler may be crowned by a distinguishing

"The waters above and the waters below," design for a stained-glass window by Fedorenko for the chapel of Lok Mazé in Le Drennec, France, created by A. Caouissin

circular emblem, the crown. This crown signifies the power of God delegated to a representative. The dentils or flowerets symbolize the light which emanates from this power. This symbol, made of precious metal or even plaited foliage, is borne by kings, by the elect, by Christ. The crown of thorns of the passion is derisory in its intention but reveals that Jesus reigns as king even through the Cross.

■ Halo, Horns, Mandorla, Nimbus

God is the true source of light. After his encounter with Yahweh, Moses' forehead bears the mark of divine glory in the form of *horns of light.* The horns at the four corners of the altar were other signs of divine power protecting those who take hold of it. The *halo* is the light that emanates from a glorified body. This aura radiates out in the form of an almond, the *mandorla* around the Christ in Majesty and sometimes around the Virgin Mary when she is crowned.

The *nimbus,* a miniature halo, is depicted as a luminous circle around the head of a saint. The transfigured Christ's nimbus is adorned with a cross. The square suited more the earthly condition and the circle the heavenly condition. The Byzantines gave a square form to the nimbus of venerable personages who were still alive.

Assumption of Mary, Buhl, Alsace

■ Arrows, Two-Edged Swords

Two-edged swords and arrows are associated with the rays of the sun. Apollo, the sun-god, strikes with his shining arrows those who have of-

Stained-glass window by Johan Soudain depicting the Assumption, dated 1524, Cathedral of Troyes, France

9

fended him and guides the arrows of his protégés. The archangel Uriel at the gate of paradise is armed with a gleaming sword.

The Apocalypse portrays the Son of Man armed with a sword of light in his mouth, symbol of the Word of God which enlightens and judges. When it is not merely an instrument of suffering and spilt blood, such as the one which pierces Mary's heart, the two-edged sword is the enlightening ray.

■ Glory

A glory, an outpouring of showering golden rays surrounding a divine symbol sometimes surmounts Baroque altars.

■ Shadow, Obscurity

The shadow of the divine cloud reveals a blinding light and gives protection from it. It guides the Hebrews in their departure from Egypt. The action of the Spirit is accompanied by an overshadowing at the annunciation. Obscurity is the lot of believers and most of all of mystics:

"Faith, which for the soul is a dark and somber cloud in the night, illumi-nates with its darkness and enlightens the darkness of the soul."

Saint John of the Cross

■ Solar Wheel

Gothic rose windows, in the form of a radiant sun, symbolize Christ, tortured and then glorified, whose presence at the center leads all time to its fulfillment.

MOON

The lunar goddess who illuminates the night, *"she who brandishes the torch"* (Sophocles), corresponds to the god who personifies the Sun and the light of day. The sun-moon pair were represented in Greece by the pair Helios-Selena, who were succeeded by Apollo-Artemis. Diana, the huntress virgin, like Artemis, bears the light of the moon. A luminous sign in the night, the moon governs the weeks and the months. Linked to water, as the sun is linked to fire, it controls the cycles of the rain and vegetation. It can be a symbol of *death* for it starts to diminish three days after its *renewal*. Thus the moon implies that death is not definitive,

but prepares a new birth. The moon signifies dependence because it receives its light without producing it. That is why Christianity has made the moon into the symbol of Mary who receives her grace from Christ. Consequently, iconography depicts her standing on a crescent moon as the Immaculate Conception, Mother of the Son of God and New Eve. The liturgy of the Assumption compares Mary with the Church, whose apocalyptic appearance in the heavens is described by John.

A great and wondrous sign appeared in heaven: a woman clothed with the sun, the moon under her feet and a crown of twelve stars on her head.

Rev 12:1

STARS

Among the stars of the canopy of heaven or throne of God, the stars are the messengers of God's will. They govern the destiny of the beings who are born under their influence. Their appearance in the sky announces to the Magi from the east the royal advent of the Messiah (Matt 2).

Mary is also the morning star or the star of the sea to whom sailors in peril on the sea can turn.

Nights and days! Bless the Lord: give glory and eternal praise to him.
Light and darkness! Bless the Lord: give glory and eternal praise to him.
Lightning and clouds! Bless the Lord: give glory and eternal praise to him.

Dan 3:71-73

Rose window of the south transept, Cathedral of Chartres, France

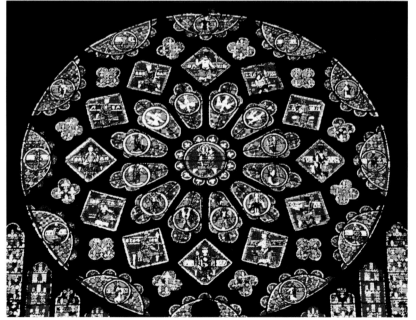

2. The Depths

Under the plateau of the earth the formidable world of the primordial depths (Gen 1:20) is hollowed out. The axis of the world which traverses the earth makes it possible to descend into this universe.

■ The Underworld and Hell

In universal mythology the underworld evokes a gloomy inferior world, the domain of *Hades, the Sheol* down into which everybody goes (Gen 37:35). It is the equivalent of the hostile forces of initial chaos, the diabolical world of the dragon which Yahweh overpowered at the beginning (Job 7:12).

Only a protective deity can allow a living being access to it. Orpheus, the hero, goes down into the underworld to get Eurydice out and reinstate her in her original condition.

The underworld ceased to be the abode of the dead after Jesus' descent there between the Friday of his crucifixion and Easter. Symbolically, he broke down the doors of hell to liberate humanity from everlasting death. The article of the Creed, *"He descended into hell,"* signifies that he himself really experienced death before rising again and offering to all a share in his resurrection. But the word hell also refers to the kingdom of Satan, the eternal fire where there is weeping and grinding of teeth (Matt 5:29 and 18:8). It was depicted after the ninth century as a reversed replica of

Stained-glass window depicting a devil, Church of Saint Stephen, Beauvais, France

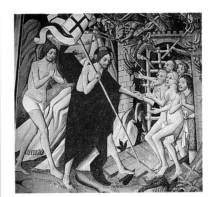

Painting depicting Christ in limbo, Chapel of Our Lady of the Fountains, La Brigue, France

heaven, a place of terror, a deep abyss of fire, the kingdom of torture and agony such as Dante imagines, the wide-open mouth of Leviathan that appeared on the stage in the medieval Passion plays. Over and above this imaginative vision, hell is the lot of the sinner who refuses salvation.

■ Purgatory

As the place in which the dead are purified in fire in order to have access to the beatific vision, purgatory is accessible to the prayer of the Church. The angels liberate those who suffer there from not being able to see God.

■ Limbo

The Middle Ages devised yet another place intended for the innocents who had been unable to receive baptism: limbo, a glory-less annex of heaven.

Certain places on earth, given over to the powers of evil symbolize the infernal dens:

■ Sodom and Gomorrah

The Canaanite towns of iniquity, Sodom and Gomorrah, were punished by rain of fire and sulphur. Thanks to the prayer of Abraham, Lot and his family escaped from the blazing fire. Lot's wife was changed into a statue of salt when she turned back to see what was happening (Gen 19:24-26).

■ Babylon

Babylon, the great power of the Euphrates, pillaged Jerusalem in 598, carrying off the Israelites to a long period of captivity in the city. Isaiah depicts its king as the ungodly rival of Yahweh. The town, a symbol of idolatry, is referred to in the Apocalypse as the great prostitute *"who gets drunk on the blood of the martyrs,"* the antithesis of the heavenly Jerusalem.

However, even if the abyss is a place destined for death, the sovereign presence of God is sometimes manifest even far into the subterranean shadows:

■ Cavern

The cavern which plunges into the depths can also harbor treasures. Just as one climbs the mountains in order to encounter God, it is possible to discover God secretly by descending into this other womb-like place of revelation. It is in a cave that Jesus was born. His tomb was also sheltered in a grotto. The architectural equivalent of the cavern is the recess, the apse, or the crypt which lies at the end of a pilgrimage made in search of precious relics.

■ Descent into Hell and Resurrection

The bronze doors shattered, the bronze crosspieces broke, and all the dead who were in chains were freed from their bonds. The king of splendor appeared with human features and the somber recesses of Hades were lit up. The Savior then blessed Adam, marking the Sign of the Cross on his forehead; then he did the same for the patriarchs, the prophets and the martyrs. They all came out of the underworld.

Gospel of Nicodemus

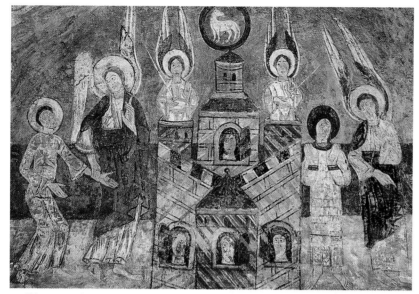

Twelfth-century fresco depicting the heavenly Jerusalem, vault of the upper chapel of the Church of Saint Theudère, France © Giraudon

Let the earth bless the Lord, give glory and eternal praise to him. Dan 3:74

3. The Square of the Earth

The square is a static figure defined by the cardinal points on the axes of the cross. It provides orientation in a world which would be chaotic without this framework. It is the symbol of divine creation, whose stability reveals the architect of the world. While God is seated in majesty in a heavenly circle, God's feet rest on a square, the earth, whence the Lord's exhortation: *"Do not swear either by heaven, for it is God's throne, or by the earth, for it is God's footstool"* (Matt 5:33).

The square is a perfect cosmos, whatever its surface may be: country, town, palace, temple or house. This universe recapitulates the construction of the world: from a central point it stretches out to the four points of the compass. Thus the town or camp "quadratus" divides into four sectors around a crossroads which forms a space for the establishment of the temple, whose roof will represent heaven, and whose crypt will represent the burial place of the dead. The house takes up again this same symbolism with its four walls, four doors, and four windows facing in the four directions.

With regard to the square, Raoul Glaber spoke of *"divine quaternity."* The number four is that of the Gospels, of the elements of the cosmos, of the virtues, the rivers of paradise, the ages of the world. It expresses the link between the elements of creation and its unity.

The transition between the square and circular planes through the *octagon* suggests the passage between the earth and heaven: it is the form proper to baptistries, or the spires and domes of church towers.

The square of the new Jerusalem (*see* cover) corresponds to the circle of Eden. Peter saw in a dream a symbol of this new earth, the Church open to all peoples: a large sheet held at its four corners to gather together all beings, not excluding a single one (Acts 10:11-16).

■ Book

The square form of the book with seven seals reveals in its contents the meaning of life. Human history unfolds between the two stages of divine creation related by Genesis and the Apocalypse, the first and last books of the Bible. The Christ depicted in mosaics, Romanesque bas-reliefs or on Gothic piers holds this book which he has come to open for humanity. The apostles carry it as a distinctive sign of their mission.

However the book, which contains the word of God, is assimilated to the Word of God, the Son who is the image of the Father and the key to his plan. With Christ, God incarnate, heaven and earth are united. He is to introduce us through his resurrection into new heavens and a new earth.

Created in the image of God, humanity sums up in itself the earthly and heavenly universe, in the material square of the torso topped by the spiritual circle of the head. These are the symbols of the body and spirit as they are schematized by the apostle of the Irish cross of Moone. The complementary aspect of these square and circular forms is accentuated by the placing of statues in their recesses, or by the extension of Christ's nimbus over the angular folds of his robe.

Mosaic depicting Christ the Pantocrator, Santa Sophia, Istanbul, Turkey

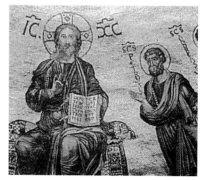

4. The Ascent of the Heights

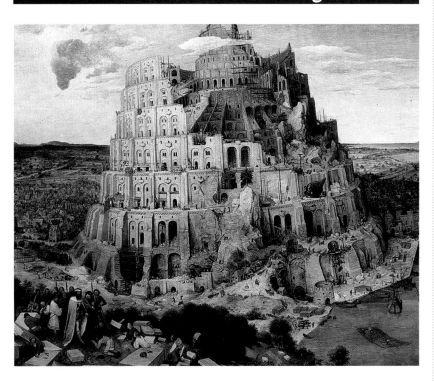

Painting by Peter Brueghel I known as the elder (ca. 1525–69) depicting the Tower of Babel, Kunsthistorisches Museum, Vienna, Austria © Bridgeman - Giraudon

Certain signs which stand on the square of the earth symbolize communication with the heavenly world. The tree and its images, the column, ladder, and the mountain are the symbols of humanity's ascension to the deity. Fixed in the middle of the earth, the axis of the universe orders the gravitation of the planets. The human family, situated on this axis, is at the heart of the world, turned toward the East whence the day, and life, are born. The West, with the gate of death, is behind. Outspread arms point to the North and the South.

The Cross of Christ is the pivot of the world and of history, the point of encounter between God and humanity, which receives immortal life from him.

■ Mountain

The mountain supports the celestial vault. It is the center and axis of the world. Since it reaches the dome above, it is a privileged place for an encounter with God.

Each country has its sacred mountains. On Mount Horeb Moses received the revelation from Yahweh in a burning bush (Exod 3). During the Exodus he received the gift of the Law there amid lightning flashes. When he came down from the mountain he bore golden horns on his forehead, signs of the divine light received (Exod 19).

On Mount Carmel, Elijah obtained God's assistance in the face of the priests of Baal (1 Kings 18:20ff.). He went to another divine encounter on Mount Horeb (1 Kings 19:9).

Jerusalem is the holy mountain, the Holy City. The *"psalms of the as-cents"* accompanied the pilgrims' every step in procession up to the temple of Yahweh (Pss 48, 84, 122).

Tradition tells of the Transfiguration of Jesus on Mount Tabor. He proclaimed the Spirit of the Kingdom on the Mount of the Beatitudes (Matt 17:1 and 5:1).

Like many a temple, churches have often been erected on the heights, whence the term "high place" used to describe the most outstanding shrines, whatever their altitude might be.

■ Tower

In building the Tower of Babel with seven floors in the manner of the Babylonian ziggurats in order to force a way as high as possible into heaven, human beings defied the divine power. This excessiveness ended in dissension and dispersion (Gen 11). The Spirit of Pentecost came down from above in the gift of tongues and restored the unity of the peoples of the earth (Acts 2:1-12).

Now men found a plain in the land of Shinar and settled there. They said to each other: "Come, let us make bricks and bake them thoroughly." They used brick instead of stone and tar instead of mortar. Then they said "Come, let us build ourselves a city with a tower that reaches to the heavens so that we may make a name for ourselves and not be scattered over the face of the whole earth"

Gen 11:2-9

■ Tree

This is a cosmic symbol. In its verticality it belongs to the three worlds: the celestial one in its foliage, the terrestrial one in its trunk and the underworld in its roots. The columns of temples and religious buildings recall the symbol of the tree.

Blessed is the man who trusts in the Lord,
and whose confidence is in him.
He will be like a tree planted by the water
that sends out its roots by the stream.
It does not fear when heat comes,
its leaves are always green,
it has no worries in a year of drought
and never fails to bear fruit.

Jer 17:7

The Tree of Life of Eden stood at the center of paradise. Watered by four rivers, the Pishon, Gihon, Tigris and Euphrates, it was intended to bring immortality to Adam and Eve. The last book of the Bible announces that those who are saved will eat from the Tree of Life (Rev 2:7) which is Christ.

Another pillar of paradise is **the tree of the knowledge of good and evil.** *"If you eat of the fruit from the tree, you will be like gods"* the serpent told Adam and Eve in order to tempt them to gather the fruit and become, like gods, the arbiters of what is good or bad for humanity (Gen 3:1-6). The words for apple and evil being the same in Latin *(malum),* this tree is traditionally an apple tree.

The tree of Jesse plunges its roots into the side of David's father and bears kings and prophets in its branches. It blossoms into a flower which bears the Savior. This is the genealogical image of Jesus, Son of Man and Son of God. It realizes the cosmic tree in its plenitude. The Son of God becomes incarnate in the heart of the humanity of saints and sinners in order to lead it to share in divine life.

■ Cross

The cross erected on the hill of Golgotha at the center of the world otherwise symbolizes the cosmic tree. It recalls the Tree of Life of Eden and of the heavenly Jerusalem. By dying on its wood, no longer symbolically but

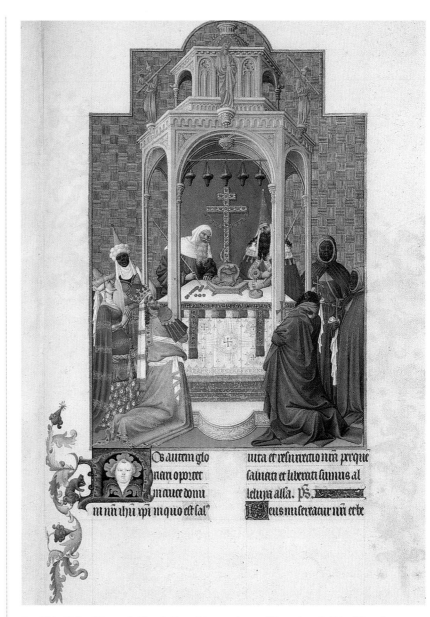

Les "Très Riches Heures du Duc de Berry" (ms. xx / xxxx, fol. xx r), end of the fifteenth century
© Giraudon - Condé Museum, Chantilly, France

historically, Christ gives life to humanity.

By means of this ladder, Christ makes his own ascent to the Father and introduces the people saved from death and sin into his kingdom. Its horizontal extension expresses the universality of salvation.

Certain miniatures depict the cross between the two trees of paradise. The crosses which are green like living, leafy plants emphasize this similarity. The crosses on the paths marking out the limits of a territory are both earthly and heavenly indicators, marks of sacred appropriation and of worldly sense.

■ Ladder

By building pyramids over their tombs, the Pharaohs dreamed of climbing up to the heavens in order to reach the deity from there individually or collectively. It is written in the *Book of the Dead: "The ladder for seeing the gods is set up for me."*

In a dream Jacob had the vision of a ladder leading up to heaven. Angels were going up and down this ladder, as messengers of prayer and bearers

of divine graces (Gen 28:12). This vision heralds the mission of Jesus, who is mediator between heaven and earth by his cross, and the link between human beings and the Father: *"You will see heaven open and the angels of God ascending and descending on the Son of Man"* (John 1:51). Yet Jacob's ladder also expresses the spiritual ascent of the living person toward God.

■ Column, Pillar

The column or pillar, with its stable base and basket capital with plant-like decoration, recalls the tree.
God alone can shake the columns or foundations of the world, as God did through Samson who destroyed the city gates (Judg 16:3) and through Christ who broke the uprights of the gates of hell, as he will break the gates of time and death in completing his work of salvation (Matt 24:29-31).

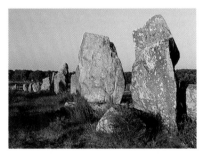

Monoliths, Carnac, France

■ Altar, Sacred Stone, Baetyl, Stele, Menhir

The ancients erected megaliths either as solar reference-markers which announced the seasons, as fertility stones, or in order to settle the souls of the dead and make their ascent possible.
Upright stones link earth with heaven. They take their name of baetyl from the altar at *Bethel* with which Jacob marked the place of his encounter with God (Gen 35:1). Just like the sacred mountain, this stone, erected and anointed with oil as a memorial, became a cos-

mic center. The same was true for the altars of Abraham (Gen 15), Melchizedek (Gen 14:17), and Moses (Exod 20:22).

The altar in a church is the place where heaven and earth meet. On Mount Sion it is one with the cross of Golgotha.

■ Throne, Scepter, Staff, Crozier, Globe

Some signs symbolize supreme power, or else the powers given from on high to those who exercise a spiritual or temporal authority. Christ in Majesty sits on a throne; the Virgin Mary herself, seated in majesty, the "Maesta," is the throne of the Child God.

At once I was in the spirit, and there before me was a throne in heaven with someone sitting on it… Then I heard every creature in heaven and on earth and under the earth and on the sea, and the entire universe singing, "To him who sits on the throne and to the Lamb be praise and honor and glory and power, for ever and ever!" After this I looked and there before me was a great multitude that no one could count, from every nation, tribe, people and language, standing before the throne and in front of the Lamb. They were wearing white robes and were holding palm branches in their hands. They cried out in a loud voice, "Salvation belongs to our God, who sits on the throne, and to the Lamb." All the angels were standing around the throne, and around the Elders and the four Living Creatures. They fell down on their knees before the throne and worshiped God.
Rev 4:2; 5:13; 7:9ff.

Princes preside on a rostrum. In the Orient the kings were carried on peoples' shoulders. The Frankish soldiers carried their leader shoulder-high on a shield. Before the Second Vatican Council, the pope entered Saint Peter's

on a *sedia gestatoria* (portable throne) borne by guards.

The scepter, originally the staff of command, is an emblem of power. Its verticality recalls the cosmic tree and the celestial origin of the authority received. Ambassadors can carry it as a sign of their mission; for example, Saint Gabriel on the day of the annunciation.

The cane with a knob or emblem equally symbolizes authority. The crozier with the top rounded into an arch or scroll also recalls the shepherd's crook and the pastoral function of the bishop.

The globe represents the world, and the universal sovereignty of the Lord of the heavens and the earth, who holds it symbolically in hand.

Hymn to the Cross of Christ

"Here is the ladder of Jacob on which the angels are climbing up and down, and at the top of which the Lord is standing.

This tree of celestial dimensions rose up from the earth to the heavens, fixing itself, as an eternal plant, in the middle of the heavens and the earth; it is the support of all things in the universe, the foothold of all the inhabited earth, a cosmic network, including within it all the colored medley of human nature. It is fixed by the invisible nails of the spirit, so as not to falter in its adjustment to the divine. It touches with its top the highest heavens, strengthening the earth with its feet and embracing the entire atmosphere with its immeasurable hands. O you who are alone among the solitary and all in everything! May the heavens have your spirit, and paradise your soul: but as for your blood, may it be for the earth!"

Pseudo-Hippolytus,
Homily on the Passover,
Christian sources.

May you be blessed in the Temple of your sacred glory,
exalted and glorified above all else for ever!

Dan 3:53

5. Temple

The temple gave people access to their god. In order to communicate with the deity, the soothsayer stood under the celestial dome at the intersection of a cross whose arms, pointing toward the four points of the compass, took possession of space. It was the *templum,* the delimited and consecrated place. There the soothsayer observed the flight of the birds in order to interpret the omens and master the future. This augural site was the point of departure for the demarcation of the divine dwelling, the temple, meeting place between humanity and the deity.

The ancient peoples of Chaldea, the Egyptians, Greeks and Romans, had their temples, whether they were buildings or were like the Celts' *nemeton,* a natural temple delimited by a glade under the canopy of heaven. The temple is an edifice *separate* from the profane world, the awesome dwelling of the sacred god. This sanctuary exercises an irresistible power of fascination.

The image of the temple and the throne sums up symbolically the cosmos, the center or *omphalos,* the axis and the cross, the square of the earth under the canopy of heaven and the divine throne. Built to recognize the deity's presence in this creation, the temple recalls primordial symbols in its cruciform design and in its pillars. In the Temple of Jerusalem, Flavius Josephus saw in the courtyard the symbol of the sea and the abyss, in the sanctuary that of the earth, and in the Holy of Holies that of heaven.

Its situation on high ground, or on a sacred mountain, sometimes accentuat-

ed by its pyramidal form like the Tower of Babel, makes of it a ladder which gives access to the heavens, outlined by the steps of the vestibule. In the dwelling of the god two colonnades divide the nave with their shafts. Their capitals take up again the image of the tree stemming from the depths of the ground, whose foliage opens up in the sky. The temple is oriented toward the point at which the day appears, the divine image radiating light. On the outside, the corners of the altar stone, raised in the four directions like horns, signify the mastery of the universe and its elements: air, fire, water, earth.

■ Paradise

The first dwelling of God among human beings was the Garden of Eden, the earthly paradise with four rivers (Gen 3:80). The expression *'earthly paradise'* (or heavenly Jerusalem), a place which was watered with living water, was to be reserved for the place of beatitude to come.

■ The Tent of the Presence

After wandering in the desert, the Israelites raised a meeting tent at each campsite. There Moses encountered God and spoke to God as friend speaks to friend. The tent evokes the celestial tabernacle, the sky, and therefore heaven itself (Exod 26).

■ Ark of the Covenant

Under the tent the *ark of the covenant* indicated God's presence

Instructions for the Ark of the Covenant

Make a chest of acacia wood two and a half cubits long, a cubit and a half wide and a cubit and a half high. Overlay it with pure gold both inside and out and make a gold molding around it. Cast four gold rings for it and fasten them to its four feet, with two rings on one side and two rings on the other.

Then make poles of acacia wood and overlay them with gold. Insert the poles into the rings on the sides of the chest to carry it.

Make an atonement cover of pure gold... Make two cherubim of hammered gold at the ends of the cover. The cherubim are to have their wings spread upward, overshadowing the cover with them and are to face each other... Place the cover on top of the ark and put in the ark the Testimony which I will give you. There I well meet with you.

Moses laid on Horeb the Tablets of the Covenant that Yahweh had made with the Israelites when they went out of Egypt.

Exod 25:8ff.

Miniature by Jean Colombe (d. 1589) depicting the ark of the covenant's entry into Jerusalem, in Les Très Riches Heures du Duc de Berry (ms. 65/1284, fol.29r), end of fifteenth century - © Giraudon - Condé Museum in Chantilly, France

amid God's nomadic people. It was an acacia chest intended to contain the Table of the Law dictated to Moses. It was topped with two cherubim fixed on its solid gold lid. Between these angels dwelt the hidden presence of God who could not be portrayed by any image or artistic form (Exod 25:10). David had planned to build a *temple* on Mount Sion as a sign of the divine dwelling and of God's covenant with this people; this was achieved by Solomon.

This temple was also the image of the world; the *vestibule* of the temple corresponded to the sea, the *sanctuary* to the earth and the *Holy of Holies* to the cloud of the heavens. It was here that the ark was to be found. It was made of acacia and covered in gold. It was the symbol of the divine throne and was guarded by the cherubim.

Prophetic vision of the temple, the divine throne

Above the heads of the animals, a sort of firmament, gleaming like crystal, arched above their heads. Above the firmament over their heads was what looked like a throne of sapphire and high above on the throne was the figure like that of a man; and then I saw a shining red color like a fire which enveloped him.

It was like the appearance of a rainbow in the clouds on a rainy day, such was the radiance around him. It was the appearance of the likeness of the glory of the Lord.

Ezek 1:22-28

THE HUMAN PERSON IS A MICROCOSM

Saint Gregory the Great said that the human person represents the universe: *"homo quodammodo omnia."* Saint Peter Damian specifies, *"Man is called by a Greek word 'microcosm,' that is, 'little world,' because in his material essence he is composed of the same four elements as the universe."* Called to become a temple, human beings belong to the earth through the clay of which they are made, but this clay is inhabited by the Spirit.

The upright position which distinguishes human beings from the animals expresses their reaching upward toward the heavens.

As the Irish cross of Moone illustrates, someone in a standing position is like a square and a circle superimposed, signifying the association of body and soul. The squareness of the shoulders is topped by the sphere of the head which can shine with the halo of sanctity.

Stretched out on the ground with arms outstretched, the body fits into a circle traced from its center, the navel or *omphalos.* The cruciform design of churches, consisting of a nave running lengthwise, a choir at the head, and the arms of a transept, corresponds to this posture.

The Church considers the edifice which bears its name as a human being whom it blesses, exorcizes, and anoints in the rites of consecration.

Leonardo da Vinci (1452–1519),
Vitruvius Canon
Academy Gallery, Venice, Italy
© Alinari - Giraudon

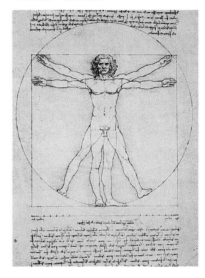

THE IDEAL TEMPLE, THE MAN-GOD

For Christians, it is Jesus Christ who is, in his perfection, the dwelling of God, the true temple. As the incarnate Word, Jesus is the *Emmanuel* or *God with us.* In him God made God's very self present and in him has made a covenant with God's own. Talking about his death on the cross, Jesus said, *"Destroy this temple and in three days I will raise it up again."* The very humanity of Christ, a sanctuary destroyed by death, yet risen from the dead, is the dwelling of God (John 2:13-21). The Church itself, united to Christ as his body, and living by his Spirit, is the temple made of living stones, built on the cornerstone of Christ (Eph 2:22 and 1 Pet 2:5). Every Christian, as a member of this Church, becomes the temple of the Spirit: *"Your body is a temple of the Holy Spirit"* (1 Cor 6:19).

The temple is thus the mystery of the encounter of God with the humanity God saves throughout history until the end of time, the moment when the divine glory will manifest itself.

Blessed be your glorious and holy name, praised and extolled for ever!

Dan 3:52

1. God of the Universe and Holy Trinity

Each people has provided itself with an image of God, either anthropomorphic or zoomorphic. The Jews adored the one spiritual God, whose representation in human or animal form was condemned as idolatry by Moses' Law. This God is totally other, and God's holiness seems out of reach. From the heart of a burning bush, Yahweh called Moses, who replied *"Here I am."* *"Do not come any closer,"* said the voice, *"Take off your sandals, for the place where you are standing is holy ground."* Moses covered his face for fear of seeing God (Exod 3:1-6).

Sinai was on fire and lightning came out from the cloud when Yahweh descended on the mountain top. The mountain, Yahweh's pedestal, became holy and inaccessible (Exod 19).

In an inaugural vision of the divine throne in the temple, while the seraphim proclaim: *"Holy, holy, holy is Yahweh… Yahweh's glory fills the earth!"* Isaiah says to himself, *"I am lost, for I am a sinful man!"* Then one of the seraphim purifies his lips with a live coal so that he may bear the words of the holy God (Isa 6:1-8).

An approach to describing this pure spirit can only be made by means of symbols.

■ Hand, Cloud, Shadow

The efficacious divine presence is suggested by a hand stretching out from the cloud, symbol of divine action and royal authority; the kings, its representatives, act as the hand of justice. This cloud, both a sign and a protective mask, indicated the divine presence to the Israelites during the long journey of their exodus from Egypt (Exod 13:21).

The shadow is an immaterial image projected by a presence. It at once reveals and conceals the mysterious action of God: *"The Spirit will overshadow you"* (Luke 1:35). Thus was announced the intervention of the Spirit which made Mary's womb fruitful.

■ Trinity of the Persons

God made the Godhead close to humanity as Father, Son, and Holy Spirit. Various symbols, either abstract ideograms or inspired by the incarnation of the Son, evoke the mystery of their unity or each one of the divine Persons and their respective activities.

■ Trinitarian Signs

The Trinity is signified by the abstract figure of the triangle, with the Hebrew inscription of Yahweh's name in the center or the drawing of an eye. It can also be signified by three interlocking circles. *"In the profound and clear substance of the supreme light, three circles appeared to me; of three different colors and one single dimension."*

Dante, The Divine Comedy

A more concrete representation is already suggested by biblical interventions. This is the case with Abraham's *three visitors* at the oak of Mamre (Gen 18:1), who are depicted by Rublev in a sublime icon.

At the end of the Middle Ages the familiar depiction of Jesus brought about that of the other two Persons. They are depicted in the form of figures clothed with the purple mantle and crowned, sitting side by side, sometimes the Father and the Son with the Spirit flying above, sometimes the three enthroned together.

Each Person can be evoked by an appropriate symbol:

The Father

The symbols attributed to the almighty Father are *the crown and the globe.* From the fifteenth century onwards artists portrayed the Father emerging

Icon by Andrew Rublev depicting Abraham's visitors (the Trinity), State Gallery, Moscow, Russia

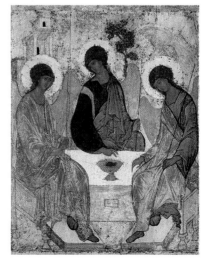

from the cloud in the form of a bust with the head of an old man with white hair and beard. Later on, he wore a tiara or an imperial crown and was seated on a throne holding the globe of the world in hand. Sometimes in a pietà the crucified Son on God's knees.

THE SON

The Word, eternal Word, is evoked by *the book.*

Although he had become visible through his incarnation, artists hesitated for a long time, until the fifth century, to do paintings, and especially sculptures of him, so as not to offend his divinity with the realism of the representation imprisoned in time and space.

The chi rho, a monogram formed by the X (chi) and R (rho) of Christos (Χριστος), was, as on many sarcophagi, inscribed on the *labarum* (military standard) which obtained victory for Constantine.

The alpha and the omega α ω are the first and last letters of the Greek alphabet. They designate the one who is the beginning and the end, the first and the last word, the Word (Rev 1:8).

The fish, in Greek Ιχθυς of which each letter corresponds to Ἰησους Χριστος Θεου Υιος Σωτηρ: Jesus Christ, Son of God, Savior.

I H S *Jesus Hominum Salvator:* Jesus Savior of mankind or *In Hoc Signo:* In this sign;

I N R I Jesus of Nazareth, King of the Jews (title given at the crucifixion);

WAW The sixth letter of ancient Greek corresponds to the number of letters in Jesus' name; it is associated with the bronze serpent on the upright stake of the cross.

Then the Son, Jesus, was represented at the different ages and in the different situations of his life, without the use of symbols. Even in his glorious life, after the resurrection, artists represent him with the features with which he was seen by his disciples.

THE SPIRIT

The Spirit of God is invisible. The Spirit is manifested in the form of a *dove* which hovers in the heavenly spaces. Thus is the Spirit revealed at creation (Gen 1:2), at the Baptism of Christ (Matt 3:16) and at Pentecost (Acts 2:1-4). During this latter event the book of the Acts of the Apostles also describes the action of the Spirit in the form of sparks or *tongues of fire.* The Spirit is also the imperceptible breath of the *wind* (John 3:8) and the breath which breathes life into living beings (Gen 2:7).

Enguerrand Charonton, The Coronation of the Virgin, 1453,
Hospice de Villeneuve-lès-Avignon, France.
Doc. photo.: Revue de Zurich

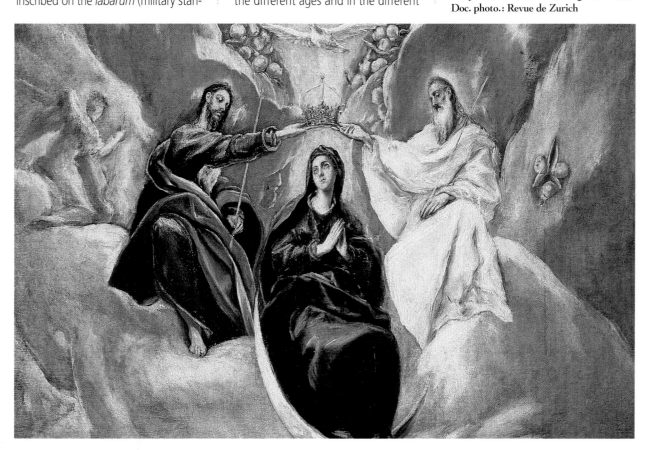

We venerate your Cross, O Lord, and we praise and glorify your holy resurrection. By the wood of the Cross joy has come to the entire world.

Good Friday Liturgy

2. Jesus Christ, God in Our Midst

If the evocation of Jesus Christ need not resort to the use of symbols since he became incarnate, the mystery of the Person who was both God and Man, and of his action, can only be expressed symbolically.

HIS PERSON

Various figures announce his coming, or sum up his mission:

■ The Son of David
The *tree of Jesse* often evokes symbolically the royal ancestry of the son of David.

Jesse, the grandson of Boaz and of Ruth, is father of David (Ruth 4:22) and of his descendants right down to his promised descendant, Jesus, through Joseph's adoption and Mary's maternity. A colorful presentation of the ancestors of Christ, which dates back to the ninth century, symbolizes the expectation of the Old Testament as well as the coming of the Messiah and his incarnation. It comments on a prophecy of Isaiah:

A shoot will come up from the stump of Jesse,
from his roots a branch will bear fruit.
The Spirit of the Lord will rest on him,
the Spirit of wisdom and understanding,
the Spirit of counsel and of power,
the Spirit of knowledge and of fear of the
Lord... Isa 11:1-3

A tree takes root in Jesse stretched out on his bed. His lineage is reduced to twelve kings who are recognizable by their names and their attributes. As many prophets sometimes accompany the ancestors on the branches. At the top of the tree, Christ sits enthroned in majesty with the dove of the Holy Spirit above, or the seven doves of the seven gifts of the Spirit. This final floweret can also blossom into a Virgin–Mother or even a crucifix.

■ The Good Shepherd
Christ was portrayed indirectly in *Hermes Criophore*. The first Christians recognized in this statue from pagan mythology "the great shepherd of the sheep" (Heb 13:20). They reproduced in graffiti on the walls and in low relief on their sarcophagi, or, as in the second century, in the catacombs of Domitilla, a young smooth-cheeked shepherd with curly hair, dressed in a short tunic, and carrying on his shoulders the lost ram which he brought back to the sheepfold. This is the Christ, Good Shepherd, the Savior, announced by Ezekiel and illustrated by the allegory of Jesus himself (John 10:11-16). He knows each sheep, he gives his life for each one, and he will not rest until he has gathered together his flock.

■ The Lamb of the Apocalypse
Lying on the Book with seven seals or standing on the altar

Stained-glass window depicting sheep, a church in Merida, Spain

with the Cross as a banner, the image of the Lamb recalls both the song of the Suffering Servant which *announces that the Messiah will be "like a lamb led to the slaughter"* (Isa 53:7) and John's vision in which the Lamb is victorious by his passion, death, and resurrection (Acts 5:6).

■ The Son of Man
King and judge of the world, the Savior is evoked by the Apocalypse of Saint John (Rev 1:13) as a priest clothed in sacerdotal robes, as a king with the royal golden sash, as the Eternal One with white hair, and as the Judge of the end of time who comes on the clouds.

Statuette representing Christ as the Good Shepherd, Louvre Museum, Paris, France

THE MYSTERIES OF CHRIST

The life of Christ, like that of everyone, has both visible and invisible aspects. In him, the mystery stems from his divinity. The stages of salvation occur through his birth, his death, and his glorification, all three of which are evoked by symbols and figures:

■ Birth

The virginal conception is depicted prophetically by the dew which Gideon gathered from a *fleece,* without dampness spreading into the surrounding area (Judg 6:36). The nativity of Jesus from Mary's womb is symbolized by a *unicorn* taking refuge close to a virgin.

■ Passion and Death

The passion and death of Jesus are not only represented iconographically, they are also evoked symbolically.

Emblem of the Cross

Right from the beginning the salvation obtained by the death of Christ has been recalled liturgically by the abstract Sign of the Cross, the emblem of the victory of Christ over death and sin which the Church venerates on Good Friday. Few representations of the crucifixion are found before the fifth century, but the naked crosses of the catacombs are numerous. The *Tree of Life* of paradise (Gen 2:9) and the *bronze snake* (Num 21:9) sometimes accompany these symbolically.

At first reserved for the tombs of the martyrs, they were chiseled on the sarcophagi. Like Procopius, a martyr under Diocletian, many had silver or gold-plated crosses laid on them. Leaden ones were laid on the chests of the dead along with a prayer of absolution. Later on, crosses indicated Christian burial places.

Over and above their use for worship, the crosses were outer, visible signs on the monuments on which they were carved or which they topped. As processional crosses they led religious processions. Roadside crosses are scattered all over Christian lands.

The Cross and Its Different Forms

- T The *tau cross,* formed by a horizontal beam nailed to the top of a vertical one, has a specific meaning, the tau, like the anchor, being a symbol of immortality. It can be found on sarcophagi (often accompanied by the X and the P - for Christos -Χριστος- and by α ω), where it represents both hope in eternal life and the memorial of the passion. It can be seen in the *tau* emblem of Saint Francis of Assisi.

- ☥ The same cross topped with a ring is known as the *ansate cross.* It is an Egyptian hieroglyph, symbol of eternal life. The Copts adopted this shape of the cross and its meaning: the key to life.

- The *immissa cross,* called the *Latin cross,* even if it is to be found in Byzantine iconography, consists of a post whose upper part is cut across by a horizontal crosspiece. According to Saint Irenaeus and Saint Augustine this was the shape of the cross at Golgotha.

- The *Greek cross* is made of two pieces which cross one another in the middle.

- The *cross of Saint Andrew* or the *decussate* cross is a Greek cross turned diagonally.

- ☩ The *Irish cross* with a circle in its center is a sign of Christian salvation and a cosmic symbol of the temple, of the omphalos, the four points of the compass, of the circle and of the four elements.

- The *Jerusalem cross* consists of a central cross framed by four smaller ones: the whole recalls the five wounds of Christ.

- ☨ The *Papal cross* has a triple crosspiece, the *Lorraine cross* has a double crosspiece.

- ☦ The *Orthodox cross* bears a *titulum* (notice of the sentence-giver) fixed to it like a diagonal crosspiece.

The Sign of the Cross

The Cross can also be expressed in a gesture. We know from Tertullian (third century) that Christians could be distinguished from other people by a sign, the tracing of a cross on their foreheads with their thumb at the beginning of all their major activities, the sign of the servants of God as described in the Apocalypse of St. John (Rev 7:3). It was not the Latin cross, but the Hebrew tav, that of the name of Yahweh, according to Ezekiel, and which was represented in the form of a + or X. For Christians this sign of divinity could only become that of the incarnate and crucified Word, the Sign of the Cross which they made over the body from the forehead to the chest and from one shoulder to the other. The Sign of the Cross, imposed as

Irish cross of Clocmacnoise

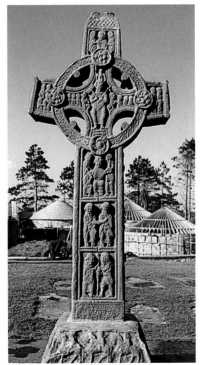

a sign of membership in Christ, first appeared in baptismal rites and it is itself the sign of baptism. A second-century inscription addresses the people that bears this *splendid* seal.

The anointing of oil with the Sign of the Cross accompanies the administration of other sacraments: confirmation, holy orders, the sacrament of the sick, and also the consecration of persons and things such as altars and churches.

Yet the mystery of salvation by the death of Christ was evoked by other more concrete signs:

■ Insignia of the Passion

The insignia of the passion are known as the **Arms of Christ,** and are fixed onto crosses depicted in the network of stained-glass windows, miniatures or low reliefs of beams or paneling. They are:
- *The cross,* the instrument of execution,
- *The chalice,* the vessel in which the angels collected the blood from the wounds,
- *The nails* hammered into the hands and feet,
- *The hammer* of the crucifixion,
- *The pliers* of the descent from the cross,

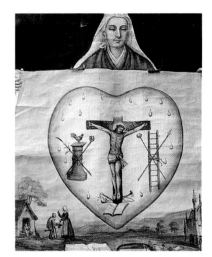

Painting of the Mission: Meditation on the passion and penance, the Vannes retreat, France

- *The crown of thorns* of the king of the Jews,
- *The cock* indicating Peter's denial,
- *The dice* of the casting of lots for Christ's clothing,
- *The ladder* for the descent of his body from the cross,
- *The sponge* filled with gall and vinegar and held out to the crucified man,
- *The whip* of the flagellation,
- *The spear* thrust into the heart in order to verify the death,
- *The lantern* of the arrest in Gethsemani,
- *The hands* of the servants who slap Christ,
- *The reed,* a mock scepter,
- *The shroud* of the burial,

- *The tunic,* seamless garment for which the soldiers cast lots,
- *The Holy Face (Veil of Veronica):* the face of Christ was transfigured and his face shines like the sun (Matt 17:2). According to an apocryphal tradition he left an impression on the linen which a holy woman used to sponge away the sweat and blood on his face during the Way of the Cross. The holy shroud of Turin bears an imprint attributed to the shrouding at his burial,
- *The Sacred Heart:* a heart, surrounded by flames, either on its own, or represented in Christ's chest where it was wounded by the spear, is also an eloquent emblem of the passion.

■ The Unfolding of the Passion

The events of the passion are rich in suitable symbols:

The persecution by the Pharisees is symbolized by the *unicorn* pursued by hunters.

Crucifixion, Golgotha, Calvary

An apocryphal writing ("Book of the Eastern Adam") relates that Noah, his son Sem, and his grandson Melchizedek transported Adam's remains to the center of the earth, the Golgotha, a place designated by an angel. The word Golgotha, Latinized into *calvaria,* means *"skull."* The

Painting by Paul Delaroche depicting Saint Veronica, Louvre Museum, Paris, France

blood of Christ flowing onto Adam's skull at the foot of the cross is a symbol of the redemption of humanity in its ancestor.

Figures Announcing the Sacrifice

Various figures drawn from the Old Testament depict symbolically the significant aspects of the passion and death of Christ:

- *the death of Abel* (Gen 4) announced the death of an innocent man,
- *the sacrifice of Abraham* (Gen 22) represented the offering of his Son by the Father,
- *the tracing of crosses in blood on the doors* of Hebrew dwellings before their exodus linked the blood of the sacrifice to the liberation of believers (Exod 12:24-28),
- *the bronze serpent* (Num 21:9) made of the cross the sign of healing,
- *the water* which Moses made flow by striking the rock announced the water which would pour out with the blood from the crucified Jesus' side (Exod 17),
- *the cluster of grapes* borne on the shoulders of the explorers of the Promised Land was an image of Jesus suspended on the cross like a bunch of grapes, whose juice was collected in the eucharistic chalice (Num 13:23).

■ Glorification

A few appropriate symbols also apply to this mystery:

Resurrection and Ascension

The death and resurrection of Christ, Son of God, are one single mystery, that of the salvation of humanity. This event of the resurrection had no eyewitnesses, but was prefigured in *archetypal figures:*

- *Samson* tearing out the gates of Gaza which the Philistines had closed against him, just as Christ pushed back the tombstone (Judg 16:1),
- *Jonah* who was vomited out by the whale ("fish") after three days in its belly (Jonah 1–2),

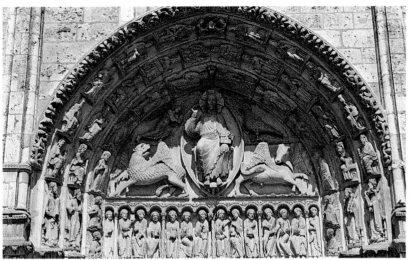

Lintel of the central portal depicting Christ in Majesty, Cathedral of Chalon-sur-Marne, France

- *the phoenix* rising from the ashes after three days,
- *the lion* resurrecting its cubs, and symbolizing the work of the Father,
- *the pelican* nourishing its young with its blood by opening up its own side.

The ascension is symbolized by the *eagle* taking flight above its young.

The glorification of Christ through his death and resurrection is the completion of his coming.

Christ in Majesty and Tetramorph

Paleo-Christian art expresses its vision of Christ through the symbols of his dou-

The bronze serpent on Mount Nebo in Israel

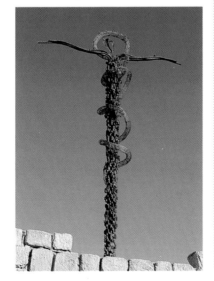

ble nature. Mosaics, ivory pieces, and icons portray him sometimes in bust form, sometimes seated on a throne, on the cosmic rainbow or on a cloud. He blesses with his right hand and presents the book in his left. Sometimes his face shines with a vast cruciform nimbus and his arms, spread out like the crosspiece of the cross, embrace the universe. Another sphere is formed from his waist down to his feet and rests on a square stool.

In church tympanums this iconographic theme glorifies the Word in majesty seated on the throne and presenting the book, symbol of the Word. This image owes its name *tetramorph* to the four figures which frame it. It is inspired by two prophetic texts. The vision of *Ezekiel* describes four *living* creatures in a cloud of fire. Each of them has four faces looking in four different directions, the face of a man, the face of a lion, the face of an ox and the face of an eagle. These figures studded with eyes pull a chariot with strange wheels which moves in four directions at once amid the flashes of lightning. This is a transposition of the movement of the stars and the constellations in the sky. Beyond this the chariot expresses Yahweh's mobility, for without being a prisoner of the Temple, Yahweh accompa-

nies this people in whatever part of the universe they are exiled (Ezek 1:5-14).

The Apocalypse of John describes the divine throne where a single emerald stone shines. Around it twenty-four elders in white robes and crowns bow low in adoration. Then it describes the four living creatures, each with its own shape, studded with eyes and with six pairs of wings, and finally the Lamb, who receives the book from the one on the throne (Rev 4:2-11).

The four living creatures of these visions explain the figures around the Christ in Majesty, which have been interpreted in various ways. A first reading makes of the four animals (or seraphim with six pairs of wings), the evangelists who are evoked by the book held by the Christ – divine Word. They are his spokesmen in the four corners of the world, which the Good News must reach:

- the figure of a *man* designates *Matthew,* who begins his Gospel with the genealogy of Jesus and emphasizes his human **birth**;
- the figure of the *lion* designates *Mark,* whose Gospel begins with the words, *"The voice that cries in the desert,"* suggesting the lion, symbol of the **resurrection**;
- the figure of the *ox* designates *Luke,* who writes of Zachary in the temple, thus recalling the ritual sacrifice of oxen and announcing the bloody **immolation** of Jesus;
- the figure of the *eagle* speaks of *John,* contemplator of the Word of God, the Fourth Evangelist, who sweeps us **up into the heights** like an eagle, his eye fixed on the divine sun.

According to another interpretation these four figures are the royal attributes of Christ himself:

- the *human* form expresses human dominion over all other creatures. It symbolizes the air and the creative breath of humanity, divine image. It signifies the **incarnation** of the Lord.
- the *lion*-like figure recalls the king of all wild animals and symbolizes fire because of its rapidity. It announces the **resurrection**.
- the *ox*-like figure recalls the ox's pre-eminence among domesticated animals and is a symbol of the earth which it cultivates. It alludes to the passion and the **bloody sacrifice**.
- the *eagle*-like figure refers to its soaring over other birds and symbolizes the *water* in which the birds are supposed to be hatched. It alludes to the **ascension**.

Thus Jesus is represented as a man in being born, an ox in dying, a lion in rising from the dead, and an eagle in going up to heaven.

Miniature depicting Saint Luke in "the Gospels," mid-twelfth century, from Cysoing Abbey, preserved in the Municipal Library, Lille, France © Giraudon

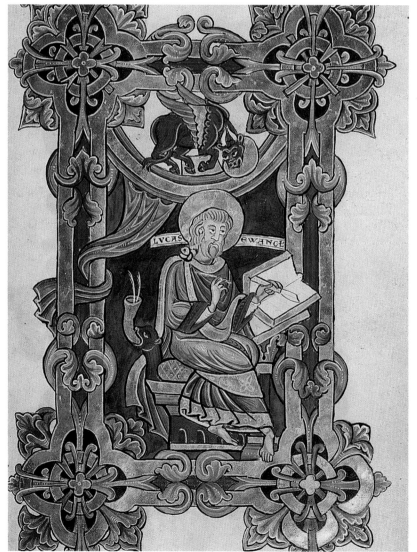

"Every major Romanesque work includes a great Christian symbol in which he is linked like the kings of Chartres to the portal and the capitals to the church. The most constant of these symbols, the Christ in the Tetramorph, symbolizes the universe. The spectator does not know that the lion, the eagle and the ox formerly symbolized the four points of the compass and the mysterious forces of the earth..."

Malraux, Métamorphose des dieux

I looked and I saw a windstorm coming out of the north,
an immense cloud, a fire with flashing lightning
darting from it and a glow all around and in the center of the fire
the glow like a ruby.
In the center I saw what looked like four animals.
They looked like this: they were of human form,
they each had four faces and four wings.
As to what they looked like, they had human faces,
and all four had a lion's face to the right,
and all four had an ox's face to the left,
and all four had an eagle's face.
It was something that looked like the glory of Yahweh.
I looked and prostrated myself…
Their wings were spread upwards; each had two wings
that touched and two wings that covered its body;
and they all went straight forward,
they went where the Spirit urged them.
Above the vault over their heads
there was something that looked like a sapphire;
it was shaped like a throne, and high on this throne
a being that looked like a man…

Ezek 1:4-8; 10-12; 26-28

Before the throne was what looked like a sea of glass,
clear as crystal. In the middle of the throne and around it
were four living creatures, covered with eyes in front and behind.
The first living creature was like a lion, the second was like an ox,
the third had a face like a man,
the fourth was like an eagle in full flight.
Each of the four living creatures had six wings
and was covered with eyes all around.
Day and night they never stop saying:
"Holy, holy, holy,
is the Lord, God almighty,
who was, and is, and is to come."
Then one of the elders said to me,
"Do not weep! See, the Lion of the tribe of Judah, the Root of David
has triumphed. He will open the scroll with seven seals."
Then I saw a Lamb, looking as if it had been slain, standing
in the center of the throne, encircled by the four living creatures
and the elders. He had seven horns and seven eyes
which are the seven spirits of God sent out into all the earth.
He came and took the scroll from the right hand of him
who sat on the throne. When he had taken it, the four living creatures
and the twenty-four elders fell down before the Lamb.
Each one had a harp and they were holding golden bowls of incense,
which are prayers of the saints.
Then I looked and heard the voice of many angels encircling the throne
and the living creatures and the elders; they numbered thousands upon
thousands and ten thousand times ten thousand!

Rev 4:6-8; 5:5-8,11

3. The World of Humanity

THOSE WHO WERE CLOSE TO JESUS, AND THEIR ATTRIBUTES

Among the descendants of Adam, to whom the Creator had entrusted the world, certain persons received a privileged mission:

■ Mary

Mary is the *virgin,* chosen by the Father to bring into the world the Father's Son Jesus, the redeemer of humanity, the New Adam. Mother of God, she is also mother of the new humanity, that is, the New *Eve.* An anagram of the angel Gabriel's greeting, *"AVE Maria,"* gives EVA, the Latin name of *Eve.*

She is the *mother* and model of the *Church* entrusted to her by Jesus on the cross when he said to John, *"This is your mother,"* and to Mary, *"This is your son"* (John 19:26-27). The liturgy illustrates the feast of the Assumption with the vision of the woman in the heavenly cloud in the Apocalypse (Rev 12).

Litanies of the Virgin, a development of an eighth-century hymn, enumerate a series of symbolic attributes borrowed from the Old Testament to evoke her hidden grandeur and her mission. She is called:

Mirror of Holiness: free from sin, she reflects the action of God.

Seat of Wisdom: Jesus, the wisdom of God, dwelt in her womb.

Vessel of the Spirit: the Spirit of God conceived Jesus in her.

Mystical Rose: the Virgin–Mother is the rose which flowers at the top of the tree of Jesse. The crown of roses of the laureates is hers by right and gives its name to the prayer of the fifteen decades of the rosary meditated in the contemplation of the mysteries of her life, which are inseparable from those of her Son.

Tower of David: like the defenses of the city of David she watches over the Church, the new Jerusalem.

Tower of Ivory: she is both strength and purity.

House of Gold: within her dwelt the king of glory.

Ark of the Covenant: the Son of God came to reside within her, like the ark of the divine presence in the Temple.

Gate of Heaven: her womb received the king of heaven. Her prayer gives us access to the Father and to the Son.

Morning Star: she heralds Jesus, the rising sun.

A Marian monogram combining the letters of her name is inscribed on altars or consecrated objects.

The Virgin of the Bushes, church of the Dominicans, Colmar, France

Painting by Georges de La Tour (1593–1652) depicting Saint Joseph the Carpenter, Fine Arts Museum, Besançon, France

■ Joseph, Spouse of Mary

A carpenter from Nazareth of the lineage of David, Joseph espoused Mary and, according to the Apocrypha, *his wonderfully blossoming staff* distinguished him from among the candidates for this marriage. Like Joseph, son of Jacob, he was able to interpret dreams and received the warning that he must take Mary and Jesus away to

Egypt on the occasion of Herod's persecution.

■ Apostles of Christ

The apostles, the founders of the Church, are portrayed at the entrance to churches as the guarantors of the faith. Aligned on either side of the porches, presenting on a phylactery a phrase of the Creed of which they are the witnesses, they can be recognized by the instruments of their martyrdom. Messengers of Christ, as the

Porch of the Apostles, Plovenez du Faou, Saint Herbot, France

angels are messengers of the Father, they too have bare feet, following Jesus' instructions: *"Do not take a purse, or bag, or sandals…"* (Luke 10:4), and so are distinguishable from the other saints.

Peter, tonsured or bald, carries one or two keys as a sign of the powers given by Christ to the pastor of his Church.

Andrew holds the diagonal cross (X) which bears his name.

James the Greater: wearing a hat on his head and holding the pilgrim's staff, wears the shell, called the scallop shell, either slung across his shoulder or on the front of his head. It recalls his burial and the pilgrimage to Saint James of Compostela.

John, smooth-cheeked with curly hair, holds a poisoned chalice, which he was made to drink: the venom is symbolized by two serpents or a toad.

James the Less holds the fuller's bat with which he was struck before being hurled down from the city wall.

Philip holds a Latin cross.

Bartholomew holds the cutlass with which he was flayed or sometimes a cross.

Matthew bears a pick or a tax-gatherers' scales for weighing the tax-money.

Thomas holds a spear or a stonecutter's square, the instrument of his profession.

Simon carries the saw with which he was martyred.

Jude holds a staff or the palm of martyrdom.

Matthias, chosen to replace Judas, carries a halberd, an ax or a two-edged sword.

Sometimes *Paul* numbers among the apostles, and holds the sword with which he was decapitated as the privilege of Roman citizens who where condemned.

Judas Iscariot, who betrayed Jesus, handing him over in exchange for thirty silver coins, is not numbered among the apostles. In representations of the Last Supper on Holy Thursday he is recognizable by the purse he holds in his hand and by lack of a nimbus.

ARCHETYPAL FIGURES WHO ANNOUNCE THE SAVIOR

The history of the Old Covenant is marked by certain biblical personages who prefigured Christ personally or prefigured the messianic times through events in which they were involved. From afar, they acted as models or sketches.

■ Precursors, Patriarchs, and Kings

Adam, Eve

Adam is the name given to the first man, drawn out of the mud – *adamah* or red clay – which God shaped in order to breathe life into it (Gen 2–7). In the first book of Genesis (1:24-31) this name is a collective name as the plural *"they will dominate"* indicates. The two biblical narratives reveal that God made "man" in the divine image, that God created them man and woman, and that they are equal by nature and intended for a monogamous marriage. Adam sinned but will be redeemed.

Entering the ark, Yann Van Kessel I the Elder, (1626-1679), Museum of Fine Arts, Rennes, France © Giraudon

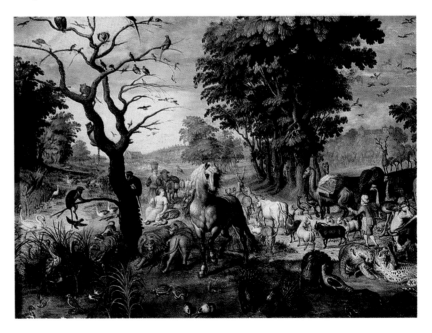

The New Adam, Jesus, Son of God, became incarnate for the salvation of humanity.

Abel and Cain

Among the sons of Adam, the second one, Abel, was a shepherd. His adoration pleased God. Jealous of the attention which God gave to his younger brother, Cain killed him and then fled in order to escape God, for he was overwhelmed by his crime. Abel represents Christ, the one loved by God and an innocent man put to death by his kin.

Noah

The patriarch Noah, who was chosen to save humanity from corruption, prefigures Christ. He gathered together his family and all the species of animals in an ark in order to save them. He made sure that the flood was over by setting free a raven, and then a dove, the messenger of the good news, which brought back a green branch. Noah is reputedly the first to have cultivated the vine, the eucharistic plant (Gen 9–20).

Abraham

Yahweh called Abraham to leave the land of Ur and make a covenant with Yahweh. When he was elderly and childless Abraham received three divine visitors near the oak of Mamre. They foretold the birth of a son from Sarah, who was barren. Then God put this friend to the test, asking him to sacrifice his son, Isaac, in a prefiguration of the sacrifice of God's own Son. However, God held back Abraham's arm just as he was preparing to immolate Isaac. An ancestor of Jesus, Abraham is the father of all believers because of his faith (Gen 12–22).

Isaac

Chosen by Yahweh to be a sacrificial victim, Isaac prefigures the immolated Jesus (Gen 22).

Melchizedek

At the close of a victorious battle started by Abraham on behalf of his nephew Lot, Melchizedek, king of Salem and priest, gave thanks and offered bread and wine in sacrifice, thus foreshadowing the Eucharist (Gen 14).

Jacob

Jacob, son of Isaac, ousted his elder brother Esau, thus illustrating the mystery of God's choice of the weakest. His twelve sons gave their names to the twelve tribes of Israel. At Bethel he had the vision of the bond between God and those who pray to God, in the form of a ladder on which angels were descending and ascending. There he struggled with a strange being who gave him the name of Israel, *"the one who is strong against God"* (Gen 32:23-32).

Joseph

Son of Jacob and Rachel, Joseph, his father's favorite, incurs the jealousy of his brothers, who throw him into a cistern. Saved by some travelers and taken to Egypt, he becomes the all-powerful minister of the Pharaoh. Through his interpretation of dreams he foreshadows Joseph, Mary's spouse. Through his flight from his father's house, through the betrayal by his brothers and his success with the Pharaoh, he foreshadows Jesus' persecution and his flight into Egypt, his being abandoned by his own and the glory of the Son of God at the right hand of the Father (Gen 37ff.).

Aaron

Aaron accompanied Moses, his brother, before the Pharaoh. By causing the staff that represented his tribe to flower, Yahweh designated him as high priest and a prefiguration of Christ's priesthood (Exod 5; Num 17:16).

Moses

Abandoned on the Nile, Moses was found and brought up by the Pharaoh's daughter. While he was guarding the flocks of his father-in-law on Mount Horeb, God was manifested to him in a bush which was on fire without being consumed. He then received the mission to deliver his people from Egypt (Exod 3). In the meal with the Paschal Lamb, the crossing of the Red Sea, and the Exodus through the desert, the transmission of the Tables of the Law, and the leading of his people to the Promised Land, he anticipates Jesus' work of salvation: the New Covenant, the Last Supper, the passion, and the resurrection. He prefigures the sign of the saving cross by raising up the bronze serpent in order to heal the victims bitten by the serpents in the desert (Num 21:9).

Joshua

By his name (Joshua–Jesus) and his crossing of the Jordan and entering into the Promised Land, this successor of Moses prefigures Jesus the Savior who calls us to enter the Church through baptism (Num 13:16; Josh 3).

Gideon

Gideon, one of the Judges, asked Yahweh for a sign of Yahweh's plan, by asking Yahweh to cover with dew the fleece he laid on dry ground. Thus was prefigured the work of the Spirit who made Mary pregnant without her losing her virginity (Judg 6:36).

Samson

Famous for his strength and his courage in the face of the Philistines, Samson defeated a lion and overcame a thousand enemies. After yielding to the coaxing of Delilah, who shaved his long hair (which was a sign of his consecration and the source of his vigor), he repented of his infidelity and regained the strength to

Statue of Moses by Michelangelo in the tomb of the Medici, Florence, Italy

knock down the columns of the Philistine temple. He foreshadows the power of Christ which broke down the gates of death (Judg 14, 16).

David

Shepherd and image of the Good Shepherd, David was called to royalty by the prophet Samuel and was anointed by him (Christ = anointed) (1 Sam 16:13). Victor over the Philistine Goliath, whom he killed with a stone from his sling, he foreshadows the victory of the Savior over Satan. He brought the ark of the covenant into Jerusalem amid the singing of psalms (2 Sam 6).

Solomon

This son of David built the Temple. Despite his failings, he prefigures Christ in the wisdom of his judgments. The Canticle of Canticles, an expression of spiritual love using the vocabulary of carnal love, is attributed to him.

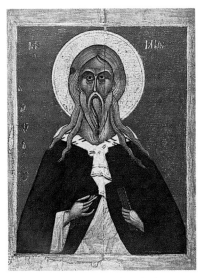

Icon representing the prophet Elijah, Moscow, Russia

■ The Prophets

Elijah

Elijah was persecuted by Jezebel for his fidelity to a single God. Alone in the desert (1 Kgs 19:3), he prefigured the abandonment Jesus experienced in Gethsemani. Having designated Elisha to succeed him, he was taken up to heaven in a chariot of fire, thus foreshadowing the ascension of the Lord. At the Transfiguration he appeared as a representative of the prophets beside Moses, who drafted the Law (Matt 17:1-9).

Isaiah

Isaiah was the first of the four great prophets (with Jeremiah, Ezekiel, and Daniel). During a vision in the Temple, an angel purified his lips with fire, which were to pronounce the word of the Lord (Isa 6:1-7). He prophesied the coming of the child born of a Virgin (Isa 7:14), the Messiah (Isa 9:6ff.), a shoot which would spring up from the stump of Jesse (Isa 11:1).

Jeremiah

Jeremiah, the prophet of the New Covenant, who was rejected and persecuted by his people, announced the passion of Jesus and his Cross through the suffering he endured during his mission.

Daniel

A Judean deported to Babylon, and a prefiguration of the risen Christ, Daniel came out alive from the lions' den where he had been thrown by his enemies. He announced the just judgment of the Lord through his clear-sightedness in the face of those who slandered the chaste Susannah (Dan 6:2-29 and 13).

Job

Probably a mythical personage, Job was a just man put to the test by Satan. He lost his family, his friends, and his possessions. He complained to God of his lot but respected the mystery of divine Providence. He is a foreshadowing of Jesus exposed to evil and misunderstood in his passion.

Jonah

According to the book bearing his name, which is neither an anthology of miracles nor a chronicle, Jonah was sent by God to convert the pagan inhabitants of Nineveh. Yet Jonah fled from his mission and took to the sea. Swallowed up for three days and three nights in the belly of a whale ("fish"), he was vomited up on the shore so that he might accomplish his difficult mission. He thus prefigures both the universal mission entrusted to the Jews and Jesus' descent into death followed on the third day by his resurrection (Jonah 1:15–2:11).

John the Baptist

The last of the prophets, known as the precursor of the Messiah, John the Baptist invited the Jews to a baptism of repentance. On the banks of the Jordan, he baptized Jesus, his cousin, whom he had pointed out as the Lamb of God prophe-

Painting by Michelangelo (1475–1564) depicting the Sibyl of Libya, Sistine Chapel, Vatican, Rome, Italy

sied by Isaiah. On the request of Herodias, he was imprisoned and decapitated by Herod at Machaerus for having denounced their incest.

■ Sibyls Likened to the Prophets

A sibyl in a trance, also called a prophetess, rendered the oracles of Apollo in the grotto at Delphi. Lactantius, St. Augustine, and St. Jerome compared sibyls to the prophets, interpreting some of the predictions attributed to such a woman and her emulators. On this account the sibyls were integrated, like Virgil, the author of a prophetic eclogue, into the liturgical plays of the Middle Ages. During Christmas matins *Judicii signum* was per-

formed, or the "Song of the Sibyl of Ery-threa." She was considered the harbinger of the end of time just as was King David. The *Dies irae* sings, *"Day of anger, that famous day which will reduce the world to ashes as David and the Sibyl testify,"* a preconciliar antiphon of Christian funerals. Virgil depicted the Sibyl of Cumae as the author of the sibylline prophetic books. The sibyl of Tibur had made Jesus and the Virgin appear in a celestial arch before the eyes of the emperor Augustus.

Artists depicted first one then ten and up to twelve, by analogy with the prophets and apostles:
- *the Agrippa,* recognizable by her set of pearls and the whip of the flagellation,
- *the Cimerian* sibyl with her ivory horn,
- *the Cumaean* sibyl with her sibylline book or a golden basin,
- *the Delphic* sibyl with her bowl of perfumes or the crown of thorns,
- *the Erythrean* sibyl with her branch of the rose tree of the annunciation or her globe,
- *the European* sibyl with her two-edged sword of the massacre of the Innocents,
- *the sibyl of Hellespont* with the cross of the passion,
- *the Libyan* sibyl with her blazing torch revealing the Messiah and her crown,
- *the Persian* sibyl with her lantern heralding the hidden Savior,
- *the Phrygian* sibyl with the gonfalon cross of the resurrection,
- *the Samian sibyl,* helmeted, with a reed or a crib,
- *the Tiburtine sibyl* with her goat's skin, staff or bellows in her hands.

Detail of the thirteenth-century stained-glass window of the Cathedral of Chalon, France, depicting the blindfolded Synagogue

A LLEGORICAL FIGURES OF THE DIVINE IMAGE IN HUMANITY

The Church (People of God), salvation and the virtues linked with it, sin and the vices, are all evoked in sacred places by allegorical or emblematic figures.

> *"The Vine of Lord was at first the synagogue which produced verjuice instead of grapes. Indignant at this, the Lord planted another vine, in accordance with his will: the Church our Mother. He cultivated it by the intermediary of his priests. And having suspended it on the blessed wood (the Cross) he taught it to bear an abundant harvest."*
>
> Zeno of Verona. Tract. II 28

■ Church

The Church is presented as a crowned virgin who reads the course of events in the divine light.

The Church is also a Vine, a garden: *"Eden is the name of the new garden of delights planted in the Orient, embellished with good trees, which is to be expected of the assembly of the just (= Church)... spiritual garden of God, planted in Christ, as in the Orient where all sorts of trees can be found, the descendants of the patriarchs and the prophets, the choir of the apostles, the procession of virgins, the college of bishops, priests, and Levites. A river of inexhaustible water flows through this garden. Four other rivers flow out of it, watering the entire earth. The same is true of the Church. Christ, who is its main river, is proclaimed to the world by the four Gospels."*

Hippolytus of Rome, Comm. Dan. 1.17

Synagogue

By way of a contrast the synagogue is negatively portrayed beside the Church as Albert the Great described in the thir-teenth century: as a woman, blindfolded and incapable of reading the divine plan. She drops her crown, and holds a broken spear as an allusion to the guards on Calvary. She is the symbol of the religious world which was not able to recognize the Messiah.

Noah's Ark

Noah's Ark was a prefiguration of the Church. It took in a pair of every species as a symbol of the salvation of creation. The rainbow's arch announcing the end of the flood marks the sky with a divine seal as an announcement of the universal salvation which the church's nave will symbolize for the humanity assembled by Christ. Noah is the precursor of Christ, and the dove that brings back the olive branch of peace is the symbol of the Spirit (Gen 8:11).

The Boat of Peter

Hippolytus of Rome says that the vessel tossed on the waves, but not engulfed by them (Luke 8:22), is the Church. Its bow faces the East. Christ is its pilot, the bishop the lookout. It has the cross as a mast, the trophy of Christ's victory over death. Noah's Ark was a prefiguration of the Church.

Heavenly Jerusalem and Salvation

The definitive state of the Church is its heavenly fulfillment, the response to the deep expectation of humanity: its liberation from death and sin. Other symbols of salvation are the ark of the covenant, the dove with the olive branch, the rainbow, the crossing of the Red Sea, the Cross of the Savior.

■ The Virtues

The seven virtues are the dispositions which in a quasi-instinctive fashion, through reason and by grace, help us to

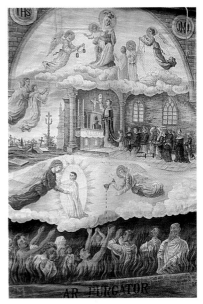

"Tableau of the Missions" depicting Salvation brought by the intercession of the Mass, Quimper, France

discern efficiently the choices necessary for our salvation.

Three virtues cause us to seek God as a source of happiness. They are called the three theological virtues:

Faith

Faith unites us with God, who is truth itself, and has us know God as God revealed God's very self. It is represented with the features of a woman with a cross or a chalice (for it acknowledges the sacrifice of Christ and the Precious Blood of the Eucharist). A torch lighting the way or the book of the divine Word are also its attributes, along with the flaming heart inhabited by the Spirit.

Hope

Hope unites with God, who is happiness itself, and has us long for God as the supreme good. It is represented as a woman wearing the crown of the elect, the cross as a standard, or the anchor signifying the assurance of resurrection (Heb 6:19), or sometimes a horn of plenty overflowing with promised goods.

Lambertus: "Liber Floridus," the Tree of Goodness bearing the medallions of the Virtues (ms. 724/1596 fol. 159 vo) from Ghent in Belgium, Condé Museum, Chantilly, France

Charity

Charity unites us to God, who is infinite love, and has us love God who is goodness itself. It is represented as a woman surrounded by children she is nursing, a gentle sheep or a heart, a pelican, a fragrant oil, or a basket of bread.

Four *moral* virtues, called cardinal virtues because they are like the hinges and doors to all the others, help us in the choice of the appropriate means to obtain salvation:

Strength

Strength can be accompanied by a broken column (Samson) or armed with a shield and club and clothed in a lion's skin like Hercules.

Justice

Justice holds scales, a set square, a sword or a lictor's fasces (bundle of rods with an axe in the middle).

Virtue of Temperance, carrying the clock and horse's bit, Cathedral of Nantes, France

Prudence

Prudence is represented with a serpent, a mirror, or sometimes a sieve for separating. For greater discernment, she can have two faces, one young and one old.

Temperance

Temperance holds an hourglass or a basin for mixing her wine with water; sometimes she holds a horse's bit as a sign of her control over the passions.

Other virtues have as an attribute:
- *patience,* the ox,
- *obedience,* the camel,
- *peace,* an olive branch.

■ The Arts

The Middle Ages represented the liberal arts on the intrados of cathedrals as the sum of knowledge, distinct from revelation but linked to the exercise of the seven gifts of the Holy Spirit and the seven virtues. These seven arts were considered to be instruments at the service of the gifts and virtues to foster progress in the knowledge of God and humanity, and to act in conformity with them, thus contributing to raising up fallen humanity again.

- *Philosophy* dominated them, and this latter science was itself at the service of the science of God, *theology.* Representatives of the Greek and Latin cultures accompany the images of the arts:

- *Grammar* holds a book on her knees, rods in her hand. The grammarians Donatus and Priscian accompany her.

- *Dialectic* appears as cunning and threatening as the serpent or the scorpion. Aristotle represents her.

- The power of *Rhetoric* is evoked by her helmet, in the company of Cicero.

- *Arithmetic* practices her sums by counting on her fingers, with Pythagoras.

- *Geometry* holds a compass, a sphere, a table in the presence of Euclid.

- *Astronomy* studies the sky with Ptolemy.

- *Music,* accompanied by Pythagoras and his numbers or by Tubalcain, the metalworker, rings bells.

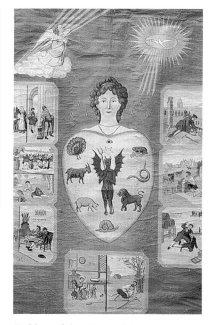

"Tableau of the Missions" depicting a heart inhabited by sin, Quimper, France

■ Sin and the Vices

Human beings prefer independence to friendship with God; this is sin. The way it is represented varies with its different forms. The tempter leads Eve to pick the fruit from the tree and offer it to Adam so that they can *"be like gods who know good and evil,"* thus substituting themselves for God in order to decide what is good and bad.

Certain animals are the *emblems of the vices and deadly sins,* for example, the *he-goat* (lust), the *pig* (gluttony), the *toad* (avarice), the *bat,* the *scorpion,* the *fox* (duplicity). The *serpent,* the *bear,* and the *lion* sometimes designate the devil himself.

Mural painting of the Master of Lusannes (thirteenth century) depicting Saint Michael weighing souls, Catalan school, Art Museum of Catalonia, Barcelona, Spain

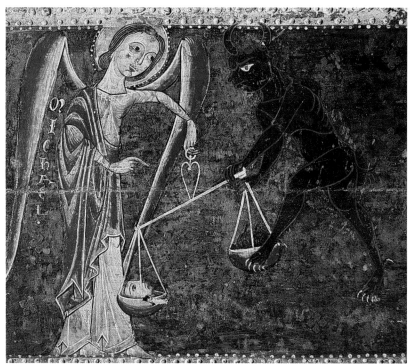

HUMAN POSTURES AND GESTURES AND THEIR SYMBOLISM

■ Liturgical Postures

The *standing* position is that of prayer, as the posture of praying figures *(orants)* indicates. It is the joyful attitude suitable for the feast of the Resurrection, according to a decree of the first Council of Nicaea. However the bishop, representative of the delegated divine presidency, prays seated on his cathedra (throne). The canons in the stalls have a misericord, a ledge along the front edge of the seat on which they can lean (when the seat is upright) in order to facilitate long periods of standing.

Postures
of liturgical
celebration

The *sitting position* is that of the person presiding over the assembly. It is also that of the judge, and of the priest who gives absolution. It is also the position taken by those listening to the reading, except during the proclamation of the Gospel, which requires the standing position of ready attention.

The *kneeling position* is an attitude of supplication and penance. It is also expressive of adoration.

The *genuflection*, the bending of one knee, a gesture which testifies to vassalage, became a liturgical rite in the fifteenth century, to express recognition of the presence of the Blessed Sacrament as it passed by.

The *inclination* of the head and torso has the same meaning as kneeling.

The *prostration* of the body stretched out on the ground is an earnest form of prayer, for which provision is made in the ordination rites.

The lifting of the eyes is suitable as a gesture of thanksgiving.

The joining of the hands is a gesture of submission characteristic of feudalism. It was adopted as an expression of prayer. However, the ancient gesture which is expressive of prayer and which the celebrant uses in the liturgy is that of the orant (praying figure) whose *hands are lifted up* to heaven, as if to receive its light and its gifts. The priest also *stretches out his arms to each side as if on a cross.*

He *blesses* by making the Sign of the Cross over the bread and chalice and over the faithful. Formerly when he did this he raised three fingers only as a sign of the Trinity.

The imposition of one or two hands on the head signifies the transmission of the grace of the Spirit.

Incensing is an action expressive of prayer, which rises up to heaven like the smoke and the scent. It is done by swinging a small dish in which the incense burns. This rite is performed before an object (altar and offerings, crucifix) or is addressed to and honors persons (the celebrant, the faithful) who represent Christ.

■ Gestures of Biblical Origin

Washing the feet of a traveler was a sign of hospitality and respect (Gen 1:4). Mary washed the feet of Jesus (John 12:3). Jesus washed the feet of the apostles before the Last Supper (John 13:1), as the liturgy commemorates on Holy Thursday.

Taking one's shoes off is an act of respect before God. This is what Moses did before the burning bush (Exod 3:5).

Naked feet indicate a divine mission, that of the angels or the apostles (*"Take neither sandals nor staff for the road"* [Matt 10:10]). Yet it would be unusual to represent the Virgin and the other saints with naked feet.

■ Religious Dress or Clothing

Male Tonsure

A shaved head, leaving only a crown of hair, is a sign of consecration. On the other hand, among the Jews, the Nazarite vow committed a person to keeping their hair intact out of fidelity to the customs of the nomadic people of the Exodus.

Feminine Veil

The wearing of a veil expresses reserve and modesty in women, in particular young girls. The renunciation of the world is expressed by the taking of the veil, whereas in marriage this is a sign of chastity and an exclusive love.

■ Romanesque Expressive Postures or Gestures

Romanesque symbolism gave a specific meaning to every gesture.

Thus *wide-open eyes* looking forward without focusing on any particular object were used for "in majesty" representations, an expression of a universal attentiveness.

The gaping mouth conveyed the wickedness of slanderers, traitors or evil beings.

Barring incompatibility with the action depicted, noble personages appear *full-face*. A vision *in profile* is a sign of inferiority.

Walking with the *face turned back* indicates departure.

One who stands up *with arms raised*, amid foliage, rises up into the glory of heaven.

On the other hand, a person shown upside down has been thrown headlong into sin and death. We can thus see Salome on Swedish baptismal fonts, carried away by her dance with her head bowed low, whereas above her the decapitated head of John the Baptist symbolizes the victory of life.

The *index finger* pointed upward conveys a sovereign authority; pointed horizontally it indicates the authority of the teacher.

The *hand under the chin* or on the cheek signifies pain or sleep according to whether the eyes are open or closed.

The *hand placed on the chest* indicates inner conviction or acceptance; placed on the knee it signifies determination.

Placing an *open hand on another's chest* is a way of taking possession or imprisoning.

The imposition of the *hand on the top of the head* signifies handing over a power.

A gesture of the hands, *as if counting the fingers of the other*, is a sign of argumentation.

4. World of the Spirits

Angel at the portal of Saint-Genis de Fontaine, France

Angels, Heavenly Messengers

For the Persian and Babylonian religions "the angels" were intermediaries between the divinity and human beings. They were represented as winged human beings and their role was that of guarding sacred places. The Greeks of the fifth century B.C.E. honored Athena Nike on the Acropolis by making winged feminine bodies into emblems of victory.

The Jews, who imagined God's court to be like that of an oriental sovereign, made the angels into servants of God's majesty, whom they also called the *saints*. They considered them as the **messengers** *(angeloi)* who intervene through dreams or appear in human form. They executed divine justice by driving Adam and Eve from paradise and exterminating the ungodly (Gen 3:24).

The *Angel of Yahweh* can merge with the Godhead, who dwells in an inaccessible light and cannot let God's face be seen. Thus the three visitors of Abraham at Mamre were considered as a visible expression of the divine Trinity (Gen 18:1).

The Bible singles out a hierarchy of angels: the Sovereignties, the Thrones, the Dominations (Eph 1:21; Col 1:16) and mentions especially the seraphim, cherubim, and archangels:

■ The Seraphim
"Burning" with love, fiery beings with six wings and flashing swords, they make up Yahweh's court (Isa 6:2-8).

■ The Cherubim
Descended from winged Babylonian beings, they guard the entrance to the divine world and also guard the ark of the covenant (Exod 25:18). Ezekiel made them into the animals harnessed to Yahweh's chariot, and John, in the Apocalypse, calls them the four *living* beings (Rev 4).

■ Archangels
They are close to the divinity; among them are

Michael, or *"who is like God?"* (Dan 10:13-21), conqueror of Lucifer (Rev 12:7) is depicted as a horseman with a shield, lance, and sword for overcoming the dragon. He is also the weigher of souls who holds the scales of judgment, and, when in armor, he carries out the sentence.

Gabriel, or *"God is powerful"* (Dan 8), is sent to Mary to announce the conception of the Son of God, who was born of the Spirit (Luke 1:26). Often depicted with feminine features, he wears the liturgical cope or dalmatic worn by the actor of the liturgical plays and presents to the Virgin his ambassador's scepter along with his message.

Raphael, or *"God heals,"* intervenes for Tobit (Tob 12:15) in the form of a traveler.

Uriel belongs to the Jewish apocalypse (4 Esdr 4), and **Azrael** to Islam.

For Christians the angels are not mythical beings, but free and intelligent creatures who express creation's praise of the Master of heaven and earth (Rev 4:11). In the Apocalypse of John seven angels like stars watch over each Church (Rev 1:16-20). As if by extension of this mission, a **guardian angel** is assigned to each human person to protect him or her. Their corporeal depiction, the representation of their missions and their attributes explain their place here.

■ Angelic Representations

Christianity at first represented the angels without wings but surrounded by light. Then they became androgynes with wings or sometimes winged heads: the cherubs or *putti* which covered Baroque decor are simply decorative elements which give a suggestion of the heavenly space. The angels sometimes have a staff or scepter, the emblem of an ambassador, sometimes the fiery sword of punishment. As acolytes and incense-bearers they adore God and shower praise on God, prostrated on either side of the tabernacle. Sometimes depicted as musicians, they play instruments. In certain representations they collect in chalices the blood which flows from the wound of Christ on the cross. They present the instruments of torture of the passion. The message that they bear is inscribed on a banderole or phylactery.

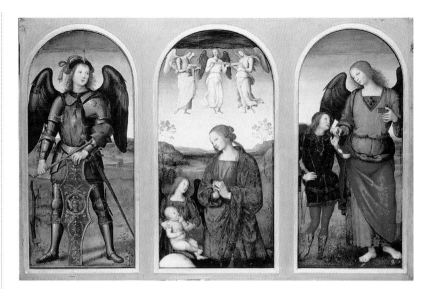

Pietro Vannuci alias the Perugin (1445–1523), Triptych: *Virgin with Child, the Archangels Michael and Raphael* © Giraudon - National Gallery of Art, Washington, U.S.A.

DEMONS, DIABOLICAL SPIRITS

The "demon" of Socrates and the Greeks was the inspirer, the inner genius of mortals, mediator between the divinity and his conscience. The oriental religions believed in evil spirits, the cause of illnesses and plagues.

For the Jews the demon is a sinful and fallen angel who refused to acknowledge dependence on God. Without making him into a divine being, Judaism named him Satan or the adversary, or again the devil or the divisive force, the prince of darkness. Sometimes he exercises a powerful domination over human beings. Human misfortunes are of his invention, first of all the sin of Adam and Eve, and then all the evils from which even just people like Job suffer (Job 1:6-12).

There is also a hierarchy among the demons with Lucifer – light-bearer – (Isa 14:12) at its summit; he is the counterpart of Michael (Rev 12:7). The Catholic Church assumes the reality of demonic action. The spirit of evil works on the human conscience in order to divert it from its vocation. However, the power of Christ frees us from evil's grasp. If the devil exercises a destructive power over us, the Cross of Christ restores us.

■ Devilish Representations

Devils are depicted as half-human, half-animal, with bats' wings, cloven hooves forked tail, and claws. They open wide a huge mouth with sharp teeth. This grotesque appearance makes the devil less credible and enables him to act in a more pernicious way. The devil is also symbolized by various animals such as the serpent coiled at the foot of the tree of paradise, or by monsters like dragons.

Lambertus: "Liber Floridus," Representation of Behemoth (ms. 724/1596 fol.42 vo), 1448 © Giraudon - Condé Museum, Chantilly, France

Sculpture in wood of an angel, St. Patrick's Cathedral, New York, U.S.A.

The World Subject to Humanity

God blessed the man and the woman and said to them, "Fill the earth and subdue it; rule over the fish of the sea, the birds of the air and over every living creature that moves on the ground."

Gen 1:28

Churches are "mirrors of the world." They also reflect the animal and plant world which God created on the fifth and sixth days and which God entrusted to humanity with the mission of making it a harmonious universe.

1. The Animal Kingdom

Sometimes animals are sacred symbols of Christ or divine attributes; sometimes they designate the demons or the forms of sin. Sometimes the same animal is ambivalent.

Animals wild and tame, bless the Lord!

Dan 3:81

QUADRUPEDS AND REPTILES

■ Lambs, Ram

The lamb is the symbol of the innocent victim, the animal used in sacrifices. It was offered in sacrifice by Abel and is used by the Jewish and Islamic rituals. The Hebrews ate a lamb for their paschal meal when they escaped from Egypt (Exod 12:4-11).

Isaiah had predicted that the Messiah would be led like a lamb to the slaughterhouse for our sins and would conquer death (Isa 53:7). John the Baptist proclaimed Jesus to be the Lamb of God (John 1:29-36).

According to the same interpretation, the ram which Abraham sacrificed instead of Isaac prefigures Christ offered up by his Father. It also represents the lost sinner whom the Good Shepherd, like Hermes (Criophore), brings back on his shoulders (John 10). The Lamb lying on the cross and the book with seven seals in the Apocalypse (Rev 5:6-14) symbolizes the Christ who was immolated and offered by the Father for the redemption of humanity. The Lamb standing with the cross as a standard is a symbol of the victorious Christ the King.

■ Donkey

The donkey is the familiar biblical mount.

Zechariah the prophet announced that the Messiah would ride this animal. Thus Jesus entered Jerusalem on the mount of the peace-loving king (Matt 21:1-5; Zech 9:9).

This animal is sometimes inspired with wisdom like the she-ass which spoke to Balaam, more clairvoyant than the prophet, its master (Num 22:28). At the crib it represented the pagans who recognize Christ, whereas the ox represented the Jews.

Yet in general the donkey is the archetype of stubbornness and even foolishness. Its pretentiousness goes as far as becoming a musician as one can see on the wall of the Cathedral of Chartres.

■ Ox

The ox, the symbol of the evangelist Matthew, is a sacrificial animal. Sometimes it is the executor of the divine will. Thus it is seen in Celtic hagiography pulling a cart which carries the bodies of saints to their burial place. At the crib it is also the representative of the Jews who recognized Christ.

■ Goat

The goat is a foul-smelling animal. The Jews sacrificed it or hunted it in the desert, as a scapegoat weighed down with the sins of the people.

■ Stag

In Christian iconography the stag quenches its thirst in the rivers of paradise, illustrating the believer's search for the source of the living water of baptism. Its antlers, which are naturally renewed, recall the new birth of the catechumen (Ps 42).

Bearing a cross erected between its antlers, it is part of the legend of Saint Hubert. Certain saints such as Edern or Thelo ride this animal which plays such a great role in Celtic mythology. Its subjection reveals the spiritual strength of the saint who is riding it.

Sculpture of an ox from the church of Fromentières, France

Mural painting depicting a stag from the church of Eguisheim, France

■ Horse

Elijah was carried off to heaven on a chariot drawn by chargers of fire (2 Kgs 2:11). In the Apocalypse horses of different colors have the power to exterminate, but the Faithful and True Victor rides a white horse (Rev 19:11).

■ Ermine (Stoat)

The stoat with white fur spotted with black was taken for an emblem of purity because it preferred to die rather than soil itself.

■ Lion

The guardian of sacred places, the lion ordinarily symbolizes supreme power and its privilege of dispensing justice. Consequently, the seat of the king and of the royal or episcopal judge was decorated with lions. It still represents mercy as it is thought to spare its grounded prey.

Horse, Fountain de la place des Terreaux, Lyon, France

Stained-glass window depicting a lion and some lambs, Church of Saint Joseph, Haguenau, France

The lion evokes the risen Christ, due to the fact that it seems to be dead at birth and opens its eyes on the third day. The Lion of Judah, the vanquishing Christ, has the power to open the book with the seven seals (Rev 5:5). This ferocious animal can also be an image of the devil "seeking someone to devour" (1 Pet 5:8).

■ Wolf

The wicked wolf threatens the sheep of the flock. It disguises itself as a shepherd in order to trick its prey (John 10:2).

■ Serpent

The serpent is sometimes a symbol of death, sometimes of life. The caduceus, made up of the coiling of two serpents head to head around Mercury's scepter, symbolizes the axis of the world and of the union of opposites, day and night, death and life, masculine and feminine (yin and yang).

It is a symbol of prudence and wisdom, but the latter may be mere slyness.

A single serpent coiled around Aesculapius' stick is a sign of healing, for this reptile gets rid of its skin and comes out of it rejuvenated, whence the sign of the serpent which the Pharaoh wore on his forehead as a symbol of immortality.

The bronze serpent, held up in the desert in order to heal the victims of the poison, prefigured the life-work of Christ, who on the cross saved all who turn toward him. Yet in the Garden of Eden, wound around the tree, the tempter-serpent acts as a diabolical instigator of death.

WINGED AND FEATHERED CREATURES

Winged and feathered creatures fly up into the sky and pass through both the clouds and the heavens. They keep the company of the divinity of whom they are the messengers.

■ Bee

A drop of light fallen out of the sky with the dawn, the bee symbolizes inspiration. It was sometimes used as an emblem of virginity since it was believed that it reproduced by parthenogenesis. Since the bee hibernates in winter and reappears in spring, it is a symbol of the resurrection, and the honey it produces is taken to be a food of immortality.

■ Eagle

Soaring to the zenith, the eagle evokes divine sovereignty. Its irresistible way of taking flight symbolizes the ascension of the risen Christ. Its rejuvenation in the water of a fountain symbolizes that of the Christian in the water of baptism. Thought to focus on the sun, it is the symbol of the contemplative. Saint John, symbolized by the eagle in the tetramorph, thus lifts his gaze toward the light of the divine Word. Theresa of the Child Jesus calls herself "the weak little bird" staring at the Sun, which the "divine eagle" will carry off. In Romanesque sculpture, the combat of the lion and the eagle represents the struggle between the body and the spirit, sin and grace, which struggle within humankind.

■ Dove

By bringing back a green branch to Noah in the ark the dove announced the end of the flood and the retreat of the waters, and symbolized the peace offered to saved humanity (Gen 8:8-12).

In the Temple the poor offered a dove instead of a lamb as an expiatory sacrifice, whence its evocation of the virtue of humility (Lev 5:7; Luke 2:22-24).

Yet the dove with outspread wings under the heavenly vault is a divine emblem. It symbolizes the outpouring of the Spirit when it hovers over the waters of creation in order to give life to them, and over the waters of the Jordan in which Jesus is baptized in order to reveal the bond of love between the Father and the Son and to announce the new creation (Matt 3:16). Iconography depicts in this way the intervention of the Holy Spirit over Mary at the incarnation of the Son in her womb, and over the apostles who are enlightened by its light in order to be sent out on their mission. Sometimes this bird also represents the human soul that has departed this world.

■ Raven

Unlike the dove, the raven freed from the ark did not return to announce the end of the flood. However, it fed Elijah in the desert, as it also did for the hermit Anthony.

■ Cock

A symbol of vigilance on the top of steeples, the cock announces the appearance of the sun and invites all to prayer. In this it is a sign of resurrection. It watches over the coming and going of the devil with the same vigilance. It is the cock which indicated Peter's denial.

The fifth day of creation, the creation of the birds and the fish

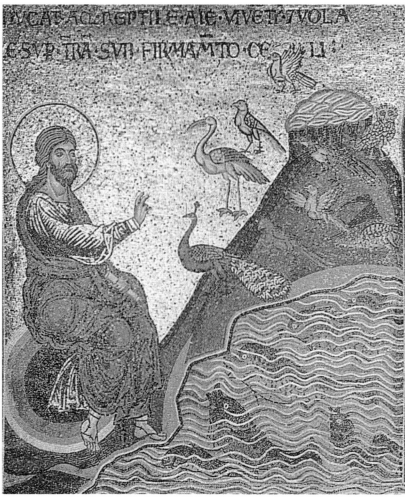

■ Peacock

The peacock is a symbol of immortality, for its flesh was thought to be incorruptible. Its plumage is renewed every spring; thus it decorates sarcophagi, announcing the resurrection of the flesh. Iranian peacocks facing each other frame the Tree of Life. However, this beautifully feathered fowl is also the emblem of vanity.

■ Pelican

It feeds its young by piercing its own side. It is thus the image of Christ who gives himself as food in the Eucharist.

Whales and sea beasts, bless the Lord!

Dan 3:79

THE BEASTS OF THE SEA

■ Dolphin

The ancients believed that dolphins brought souls to their goal safe and sound. Prefiguring the resurrection, one of them or a fish with a whale's mouth swallowed up Jonah into its belly and vomited him up, still alive, on the seashore (Jonah 2).

■ Fish

Spared during the flood, fish symbolized the grace given to the newly baptized in the water of the font. Moreover, by the sacrament the latter are assimilated to Christ who is symbolized by the fish. Similarly, these new members of the Church are like the fish gathered up by the apostles in their miraculous catch (John 21:6). Jesus multiplied the fish as well as the bread in order to feed the crowds in the desert, thus announcing the Eucharist in which he gives himself (Matt 14:15).

THE WORLD OF SHADOWS AND DREAMS: MYTHICAL ANIMALS AND MONSTERS

Apart from the animals of creation, Christian art draws on *the world of shadows and dreams* and makes use of fabulous beings which are at the service of good and especially of evil. The Christ, the "Beautiful God" of the pier of the portal of Amiens tramples certain symbolic animals underfoot, for example:

The Asp, a dragon-serpent which glues one ear to the ground and plugs the other with the end of its tail: it is the symbol of the sinner who refuses to hear the call to conversion.

The Basilisk, both cock and reptile, which kills with a single glance or with its breath.

The Chimera, spitting fire, a hybrid of a lion, goat, and dragon.

The Dragon, one of the representations of the devil.

The Demon-Siren, a monster with a woman's face and upper body and the scaled lower body of a serpent. Through its song, the siren with bird's wings and a fish-shaped body attempted to be the ruin of Ulysses, whence its representation as the seductress of Adam and Eve, a diabolical feminine image in accordance with the misogyny of antiquity. She is often portrayed holding out the tempting apple and sometimes under the feet of the Virgin Mary, thus designating the New Eve, the Immaculate Conception, who crushes her.

All the varieties of winged serpents and monsters, the fruit of the imagination which is a prey to fear, are abundantly represented on church crosspiece beams as gargoyles or devouring beasts biting the beams that give physical expression to the sacred power of this place that expels evil and sin.

The Griffin is a lion with an eagle's head and wings. Through this double configuration it expresses the two natures of Christ.

The Virgin Mary trampling on the serpent-demon, church of Brennilis, France

The Unicorn, a member of the horse family which bears a vertical pointed horn, is a mythical animal. It singles out the virgins among women and lays its head on their laps (wombs), whence the Christ-like interpretation of this symbol of the incarnation of Jesus who was born of the womb of the Virgin Mary. The animal's horn signifies the invincible strength of the Son of God.

The Phoenix, a fabulous bird, is depicted as a pheasant or a heron. It passes through the midst of the flames in order to be reborn from its ashes as symbol of resurrection.

Saint Bernard of Cîteaux became indignant at this invasion of the churches by these extravagant fauna.

"What is the use of these monsters before the eyes of brothers who are busy reading?... These hideous monkeys, these fierce lions, these centaurs, these spotted tigers, these warriors, and hunters who blow their horns? On one side several bodies are united by one head, on the other several heads by one body, elsewhere a quadruped with a serpent's tail and further along a fish with a quadruped's head!..."

Everything that grows on the earth, bless the Lord!

Dan 3:76

2. Plant World

Flora decorate the capitals, the vaulting of the arches and the cornices of Gothic buildings. They are copied from local vegetation. As well as their decorative role they can also have their own significance.

Two plants play a striking role in the churches, wheat and the vine.

■ Wheat

The Jewish Pentecost celebrated the harvest. Wheat illustrates the appearance of life born out of the burial of the grain. In the mysteries of Eleusis, an ear of wheat was presented to the initiated as a guarantee of future crops. By consenting to die before coming out alive from the tomb for the salvation of the world, Christ revealed the mystery of death and life in this symbol: *"Unless the grain of wheat falls on the ground and dies it remains only a single grain, but if it dies it yields a rich harvest"* (John 12:24). Wheat is the symbol of the eucharistic bread, the Body of Christ.

■ Vine

For the ancients, wine, the fruit of the vine, was the drink of the gods which caused one to share their knowledge. The Jews gave thanks for the grape harvest on the day of the feast of the Tents (Deut 16:13-16). Isaiah composed a song of the vine for this occasion. As an object which is given much attention and which is a source of joy because of its fruit, the vine represents the Chosen People (Isa 5:1-8). The vine is also a messianic plant. Allegorically speaking Christ is the Vine, whose shoots are the baptized (John 15:1-7).

The cluster of grapes suggests the wine of the Eucharist, the Blood of Christ. Above the altars the wreathed Baroque columns bear rolled vine tendrils and bunches of grapes in tune with the celebration of Mass. The same chalices, held in the hands of the celebrant of the Mass, or in those of the angels at Calvary, receive the eucharistic wine and the Blood of Christ.

■ Incense

Incense, a vegetable resin, was burnt in bowls to give off a scented smoke in honor of the divinity, the dead, or the emperor. Incense was offered by the Magi to recognize the divinity of the Child Jesus (Matt 2:11). The elders of the Apocalypse (Rev 5:8) hold golden bowls full of incense up before the face of God, for the incense smoke symbolizes the prayers of the saints rising up to heaven.

■ Hyssop

Hyssop is a plant used by the Jews to sprinkle cleansing water, purifying persons and buildings.

■ Rye Grass

A grass which mingles with wheat, the rye grass illustrates a parable of Christ (Matt 13:36). He says that it is sown by the devil amid the good grain, but that at the end of time it will be separated from the wheat at the harvest, an image of the last day on which the wicked will be separated from the good.

■ Lily

According to the Apocrypha the same floral sign that designated Aaron for the priesthood (Num 17:16-26) flowered on the dry stick that Joseph held, designating him among Mary's suitors as the one who was to become her spouse. In the nineteenth century Joseph was pictured carrying a lily which signified his chastity.

The lily is an emblem of fertility as well as of purity. It announces the Cross of Christ, the fruitful tree of the Church.

Depictions of the annunciation include a lily placed between the archangel Gabriel and Mary. The lily's symbolic meaning unites the two interpretations, virginity and fecundity, in Mary, who is both virgin and mother.

Olive

The olive branch has belonged to the symbolism of peace ever since the dove brought an olive branch back to Noah's Ark to announce the end of the flood. Like the palm, the olive wreath rewards the victor. The oil of this plant was used to make the oil for the anointing of prophets, kings, and Israelite priests and is now used for those who are baptized, confirmed or ordained in the Catholic Church.

Detail of a sculpted door representing a dove carrying a branch in its beak, Church of Saint Agnes, Rome, Italy

Manna

Manna was food for the Israelites during their stay in the desert. According to the account in Exodus, it covered the ground every morning with the dew, ready to be collected by the people (Exod 16). A small quantity of manna was kept in the ark of the covenant (Heb 9:4). It announces the eucharistic food, a gift from heaven, which the Apocalypse calls the food of the Victor (Rev 2:17).

Myrrh

A perfumed gum produced by the balsam tree, myrrh was used for embalming the bodies of the dead (John 19:39). The myrrh offered by the Magi (Matt 2:11) to the Child Jesus foreshadowed his eventual death.

Palm Tree and Boxwood

The last Jewish feast of the agrarian cycle is that of the Tents (the grape harvest). It consists of a weeklong sojourn in huts in commemoration of life in the desert and as a foreshadowing of dwelling with God on the mountain. Consequently, on the day of the Transfiguration, when the Father designated his Son, Peter offered to set up three tents on the mountain for Jesus, Elijah, and Moses.

The feast of the Tents, which took on a messianic meaning in the time of David, ended with a procession with cheering and waving of palm branches called *"hosanna."* The liturgy of Palm Sunday evokes this procession of the entry of Jesus into Jerusalem before the Passover feast. The acclamations with palms announced the reign of the Messiah, Son of David, and, prophetically, his triumph over death.

The palm, a symbol of victory, is the emblem of the elect, and especially of the martyrs, who are victorious over death. Greenery plaited into crowns was presented to the newly baptized as an assurance of their resurrection with Christ.

Boxwood joins the palms as a symbol of the victory of Christ over death. Boxwood blessed on Palm Sunday is used to sprinkle the deceased and their tombs. When reduced to ashes by burning, it becomes a sign of the inescapable passage of death and an invitation to lenten conversion.

Pine, Yew

The pine and yew trees are evergreen and bear the fruits of immortality, whence the yew tree has become the tree of cemeteries, whose image is sometimes engraved on tombstones.

Master of Manna, fifteenth century, The Harvest of the Manna © Giraudon - Charterhouse Museum, Douai, France

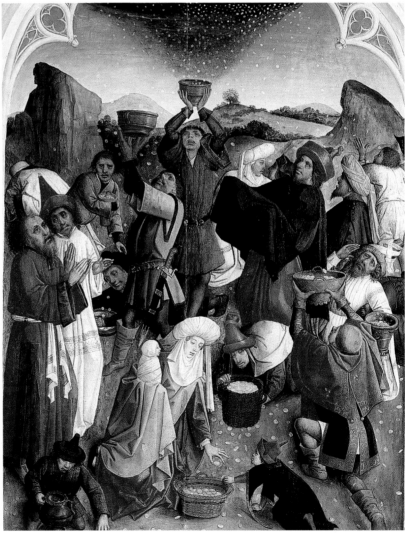

Detail of the triptych of the *Virgin of the Rosebush*, Dominican church, Colmar, France

Let the earth bless the Lord! Give glory and eternal praise to him.

Dan 3:74

3. Products of the Earth

■ Apple Tree

The tree with golden fruits in a marvelous garden is still a symbol of immortality. Tradition has associated the apple with the original sin, although the Bible does not specify the name of the fruit of the tree in Eden. This tradition comes from a play on the words evil and apple, which are both *malum* in Latin.

■ Rose Tree

The rose tree produces the flowers dedicated to Adonis, the symbol of love stronger than death. In the Middle Ages the Virgin Mary was crowned with roses for the celebration of the mysteries of the rosary, in which she accompanied her Son with love in joy, suffering, and glory.

> *He waters the mountains from his upper chambers;*
> *the earth is satisfied by the fruit of his work.*
> *He makes grass grow for the cattle,*
> *and plants for man to cultivate,*
> *bringing forth food from the earth,*
> *wine that gladdens the heart of man,*
> *oil to make his face shine,*
> *and bread that sustains the heart.*
> *The trees of the Lord are well watered,*
> *the cedars of Lebanon that he planted.*
>
> Ps 104:13-16

■ Ash

Ashes, which testify to the death of all passing things, were used as a penitential symbol by the Jews. Nowadays Christians receive ashes at the beginning of Lent.

■ Gold

Gold, the most precious and most dazzling of the metals, is an image of the sun and a symbol of royalty. It is the third gift of the Magi who celebrated the epiphany of the Son of God, king of the universe (Matt 2:11).

■ Silver

White and shining, silver is a symbol of purity, associated with water and the moon.

■ Salt

Salt gives taste to food and preserves it from corruption. Formerly the baptismal rites made use of it. Jesus compares his disciples to salt which resists earthly corruption (Matt 5:13).

■ Stone, Rock

Stone is solid and stable and as such is an image of God's constancy (Ps 18:3). It is a symbol of Christ, the cornerstone on which the whole edifice of his Church rests. Christ designated Simon, whom he called Peter, as the "rock" on which his Church is built (Matt 16:18). The members of the Church are its living stones (1 Pet 2:5).

4. Objects

■ Bread–Wine

Unleavened bread was used to celebrate the Passover. Jesus' preaching was accompanied by the multiplication of bread to feed the crowd in the desert, in a symbolic prefiguration of the Eucharist (Matt 14:19). Indeed the eucharistic bread symbolizes the food of body and soul: the Word being the food of faith and of communion. At the beginning of his ministry Jesus changed water into wine at the wedding in Cana. This gesture was another eucharistic sign, announcing his death for the Church (John 2:1-11). The blood of the Vine, an allegory of Christ himself, announces the wine of the Eucharist.

■ Oil

The use of olive oil accompanies consecrations and blessings as a symbol of joy and strength. The "anointed one" is the translation of the Hebrew word Messiah and the Greek word Christ, whence the anointing which takes place during the consecration of the altar, which represents Christ. The anointing with oil consecrates priests, prophets, and kings. It is part of the rites of baptism and confirmation which identify the life and mission of each Christian with those of Christ.

Menorah from Jerusalem

Certain objects and instruments of ancient civilizations are open to symbolic interpretation:

■ Ring

A ring is worn on the finger as the sign of a covenant by spouses and by bishops.

■ Boat

A symbol of the Church, the boat receives those whom Christ saves, like the ark which sheltered the survivors of the flood, or the apostles threatened with shipwreck (Matt 8:23). Church vaults are hull-shaped, and the part of the church between the doorway and the sanctuary called the "nave" because of its analogous shape.

■ Shield - Helmet

The shield, the warrior's protection, recalls divine protection (Ps 3:4). The helmet is also an instrument and symbol of salvation.

■ Chain, Yoke

The chain is a hindrance from which the angel of God frees Peter, who is

Statue of a warrior, Fishermen's stronghold, Budapest, Hungary

imprisoned (Acts 5:19). However the chain can also symbolize the spiritual bond of prayer.

The yoke subjugates (Jer 28:12) unless it is borne voluntarily as a sign of obedience to Christ (Matt 11:29).

■ Candlestick

The golden candlestick with seven branches (*menorah* in Hebrew) was a tree of light, the symbol of divine light in the Jewish temple (Exod 25:31). Each branch bears a light representing one of the seven planets or the seven stars of the Great Bear on the axis of the world, the seven Churches of the Apocalypse guarded by seven angels (Rev 1:4-7).

■ Chariot

The chariot of fire which carried Elijah off in a whirlwind to heaven (2 Kgs 2:11) recalls the chariot of the sun of Greek mythology. The image of the chariot is also evoked in the prophecy of Ezekiel (Ezek 1:15). It can symbolize the flight of the baptized who are carried off by the Spirit of fire on its wings.

■ Key

The key is a sign of access and judgment. The keys of the kingdom are entrusted to Peter so that he may bind or set loose, receive or reject. The key also opens up the mind to the meaning of the Scriptures. One who confiscates it takes away the

Ramses II and his war chariot, Egyptian Museum © Z-ART Co., Cairo, Egypt

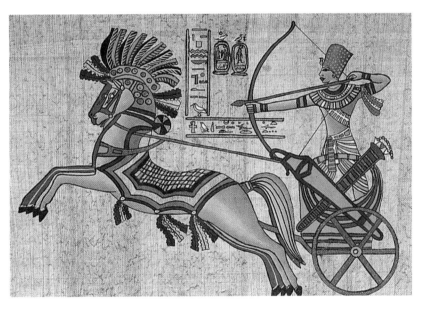

possibility for others to have access to them (Luke 11:52).

■ Nail

The nail is an emblem of the passion.

■ Cup, Chalice

In the Ancient Near East cups were used for drawing lots. They were the cups of destiny. At Gethsemani, Jesus accepted the cup offered to him as being the will of the Father, whence the assimilation of the chalice to a cruel ordeal.

It is also the cup of thanksgiving, the chalice of the Eucharist in which Jesus offers his Blood in communion with the faithful. The Breton Romances made of the Grail the cup containing the drink of immortality, the Blood of Christ.

■ Canopy, Baldachin
The canopy is a sign of dignity placed above statues or the Blessed Sacrament.

■ Flag, Banner, Standard
The risen Christ, the Vanquishing Lamb, bears a standard as a symbol of his victory over death. Constantine attributed his victories to his *labarum*. This Roman standard bore the inscription "by this sign you will conquer"; it displayed the Cross of Christ and the monogram of Jesus Christ.

■ Sword, Two-Edged Sword
The sword symbolizes power over life and death. It is the weapon of the angels, given to Michael and to the guardian of Eden. In St. John's vision the Word of Christ carries out his judgments like a double-edged sword (Rev 1:16). The apostle Paul and Catherine of Alexandria are depicted with the swords of their martyrdom. Metaphorically speaking, according to the prophecy of Simeon, the two-edged sword pierces the heart of Mary with pain (Luke 2:35).

■ Arrow
The arrow penetrates symbolically into the deepest part of our being,
- either to destroy life (Apollo, the night archer, spread the plague among the Trojans, and the allegory of death is armed with arrows).
- or to awaken love (Eros–Cupid is inseparable from his bow).
The arrow symbolizes the effect of human or mystical love, as Saint Teresa of Avila's experience is illustrated by Bernini's work in the Church of Santa Maria della Vittoria in Rome.

■ Lamp - Lantern
In the Bible the lamp or lantern symbolizes the inner light of faith. They also indicate materially the eucharistic presence.

■ Cloak
Lacking a cloak is a sign of indigence. Covering someone with one's cloak is a work of mercy which Saint Martin of Tours practiced. The handing over of the cloak can represent the investiture of priests or prophets, making known the mission (2 Kgs 2:8) or the function (1 Kgs 19:19) which they will assume in the place of their predecessor.

■ Press
A wine or olive press could be found in the vineyard or olive plantations such as Gethsemani. It symbolizes an ordeal, especially that of the passion of Jesus Christ which caused a generous flow of blood.

Lamp in a Carmelite church in Haifa, Israel

The Language of the Symbols of Creation

Most high, almighty and good Lord,
to you praise, glory and honor,
and all blessings;
to you alone are they owing, O Most High,
and no one is worthy of naming you.

Be praised, my Lord, with all your creatures,
especially my Lord brother Sun,
through whom you give us the day, the light;
he is beautiful and radiant with great splendor,
and he gives us the symbol of you the Most High.

Be praised, my Lord, for sister Moon and the stars,
you formed them in the sky,
bright, precious and beautiful.

Be praised, my Lord, for brother Wind,
and for the air and the clouds,
for the calm blue sky and all weather:
thanks to them you give life to all creatures.

Be praised, my Lord, for brother Fire,
through whom you illuminate the night;
he is beautiful and joyful,
invincible and powerful.

Be praised, my Lord, for our mother the Earth
who carries us and feeds us,
who produces the variety of the fruits,
with the many-colored flowers and the grasses.

Be praised, my Lord, for those who forgive others out of love for you,
and who bear trials and sickness:
happy if they retain peace,
for by you, the Most High, they will be crowned.

Be praised, my Lord, for our sister bodily Death,
from whom no living person can escape.
Woe betide those who die in mortal sin;
blessed are those who are caught unawares by her while doing your will,
for the second death will not be able to harm them.

Praise and bless my Lord,
give thanks and serve him in all humility!

Canticle of the Creatures of Francis of Assisi – 1225

Elements, Space, and Time

IV

The combination of these diverse elements and their relationship with space and time, the points of the compass, the numbers and the colors, explained to the ancients the infinite variety of things.

Fire, however, or wind, or the swift air, the sphere of the stars,
or the impetuous water, or heaven's lamps are what they have held
to be the gods who govern the world!

Wis 13:2

1. Elements

The Greek philosopher Empedocles, seeking the principle of all things and the cause of their infinite variety, noted in turn as the ultimate elements water, the air, the earth, and fire. The Chinese also named wood and metal, but omitted the air. In addition, the active or passive element, dry and wet, cold and hot, were influential in their combinations. Thus water could be related to winter along with the kidneys, the color black, the north, and the number one, and fire with the summer, the liver, the color red, and the south...

■ Air

A spiritual element, intermediary between heaven and earth, the air is carried by the winds which spring from the gates of the world at the four compass points.

You lay the beams of your upper
chambers on the waters,
you make the clouds your char-
iot and ride on the wings of the wind.

Ps 104:3

It is inhabited by birds. The initial wind emanates from the breath of the Spirit which hovers above the waters in order to breathe life into them, or from the Creator who breathes life into the mud to make Adam in the divine likeness (Gen 2:6).

The biblical writers made of this subtle element, which lies beyond the human grasp, the accompaniment to divine manifestations or theophanies. Sometimes on Mount Sinai-Horeb it blew in a storm for Moses, at other times as a gentle breeze for Elijah.

The Lord said, "Go out and stand on
the mountain before Yahweh." Then
Yahweh himself went by. There came
a mighty wind, so strong it tore the
mountains and shattered the rock be-
fore Yahweh. But Yahweh was not in
the wind. After the wind came an
earthquake. But Yahweh was not in
the earthquake. After the earthquake
came a fire, but Yahweh was not in

Stained-glass windows depicting the different stages of Creation (water, light, the earth), Church of Saint Madeleine, Troyes, France

the fire. And after the fire there came the sound of a gentle breeze. When Elijah heard this, he covered his face with his cloak and went out and stood at the entrance of the cave. Then a voice came to him, which said, "What are you doing here, Elijah?"

1 Kgs 19:11-13

The Spirit came down on the apostles at Pentecost like a violent wind, fortified them and sent them out to proclaim the gospel (Acts 2:2). The Spirit also breathed inspiration into sacred writers.

■ Water

The pagans thought water to be inhabited by God and demons, as a power to be warded off or beseeched, sometimes evil like the water *"below"* – the destructive shipwrecking ocean – and sometimes beneficial like the waters *"from above"* – the fertilizing rain and the dew and the rivers which nurture fish (Gen 1:6-20). Invigorating rivers stemming from the earthly paradise (Gen 2:10) or from the Throne of the Heavenly Jerusalem (Rev 21–22) give Life.

*For the Lamb who is
at the throne will be their shepherd
and will lead them to the springs
of living water.*

Rev 7:17

Yahweh mastered this element whose unleashing brings back the initial chaos; the waters of the Red Sea were held back to save the Hebrews, but its raging waters engulfed the persecuting Egyptians.

Sometimes deadly, the waters of floods swallow up unfaithful humanity. Elsewhere waters are beneficial; the water of baptism helps believers to reemerge toward life. This sacrament – submersion into death to sin and emergence toward risen life – symbolizes the purifying and life-giving effect of water.

The cult of sacred fountains is a quest for this water which regenerates. Divine encounters and covenants are commemorated by a watering place. At Jacob's well Jesus presents himself to the Samaritan woman as the source at which people can quench their thirst for eternal life.

Jesus replied: "If you only knew what God is offering and who it is that is saying to you:

'Give me a drink,' you would have been the one to ask and he would have given you living water…

anyone who drinks the water that I shall give will never be thirsty again;

the water that I shall give will turn into a spring inside him, welling up to eternal life."

The woman said to him, "Lord, give me some of that water, so that I may never get thirsty and never have to come here again to draw water." John 4:10-15

He who believes in me… - as Scripture says - "From his breast shall flow fountains of living water." John 7:38

The living water of baptism calls the outpouring of the Holy Spirit down onto the baptized.

■ Earth

This element can be made fruitful by the three others. It is the domain of the quadrupeds and of human beings. In the account of creation, the clay of the earth is used to fashion Adam, whom God shaped as a potter shapes a clay vessel.

*And the Lord God formed man
from the dust of the ground and
breathed into his nostrils the breath of
life, and man became a living being.*

Gen 2:7

One who is made from the dust of the ground returns to dust. As a sign of penance earth and ashes on the hair recall this inescapable lot.

■ Fire

An element which is either celestial or infernal, fire purifies or chastises.

According to Greek mythology it is a divine property, kept alive under the earth in the smithies of Hephaistos-Vulcan and coveted by human beings. With Prometheus, the latter are punished for having tried to rob the gods of their power over fire. In biblical symbolism, God used the sign of fire to enlighten, warm, and guide

the Hebrews when they came out of Egypt.

By day Yahweh went ahead of them in a pillar of cloud to guide them on their way and by night in a pillar of fire to give them light, so that they could travel by day or night.

Exod 13:21

Yahweh was revealed to Moses through the burning bush, which burned without being destroyed:

The Angel of the Lord appeared to him in flames of fire from within a bush. Moses looked and saw that though the bush was on fire it did not burn up.

Exod 3:2

God talked to him on Mount Sinai in fire and lightning:

Mount Sinai was covered with smoke, because the Lord descended on it in fire. The smoke billowed up from it like smoke from a furnace and the whole mountain trembled violently.

Exod 19:18

Fire indicated a divine visit in the Temple:

When all the Israelites saw the fire coming down and the glory of the Lord above the temple they knelt on the pavement with their faces to the ground, and they worshiped and gave thanks to the Lord saying: "He is good, his love endures for ever."

2 Chr 7:3

God can also exercise justice through fire; lightning and thunder are the punishment for the ungodly.

Yahweh rained down burning sulfur on Sodom and Gomorrah.

Gen 19:24

The fiery sword of the angel had driven Adam and Eve from the original paradise. At the end of time the archangel

Michael will be the agent of divine justice, whence the cult rendered him on high places exposed to lightning. The fiery hell, in which Lucifer and the demons dwell, burns in the abyss.

Fire also symbolizes the love and salutary action of the Holy Spirit and the Spirit's gifts.

Set me like a seal on your heart, like a seal on your arm. For love is strong as Death, jealousy relentless as Sheol. The face of it is a flash of fire, a flame of Yahweh himself.

Cant 8:6

This fire of the Spirit rests on the heads of the apostles in the form of flames or tongues of fire at Pentecost.

Suddenly they heard what sounded like a powerful wind from heaven, the noise of which filled the entire house… and they saw what seemed to be tongues of fire that separated and came to rest on each of them.

Acts 2:1

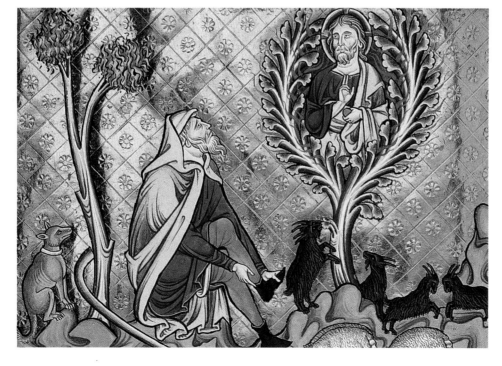

Above:
Mural painting depicting Adam and Eve driven from paradise, Saint Thégonnec, France

Opposite:
Psalter of Ingenburg of Denmark, Moses and the burning bush (ms. 9/1695 fol. 12 vo), 1210 © Giraudon - Condé Museum, Chantilly, France

Winds! all bless the Lord:
give glory and eternal praise to him!
Fire and heat! bless the Lord:
give glory and eternal praise to him!
Dews and sleets! bless the Lord:
give glory and eternal praise to him!
Frost and cold! bless the Lord:
give glory and eternal praise to him!
Ice and snow! bless the Lord:
give glory and eternal praise to him!

Dan 3:66-70

"Scents, colors and sounds match each other."

Baudelaire

2. Colors

In the present human condition in finite space and the limitation of time, the perception of the world is received through appearances. The colors combine in the splendor of natural light and reveal the uncreated light, the divine Word. Their liturgical symbolism follows from the language of colors.

■ White

White springs from the combination of colors and is also a potential color, a symbol of the passage from one state to another:
- passage from adolescence to adulthood marked by the wearing of the white toga among the Romans;
- candidacy (candid = white) for a public office;
- entry into or departure from life - the garment for baptism and the shroud are white;
- it is the symbol of purity and virginity worn by brides;
- among the Celts the white tunic was reserved for the priestly classes;
- the color white was linked liturgically to the divine light.

It was also the color of theophanies or manifestations of divine glory and of the clothing of the transfigured Christ. It is the color of the Epiphany "because of the splendor of its star," of Easter and of the ascension, of the angels and the redeemed who have vanquished death, according to the Apocalypse. Therefore it is the color of the feasts of Our Lord, of Mary, of the dedication of churches, of confessors of the faith, and of virgins. (In heraldry = argent; precious stones: diamond, crystal, pearl.)

■ Gold

The color of the sun and the precious metal, gold symbolizes transcendence and the radiance of the divine presence. Gold backgrounds express the glory of God and represent the celestial world in Romanesque and Byzantine painting. Gold and silver are colors of liturgical substitution, replacing the white, red, or green on major feasts because of their splendor. (In heraldry = or; precious stones: chrysolite, topaz.)

■ Yellow

The interpretation of the color yellow is sometimes unfavorable. It is a sulfurous color which reveals the degradation of love, adultery, or prostitution. (Mary Magdalen wears the clothing of her former profession as traditionally interpreted.)

The yellow star was imposed on the Jews as a discriminatory and insulting badge. (In heraldry = or.)

■ Green

Green is the color of Venus. Contrary to purple, it marks the return of life in spring and conveys hope. This explains the green crosses. It is the color of plants and the purifying waters which regenerate. Green gold, the emerald, is part of the splendor of precious things. However, green is also the color of the devil and fools and jesters (green and yellow). Liturgical green, symbolic of the "Tree of Life," in which the *Song of Songs* bathes according to William Durandus, is the color of the ferial days and Sundays of Ordinary Time, which are oriented toward the last days and the expectation of the world to come. (In heraldry = vert; precious stone: emerald.)

■ Red

Reserved for Mars, red is the color of fire, blood, and passion. It is also the imperial color, that of the Roman patricians which the cardinals have inherited. Formerly the "color of the livid wounds" of Christ was violet, according to William Durandus. Since Vatican II, red is the color referring to the spilt Blood of Christ, Passion Sunday, and Good Friday as well as the feasts of the Cross. It recalls the blood of the martyrs. It is also the color of the flames of love and the tongues of fire of Pentecost. (In heraldry = gules; precious stone: ruby.)

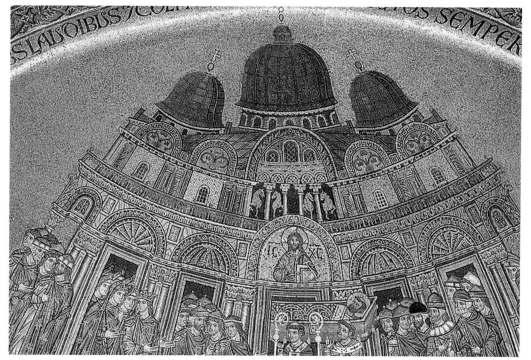

Mosaic of the vault of the apse of the Cathedral of San Petronio, Bologna, Italy

■ Purple

The color of Saturn, purple is suited to the autumnal passage from life to death, to trials and ordeals. This color was sometimes reserved for the mourning clothes of widows. It is also the episcopal color, derived from crimson. Liturgically, it replaced black from the thirteenth century for times of mourning and penance, vigils, Advent, and Lent. The 1969 Missal still notes that because of the more joyful texts of the Third Sunday in Advent and the Fourth Sunday in Lent, the color *rose* can replace purple. (In heraldry = purpure; precious stone: amethyst.)

■ Blue

The color of Jupiter, it is the color of the sky and the sea, in which it changes in hues from grey to blue and to green, shades of blue which neither the Bretons nor the Chinese distinguish by different terms.

It is suited to the spiritual world. However, it only became the color of heavenly backgrounds in paintings, instead of gold, in the twelfth century. It became the habitual color of Mary's mantle, when her mantle was not dark blue as a sign of mourning for her Son. Her tunic is red when she is carrying within her the King of the Heavens, or white as a symbol of her virginity. In competition with red, blue is also the color of the divine mantle. When Jesus proclaims the kingdom of God he wears a blue garment. In Spain blue has become the color of celebrations of the feasts of Mary. (In heraldry = azure; precious stones: turquoise, sapphire.)

■ Black

Black, the absence of color, is a dark symbol of gloom and obscurity. It is the color of bereavement and the veil of those who are sentenced to death. The passage from black to white is the passage from darkness to light, from the earth to heaven, from ignorance to knowledge.

Paradoxically, black stones, aerolites, are linked to sun worship. The Chtonian black virgins symbolize the fecundity of the seed buried in the ground. Formerly black was the color used for the Office of the Dead, but it was replaced by purple after Vatican II. (In heraldry = sable; precious stone: black jasper.)

■ Lights and Colors

The veined marbles, the polychrome mosaics, the great paintings of the vault, the great walls, the pendentives, which made it possible to inscribe exactly in the square of the edifice the heavy circle of the star-spangled dome, the silver gate of the sanctuary, the golden altar and gallery, the six thousand golden chandeliers, the bevy of inlaid gemstones which covered with a glistering cascade of glitter the gold of the gallery and the altar, of the censers, the crosses, the enamelled statues, the reliquaries, the tiaras and diadems, the rigid brocade robes in which living idols, the emperor and the patriarch stood still, were all like an enormous diamond sphere penetrated with flames, a brilliance suspended by garlands of light. The promised paradise came true here below.

Elie Faure, *History of Art,*
"About Byzantine Art," p. 29

"The elements of numbers are the elements of being and the whole of the sky is a number."

Aristotle

3. Numbers

Modern sculpture of an Ionic column in New Orleans, U.S.A.

In the sixth century B.C.E. the Pythagoreans believed that numbers were a sacred language and considered them to be the key to the harmony of the universe. The use of numbers has a symbolic significance which was well recognized by the Jews and in all the East. One cannot neglect this symbolism when one attempts to interpret the numbers in the Bible (days of the creation, age of the patriarchs, number of tribes...).

The measurements of Solomon's Temple were based on the square and the double square: the Holy of Holies formed a perfect cube of twenty cubits in all three dimensions; the cherubim were ten cubits high and there was a length of ten cubits between the tips of their wings where they touched the walls (1 Kgs 6:20-31). The Jewish writer Philo noted that the seven branches of the candlestick symbolized the seven planets and that the number of loaves of offering on the table was that of the twelve months of the year.

The Fathers of the Church, under Neoplatonic influence, made wide use of the language of numbers. They broke them down and analyzed them. Thus, during the first multiplication of the loaves (Matt 14:13-21), the sum of 5 loaves and 2 fishes (= 7) is the symbol of Jesus and his fullness of grace. The disciples collected 12 baskets of leftovers to feed the people who would make up the Church, the number 12 corre-

sponding to the total of the 12 tribes of the people in the Bible. The numerical speculations of the Fathers are not unfounded, but they sometimes wander from the point in their excessive subtlety.

Sandro di Mariano, Filipepi alias Boticelli (1444–1510), Young men led to the seven liberal arts © Lauros-Giraudon / Louvre Museum, Paris, France

■ Art–Numbers and Rhythms

"The world is... 'an ordered collection of creatures.' It appears 'like a great zither.' Accordingly, is it not justifiable to regard music as the royal path which leads to knowledge, since it is above all an ordering, a perception of harmonies and rhythms. The science of numbers accompanies it, for on arithmetical relationships rest the secret links between things, of which the intuition enables the soul to approach God."

George Duby,
The Middle Ages,
vol. 1

■ Numbers and Architecture

"When the temple is completely bare, as in Perigueux for example, or when the mosaics, by their tone, are so joined with it that one can no longer see in the warm and reddish-brown half-light anything foreign to the thick walls, the solid, stocky pillars, nothing but lines which curve, vaulting, barrel vaults and full arches, then a strange harmony sweeps through you little by little. The virtue of the number, that mysterious power ever present and active in great architecture, on which all the masters rely, and which they always refer to and never formulate, the virtue of the number imposes itself on them with a formidable and monotonous and musical authority. Yes, the dwarfed dome prevents the rise of dreams, but dreams ceaselessly turn and come back upon themselves in a few closed orbits, shifting geometry in space which copies, summarizes and freezes the gravitation of the heavens."

Elie Faure,
History of Art

Statue depicting a zither player,
New York, U.S.A.

1	**Symbol of the personal God, the first Being:**	
	Everything is called to come back to unity: the unity of the couple, of humanity, of the Church, of salvation, of faith, of baptism.	
2	**Sum of two halves:** Duality, sexuality, antagonism, or love.	
3	**Triad:**	Perfect number; expression of totality and culmination of the triangle; the three-leaved trefoil.
		The number of divine Persons in the unity of the Trinity.
		The number of the theological virtues.
4	**Tetrad:**	Number whose significance is related to the square and the Cross,
		the cardinal points of the space in which the Word is manifested,
		the knotted corners of Peter's sheet from which nothing can be lost (Acts 10:11),
		the seasons, the elements, the periods of life, the archangels, the evangelists.
5	**Pentacle:** The number of fingers on the hands,	
		of the senses, of the books attributed to Moses,
		of the loaves multiplied by Christ in the desert.
		Symbol of the human being with five extremities, whose height and width
		with outstretched arms can be divided into five equal parts.
6	**Number of the day of the creation of man and woman:**	
		Number of the directions of space (zenith, nadir, and the four points of the compass)
		and the six colors (three primary, three secondary).
7	**Indicates plenitude and totality:**	
		Number of the day of God's rest, number of days in the week, number of the planets,
		of the notes in the scale, of the deadly sins, of the demons which take possession of people,
		of the gifts of the Holy Spirit, of the sacraments,
		of the virtues (theological and cardinal).
8	**Octave:** The octagon is the former shape of baptistries,	
		a figure which is intermediate between the square of the earth and the circle of the canopy of heaven.
		The eighth day is that of the resurrection, of renewal, the first of the week.
9		Number of the totality of the worlds, muses, and celestial spheres described by Dante.
10	**Decade:**	
		Ten fingers of the hand, Ten Commandments.
12	**The number of the months:**	
		of hours in the day.
		The number of divine choice, e.g., of the tribes of the Jewish people (for the religious service of the twelve months),
		of the apostles of Christ.
		This number is the product of 3 x 4, 3 being the figure of the Trinity and of the soul made in its image, and 4 being the figure of material things (cf. the square) and the 4 elements. To multiply 3 by 4 is to inform matter with spirit, to proclaim the truths of faith to the world. Consequently it is the global number suitable for all the saints, who are called from the four points of the compass for their faith in the Trinity in order to make up a single Church.
40	**The number of the years in one generation:**	
		The total number of days of the flood,
		of the years of the Exodus in the desert,
		of days of fasting of Jesus in the desert and of the Christian Lent,
		of the days of the appearances of the risen Christ.
50	**This is the number of the Jubilee year:** of the Jewish Pentecost (feast of the first wheatsheaf),	
		of the Christian Pentecost (fiftieth day after Easter).
70	**Multiple of 7, symbol of plenitude:**	
		The number of disciples chosen by Christ.
		The number of times one must forgive and even 70 times 7 times.

4. Time

■ An Eternal Repetition

Vanity of vanities, all is vanity. For all his toil, his toil under the sun, what does man gain by it? A generation goes, a generation comes, yet the earth stands firm for ever. The sun rises, the sun sets; then to its place it speeds and there it rises. Southward goes the wind, then turns to the north, it turns and turns again, back then to its circling goes the wind. Into the sea all the rivers go, and yet the sea is never filled, and still to their goal the rivers go. All things are wearisome more than one can say.

Eccl 1:1-8

■ March Toward Salvation

Time affects only creatures. God, who is beyond time, does not change. However, it is in the unfolding of the history of the world that God accomplishes human salvation.

Sundial, Merida, Spain

The time of Advent begins with Abraham and ends with John the Baptist. God gets involved in the progression of time by becoming incarnate, by taking on human life, and by dying. He will come back in glory. The intermediary time between the resurrection and the return of Christ is that of God's patience, given to humanity, which God has saved, so that they can make heard everywhere the proclamation of salvation and be converted.

MITHICAL INITIAL AND SACRED HISTORY

Just as the axial center and the temple enable religious peoples to communicate spatially with their gods, sacred time brings them close to divine gestures, to the point of confusing time and space, *time* and the *temple*, and saying of their sacred house with openings in the direction of the four compass points that *"the year is a circle around the world."*

Myths are a response to the human desire to escape the hold of the present and come back to the beginnings, to the initial moment, to sacred time, to familiarity with the gods.

The festive and ritual evocation of the myth projects the listener out of historical time, which melts away irreversibly, and situates him or her in primordial sacredness. Then this narrative, received liturgically, as if in the glow of a fire which opens up the darkness of the night, enlightens those whom it snatches cyclically from their time and its duration. The liturgy of the Paschal Vigil no doubt chooses an analogous framework in order to evoke, in the light of the new fire, the days of Creation and of the passage through the Red Sea. Yet it does not relate a myth to us, but the sacred story of Christ, whose coming was announced and who became incarnate, who died *under Pontius Pilate* and rose from the dead, once and for all. Commemorating this unique event, the liturgy does not aspire to reverse time, but proposes to sanctify the present, of which every instant is the favorable moment for living and celebrating the death and resurrection of the Lord.

■ Christian Liturgical Cycle

The liturgy is an action situated in Church time which puts each one of the faithful in the presence of the unique event which is being commemorated. Time both recovers the past and anticipates the future in which the Church will participate fully in the mystery celebrated. Sanctified time is an actualization, liturgically renewed, of the divine actions. The week of creation justifies the rest of the Jewish Sabbath, the seventh day.

The expectation of the Old Testament is commemorated by the liturgical time of Advent. The great phases from Abraham, Moses, the Passover, and the forty years in the desert of the Exodus (Num 14:34) are relived in Lent. The forty days of Christ's fasting (Matt 4:2) have been the symbolic reference for the duration of Lent, which prepares for the celebration of salvation.

The *cycle of the Lord* invites the members of the congregation to relive each year of their lives the mysteries of salvation:
- The four Sundays of Advent prepare for *incarnation and epiphany:* the celebration of the feasts of the **Nativity,** or Christmas, the recognition of the royal Messiah by the Magi.
- *Ash Wednesday* and the *Sundays of Lent* precede the celebration of *passion* and *resurrection: Holy Week* and the celebration of the feast of **Easter;** followed by Eastertide and the Ascension.

The creation of the new Israel is celebrated with the *Baptism of Christ,* and the creation of the Church with the coming of the Holy Spirit, **Pentecost** (the "fiftieth day" after Easter). The time called **"ordinary"** is the time of the Church which lies

> *In the beginning was the Word,*
> *and the Word was with God,*
> *and the Word was God.*
> *He was with God in the beginning.*
> *Through him all things came to be*
> *and not one thing had its being but*
> *through him.*
> *All that came to be had life in him*
> *and that life is the light of men.*
> *A light that shines in the dark,*
> *the Word was the true light that enlight-*
> *ens all men.* John 1

between the coming of Jesus and his return in glory. It is punctuated by each Sunday, the eighth day, that of the resurrection and the first day of the new creation. The creation of the new heavens corresponds to the end of Ordinary Time and the feast of *Christ the King.*

"In the world all is symbol. The sun, the constellations, the light, the night, the seasons speak to us a solemn language. In winter when the days shorten sadly, when the night seems to want to triumph forever over light, of what does medieval man think? He dreams of the long centuries of half-days which preceded the coming of Jesus Christ... He calls these weeks of December the weeks of Advent (adventus) and he expresses in liturgical ceremonies and readings the expectation

of the old world. And the Son is born at the winter solstice, at the moment at which light is going to reappear in the world and increase. Moreover the year is entirely in the likeness of man: it relates the drama of life and death. The spring which renews the world is the image of the baptism which renews man at his entry into life. The summer is an image: its burning heat and its light make us dream of the light of another world, of the radiance of charity in eternal life. The autumn, the season of crops and harvests, is the redoubtable symbol of the universal judgment, of the great day on which we will reap what we have sown. Finally, winter is the shadow of death which awaits mankind and the world."

E. Male, The Thirteenth Century

THE SYMBOLS OF TIME

■ Hourglass
The swift passing of time is represented by the hourglass or the sundial. The latter bears inscriptions such as *"For me the sun is my guide, for you your guide is the shadow"; "Hora fugat, ultima necat"* ("The hours fly by, the last one kills").

■ Wheel
The wheel symbolizes the cycles of time, its perpetual movement, its eternal repetition, the relation between time and eternity.

■ Spiral
The spiral is born of a curve rotating around a point away from which it moves with every turn. When double it also returns toward its center, symbolizing the two movements, outward and inward, of life and death.

The symbol of the spiral is better suited than the wheel to the celebration of the mysteries of the Liturgical Year

which repeat the same cycle, but each time bring to bear their saving effects on those they touch.

■ Swastika, Triskele, Yin-Yang
- *The swastika* with four elements is formed by the intersection of two **S**'s inscribed in a circle in which they evoke the movement of a wheel. Turning clockwise it is the swastika. In the counterclockwise direction it evokes the movement of the stars and transcendence. Some Romanesque crucifixes take on this shape of the vortex of creation.

- *The triskele* is an analogous figure with three elements, sometimes three legs bent at the knee. The Gothic windows which use this figure as an internal division do so in honor of the Trinity.
- *The yin-yang* of Chinese symbolism, based on the complementarity of the yin – femininity, cold, darkness, earth – and the yang – masculinity, warmth, light, sky – inspires the image of a circle divided in two parts by a curved line in the form of an **S**. The flamboyant window thus decorated seems to be swept away by a cosmic movement.

CALENDARS

Christ the *"chronocrator,"* the master of time, presides in the tympanums and rose windows as the sun of justice, source of light, supervising the unfolding of the days. He is at the center of the zodiac figures on the ring of time.

■ Signs of the Zodiac

The zodiac, based on the ring of the twelve constellations and the apparent movement of the sun, is a symbolic ensemble made up of twelve astrological signs whose names and figures vary with different civilizations. The base of porches, such as that of Saint Firmin in Amiens, France, depicts these signs alongside the seasonal succession of the different forms of work and the days and months.

Pol de Limbourg, fifteenth century, *Les Très Riches Heures du Duc de Berry,* Anatomical Man (ms. 65/1284 fol.14 vo), Condé Museum, Chantilly, France

Sign	Month	Element	Apostle	Season	Form of work
Aries	March 21	Fire	Peter	Equinox	Work of the vine
Taurus	April 21	Earth	Andrew		Farmer in the fields
Gemini	May 21	Air	James the Greater		Falconer or traveler on a horse
Cancer	June 22	Water	John	Solstice	Cutting the hay
Leo	July 23	Fire	Thomas		Wheat Harvest
Virgo	August 23	Earth	James the Lesser		Wheat threshing
Libra	September 23	Air	Philip	Equinox	Grape harvest or fruit-picking
Scorpio	October 23	Water	Bartholomew		Pressing or barreling
Sagittarius	November 22	Fire	Matthew		Sowing, or pig at the acorn harvest
Capricorn	December 21	Earth	Simon	Solstice	Bleeding and salting of the pig
Aquarius	January 20	Air	Jude		Janus with two faces at table
Pisces	February 19	Water	Matthias		Old man seated by a fire

■ Extending the Symbolism

When describing the pectoral worn by the Jewish high priest, Clement of Alexandria makes parallels between symbols: *"The twelve stones in rows of four on the chest describe for us the cycle of the zodiac with the four changes of season. One can also see in them the prophets who designate the just in each covenant (old and new). One would not be mistaken in saying that the Apostles are both prophets and just"* (Strom. V, 6, 38).

■ Eternal Life and Time

Eternity, "a world in which form no longer exists and on which the senses in their superficial state no longer have any hold to bring to bear... For it everything is reduced to a relationship and the musical modification of this relationship which we call Time. For me it is the Time in which all things are constituted and composed, which has become readable to my eyes thanks to the innumerable indicators with which I am provided, just as a score becomes readable to the inner eye of the performer thanks to the dots squeezed into an apparent disorder which arm the stacked staves with this disorder..."

Paul Claudel, *Présence*, 301

ETERNITY AND CIRCUMSTANCES OF THE WORK OF ART

"And the church, entering into my concentration with the Cafe, with the passer-by of whom I had to ask my way, with the station to which I was going to return, was one with all the rest, seemed an accident, a product of the end of this afternoon, in which the smooth dome swollen against the sky was like a fruit whose pink, golden and fondant skin was ripened by the same light as that which bathed the chimneys of the houses. But I no longer wanted to think of anything but the eternal significance of the sculptures, when I recognized the Apostles whose cast statues I had seen in the Trocadero museum, and who, on either side of the Virgin, before the deep opening of the porch, were awaiting me as if to do me honor. With benevolent, pug-nosed and gentle faces, they seemed to advance with a welcoming air, singing the Alleluia of a beautiful day. But one became aware that their expression was unchanging like that of the dead and only altered if one walked around them. I said to myself: This is the church of Balbec. This square, which seems to know its glory, is the only place in the world which possesses the church of Balbec."

Yet the admirer becomes conscious of the temporality of the work:

"If I had wanted to write my signature on this stone, it is she, the illustrious Virgin who until then I had endowed with a general existence and an intangible beauty, the Virgin of Balbec, the only one... who, on her body clogged with the same soot as the neighboring houses, would have shown, without being able to get rid of it, to all the admirers who came there to contemplate her, the traces left by my piece of chalk and the letters of my name, and it was her finally, the immortal work of art which had been desired for so long, that I found metamorphosed, as well as the church itself, into a little old woman of stone whose height I could measure and whose wrinkles I could count..."

Proust, *In Search of Lost Time*, "In the shadow of the young girls in flower"

Façade of the St. Patrick's Cathedral, New York, U.S.A.

SACRED ART ASSOCIATES TIME WITH ETERNITY

Fifteenth-century Flemish art *"marks the annexation of the world of God by that of men: the invasion of eternity by time, which Christian art had ignored… no religious art had yet fixed the passage of the hour. Time had already touched divine figures when art had made of the Virgin the daughter of Saint Anne and the elderly woman of Calvary. Yet the Virgin had aged in an hourless time. Admittedly it is not a matter of the hours which the clock shows. Rather it is a matter of a time of day: morning, rather vague afternoon, twilight, and those nocturnes with which illumination was to be familiar."* Yet *"on the day of the Nativity, the dawn came early…" - and the darkness on the day of the crucifixion. The bells, from the Angelus onwards, ordered the day by recalling the events of the Book. Christian art had not escaped time either by clumsiness or by accident, but because it portrayed what was happening in eternity. For mosaics, the light was that of the sanctuary, for the stained-glass window, the living light of God, just as for the statues, for sculpture knows no other hour than the one that sheds light on it. In the 15th century an imaginary time became one with an imaginary space. Light passed from God to the painter."*

Malraux, *Métamorphose des dieux I*

JOURNEY OF LIFE

The life of humanity is constrained by the multiple bonds from which it seeks to liberate itself. Myths illustrate this dependence through a "binding" deity. Bonds, ropes and knots are the symbols of the various trials, and of illness and death. In biblical language itself divine or diabolical power is also expressed by an image of the thread of life, of a supernatural grip, of the bonds of sin from which salvation delivers us.

Homer leads Ulysses on the path of souls, to Hades or the Isles of the Blest. Every journey can be symbolic of the path of life and its term, like that taken by Saint Brendan to the *Islands of the Blessed* (Paradise, Sojourn of the Saints) according to the Irish legend. It is also the sense of pilgrimages to holy places, of liturgical processions around the church, steps and efforts made in the direction of the Jerusalem on high.

Adoration of the Magi, Duccio. Museo dell'opera, Sienne © Scala. The three kings represent the three ages of human beings recognizing the origin of life.

■ Labyrinth
Octagonal or circular, the labyrinth is an image born of Greek mythology: the palace of Minos built by Daedalus had no outlet for those who had none of Ariadne's thread at their disposal. This image traced on the paving of certain cathedrals and named the *league*

of Jerusalem represents the pilgrimage of life whose outcome for the Christian is the heavenly Church.

■ Death and Its Symbols
The rite of burial in the depths of the earth symbolizes the return to primitive clay and to the maternal womb, in the expectation of regeneration and of a new birth.

The departure of the dead person was sometimes perceived with anxiety, as expressed in the Gregorian motets of the entry into Lent: *"Media vita in morte sumus"* ("In the middle of life we are hit by death, what help can we seek other than that of the merciful Savior"), sometimes with serenity as a voyage toward the port of beatitude.

> *"Listen, ashes! Listen, dust! God who knows the number of his stars and who takes care of each one of his little birds, God beneath the tombstone has not forgotten you!"*
> Paul Claudel, *Sword*, 166

■ Skeleton
Death, which affects every human being, is recalled in cemeteries and ossuaries by a sarcophagus, a flagstone on the ground, a funereal recess, or a recumbent statue in the likeness of the deceased person stretched out on the ground. The skeleton, armed with a scythe or shooting an arrow (called *ankou* in Brittany), announces death. The skull and crossbones represent the expectation of the resurrection, such as Ezekiel announced it in his prophecy of dried bones coming back to life (Ezek 37).

■ Dance of Death
The *danses macabres* of La Chaise Dieu or Kermaria-an-Isquit portray the procession of the departed of all classes in

society dragged along one after the other by grimacing skeletons in an irresistible ballet. Inspired by the *"Dictionary of the Three Dead and the Three Living Men"* illustrated in Pisa by Orcagna, they depict the implacable advance of death which carries off young and old, rich and poor. The great plagues were at the origin of these staggering images.

■ Weighing of the Soul and Judgment

The weighing of souls is a universal religious theme in Greece and the Orient. The scales used by Osiris or the archangel Saint Michael, *the weigher of souls,* are symbolic images of the judgment which follows death.

BEYOND DEATH: THE RESURRECTION

■ The Resurrection

The event of the resurrection of Christ is a historical one, just as the universal resurrection will make its mark on history. The language of symbols illustrates this major mystery of faith.

"Day and night show us the resurrection; night falls, day comes; day ends, night comes."

Clement of Rome

"Is there not a resurrection for seeds and fruits?"

Theophile of Alexandria

Besides lion cubs, eaglets, the pelican's young which are revived by their parents, or Jonah's adventure, **the dried out bones** which Ezekiel sees coming back to life express symbolically the resurrection of the human beings who are saved, body and soul, by Christ.

■ Liberation in Eternity

"Like a prisoner who happily amuses himself with his chains, it is our captivity itself which has become the matter for our frolics, it is our wake which has become our sole frontier, it is the bond which has become our wing, it is our soul which realizes, frantic with delight, and whatever it may do, its impossibility on every side of escaping from divine joy! We fly up to heaven like an arrow, we plunge down on our prey like an eagle, like a dart of

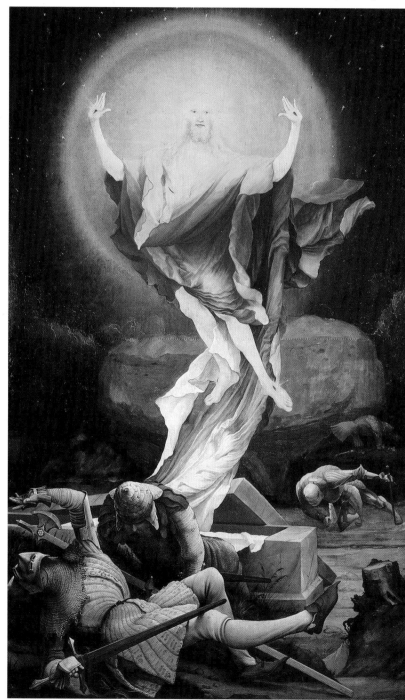

Matthias Grünewald, ca. 1480, Retable of Issenheim, *The Resurrection.* The mystery of the passage from death to life is expressed by the snatching out of the tomb, the heavenward thrust, the halo, and the flame.
© Unterlinden Museum, Colmar, France

The hand of Yahweh was upon me, and brought me out
by the spirit of Yahweh and set me in the middle
of a valley; it was full of bones. He led me to and
fro among them, and I saw a great many bones
on the floor of the valley, bones that were very dry.
He asked me "Son of man, can these bones live?"
I said, "O, Lord Yahweh you alone know."
Then he said to me, "Prophesy to these bones
and say to them, 'Dry bones, hear the word
of the Lord!' This is what the Lord Yahweh
says to these bones: 'I will make the spirit
enter you and you will come to life. I will attach
nerves to you and make flesh grow on you and cover you
with skin, I will give you the spirit and you will come to life.
Then you will know that I am the Lord.'"
So I prophesied as I was commanded. As I was prophesying
there was a noise, a rattling sound and the bones came
together, bone to bone. I looked; they were covered with nerves,
and flesh had appeared and skin had covered the flesh,
but there was no spirit within them.
Then he said to me, "Prophesy to the spirit, prophesy,
son of man. Say to it, 'Thus speaks the Lord Yahweh:
come from the four winds, spirit, and breathe on these dead
bodies so that they may live.'" I prophesied as
he commanded me and the spirit entered them;
they came to life and stood up on their feet, a great,
immense army… "You will know that I am Yahweh,
when I open your graves and bring you up from them,
my people. I will put my spirit in you and you will live
and I will settle you in your own land.
Then you will know that I, the Lord, have spoken
and that I act, oracle of Yahweh"

Ezek 37:1-10, 13, 14

lightning! O arpeggio! O powerful spreading of wings! O outburst of our engine at full speed! O just and strong commandment! Flight borne up by its weight! O radiant liberty of all that, far from the ground, now occurs in the world of the air! We have at our disposal all of space, in order to transform it, victoriously, with the sign of the cross!"

Paul Claudel, *Poet*, 183

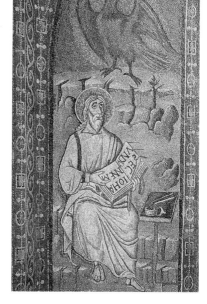

Saint John the Evangelist, sixth-century mosaic © Giraudon - Basilica of San Vitale, Ravenna, Italy

THE KEY TO ALL SYMBOLS

"The West is presently forced into a dialogue with the other 'exotic' and 'primitive' cultures. It would be unfortunate if it were to start without having drawn a single lesson from all the revelations provided by the study of symbolisms."

Mircea Eliade

In a secularized world which is foreign to the transcendent and sacred, since it casts aside all sense of God, the meaning of the great symbols is obliterated along with the ultimate questions about our present existence and the existence of a beyond.

Christ, whose life marked the course of history through his words and his witness, can awaken the desire for open-mindedness and meaning which slumbers in all people's hearts. He can have them discover the key to the symbols which humanity has kept alive since its origins, and give them faith in him. It is in the light of Christ that the Scriptures can be deciphered:

Then I, John, had this vision: I saw in the right hand of the one who sat on the throne a scroll with writing on both sides and sealed with seven seals.

And I saw a mighty angel proclaiming in a loud voice, "Who is worthy to break the seals and open the scroll?" But no one in heaven or earth or under the earth was capable of opening the scroll and studying it.

I wept and wept because no one was found worthy to open the scroll and look inside. Then one of the elders said to me, "Do not weep! The lion of the tribe of Judah, the root of David has triumphed. He is able to open the scroll with seven seals."

Then I saw a Lamb standing before the Throne, encircled by the four living beings and the elders. He was as if slain. He had seven horns and seven eyes, which are the seven spirits of God sent out into all the earth. He moved forward and took the scroll from the right hand of him who sat on the throne. When the Lamb had received the scroll, the four living beings and the twenty-four elders prostrated themselves before him. Each one had a harp and golden bowls full of incense, which are the prayers of the saints.

They sang this new song: "You are worthy to take the scroll and open its seals because you were slain and with your blood you redeemed men for God, from every race, language, people and nation. You made them into a kingdom of priests for our God and they will reign over the earth."

Rev 5:1-10

According to the Apocalypse the mysterious plan of God for the world is symbolized in the closed book with seven seals. The angel calls upon an interpreter to open and decipher the scroll.

One of the twenty-four elders (who are the twelve leaders of the tribes of the Old Covenant or its prophets, and the twelve apostles of the New Covenant) announces the victorious Christ's intervention.

Christ, the Paschal Lamb, is surrounded by his heralds, the four evangelists, and he is acclaimed by the elders who offer up the prayer (music and fragrances) of the members of the Church.

He is the only person capable of interpreting the Book, he who fulfilled the promised salvation, for he is himself the book with seven seals, the incarnate Word, the image of the Father whom he reveals to humanity.

Church Symbolism

Cathedral of Santa Maria de Fiori, Florence, Italy

As buildings dedicated to Christian worship,
churches are filled with symbolic elements.
Can the origins of the symbols
linked to the architecture and the art of churches be retraced?
What are the significance and the scope of these symbols?

From Sacred Places to Churches

All religions have appropriate places for carrying out their worship, which are separated from secular activities and reserved for the encounter with the deity. They can be "low" places, like grottos; demarcated natural spaces, like the Celts' clearings under the heavenly vault; or yet again lofty buildings, entrusted to the Egyptian, Greek, or Latin protective deity.

During their history the Israelites first erected stones (steles and altars) in honor of Yahweh, the unique immaterial God who inhabits the heavens, the earth and Sheol, fire and cloud, and who cannot be confined in an image. Then they built the Tabernacle and finally the Temple. As did other peoples, they stressed the sacred character of these by adding more and more inaccessible enclosures which were linked to one another and consisted of the forecourts, vestibules, and the Holy of Holies. Thus they expressed the presence of the one who is Totally Other, *"tremendum et fascinans,"* and is a mystery which both inspires fear and exerts an irresistible attraction.

How did Christianity make the passage from the living organism of the primitive Church to an increased number of symbolic buildings?

Meaning of the Terms: the Church As an Assembly and Churches As Buildings

The Second Vatican Council, recalling that the Lord compared himself to the cornerstone on which the Church was built by the apostles (Matt 21:42; 1 Pet 2:7; 1 Cor 3:11), offered various architectural images of the Church: *God's building* (I Cor 3:9), *God's household* (1 Tim 3:15), *tabernacle of God with mortals* (Rev 21:3) and *the sa-*

Irish cross

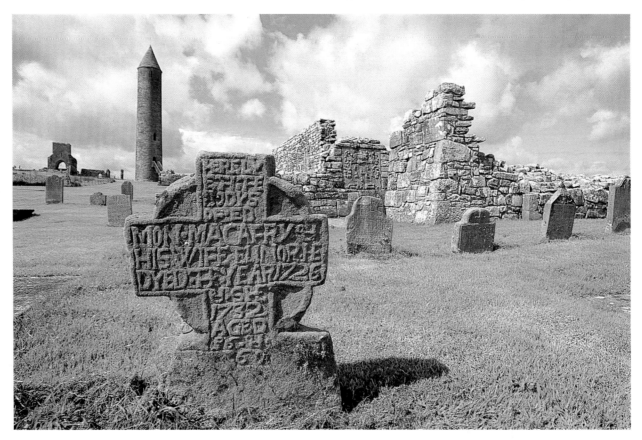

cred temple which in the liturgy announces the Holy City, the New Jerusalem (Origen, *Comm. Matt.* 16.21; Tertullian, *adv. Mark* 3.7). *As living stones we here on earth are being built up along with this city* (1 Pet 2:5) (Vatican II, *Lumen gentium,* The Mystery of the Church, no. 6). These are all symbolic images of a spiritual edifice.

A Church without Churches?

This Church, when it is assembled, can dispense with all specific buildings intended for divine worship. The tent of Moses, the temples of David and Solomon saw their time. Jesus announced the ruin of the last one, Herod's temple.

Jesus came to raise a new dwelling for God amid the people, as he announced to the Samaritan woman: *"The hour will come when you will no longer adore the Father on the mountain or in Jerusalem, but the true adorers will adore the Father in spirit and in truth"* (John 4:21). He declared to his apostles, *"There where two or three are gathered in my name, I will be in their midst"* (Matt 18:20), for Jesus himself is the temple in which the Father and the Spirit dwell (John 2:19 and 1:14). This was affirmed by the early Christians, notably Stephen: *"The Most High does not dwell in man-made dwellings"* (Acts 7:48). The apostle Paul, on the Areopagus of Athens (Acts 17:24), used an expression which he condensed for the Corinthians in searing words: *"The Spirit of God lives within you… you are the Temple"* (1 Cor 3:16). Saint Augustine, when he was consecrating a church, called it *"house of our prayer,"* for *"the house of God is our selves; we must build it up here below in order that it be consecrated at the end of time"* (Sermon 336).

Hence the new freedom to worship the living God in all places, a freedom of which the church has made use throughout the course of its history.

Nave of the rococo church of Zwiefalten, Germany

So Why Have Churches As Buildings?

In times of peace the Christian Church has erected buildings consecrated to God. The Church thus gave a form to *permanent indicators* of its existence and its action. It was in these structures that its "assembly" or "church" *(ecclesia)* took place. They would be more justly called *houses for the Church,* but the link between the institution and its meeting places is so natural that the latter have appropriated the name "churches."

The Church makes the word of the Lord heard in these churches; it prays and gives thanks to the Father. As the body whose head is the risen Christ, it is in these places that the Church performs the sacramental signs of its presence and action.

Churches provide a symbolic corpus of the mystery of faith, of the mysteries of God and of humanity. They provide a key which gives access to them, by passing from the visible to the invisible. They reflect a face of the Church, of its history, and of its relationship with the world.

Built for believers, churches offer everyone a sign of welcome. They spur people on in their quest for the meaning of life with its aspirations and its hazy expectation of a beyond. They show *the Church to those who are outside of it, like a signal raised up before the nations* (Vatican II, Sacred Liturgy 2).

There can be an ecclesial assembly outside of churches

In constructing and decorating the buildings in which it worships God, the Church has adopted the architecture in current use, as well as inventing throughout its history new forms and images of recognition.

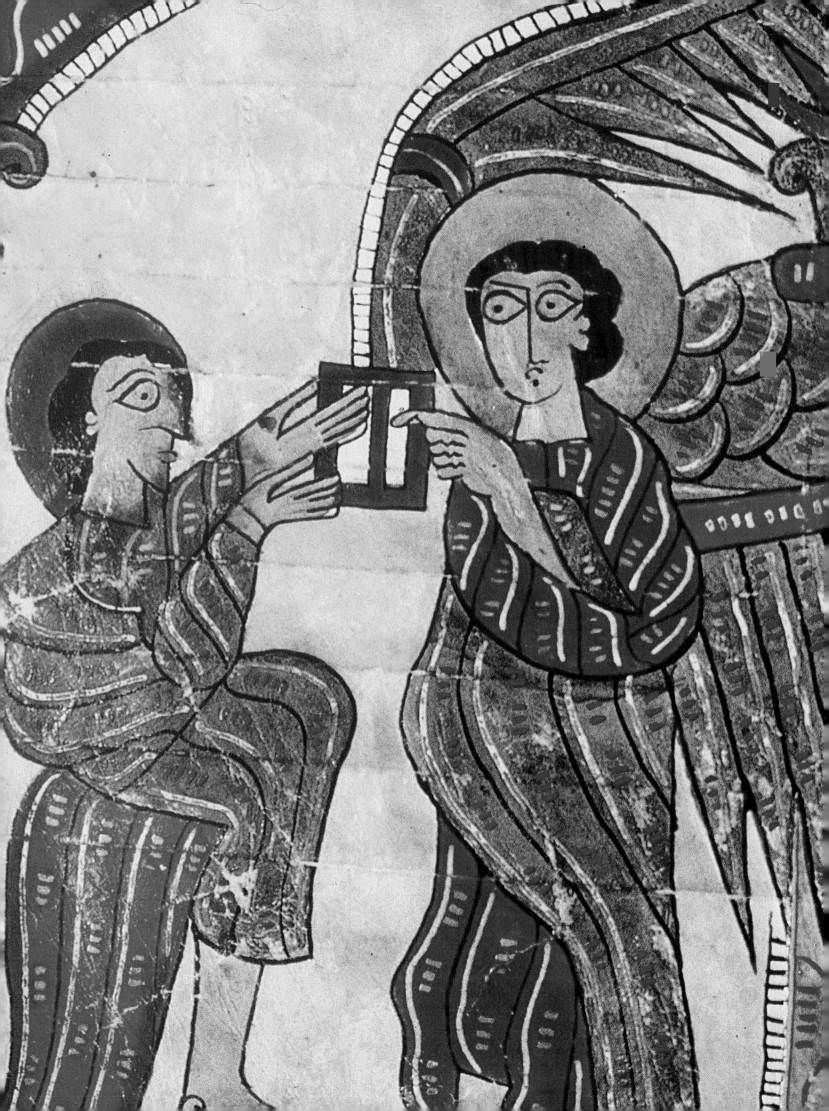

Evolution of Churches and Their Symbolism

FORMS IN THE IMAGE OF THE TIME

After integrating foreign forms in the architecture of their churches Christians constantly renewed their churches according to the spirit of the time. Thus each century saw the birth of new forms: basilican or round churches, churches in the shape of a Greek or Latin cross, monastic or secular churches, Carolingian, Romanesque, Cistercian churches, becoming Gothic in the thirteenth century, then Classical ones fashioned by the Reformation. Church halls appeared in the eighteenth century. The following century, influenced by the Romantic taste for the Middle Ages, saw neo-Gothic and neo-Romanesque edifices. In the twentieth century, concrete churches were shaped by the liturgical renewal of Vatican II.

Reviewing all these churches, one cannot forget that the change in their forms was dictated not only by ideas, theology and the sensibility of the time, but also by a matching symbolic expression. For theorists, the orders were meaningfully linked with the form of worship:

Doric capital of the Parthenon

"The Doric order," Serlio said in 1537, is suitable for *"churches consecrated to Jesus Christ, Saint Paul, Saint Peter and Saint George, and more generally for all the edifices dedicated to manly and heroic personages, the Ionic order for holy women and 'the well-read who lead a peaceful life,' and finally the Corinthian order for the churches dedicated to the Virgin Mary and the virgin martyrs."*

Bramante adopted a Doric order for Saint Peter in Montorio in Rome, more adapted than the Corinthian order to the heroic death of Saint Peter, but for the Holy House of Loreto he chose the Corinthian order, which was the most suitable for the Virgin.

Corinthian capital in Capernaum, Israel

We propose a reading of these successive forms in the light of economic circumstances, ways of life and techniques, along with an interpretation of their specific symbolism and its spiritual significance.

A few milestones in this panorama:

1 *Foreshadowings*
2 *Primitive churches*
3 *Basilican symbolism*
4 *Romanesque and Cistercian*
5 *Gothic*
6 *Renaissance*
7 *Baroque and Classical*
8 *Neoclassical*
9 *Neo-medieval and academic*
10 *Churches of today*

Previous page: The apostle John receives the Book, key of the universe

Ionic capital in Delphi, Greece

THE EGYPTIAN, GREEK, OR ROMAN TEMPLE

The temple, *temenos* for the Greeks, *templum* for the Latins, or *nemeton* for the Celts, was originally a natural place reserved for the celebration of sacred rites. The term then came to designate the structure, *naos* or *cella,* inhabited by the deity. The statue of this deity, lit up by the rising sun, resided in this place which was accessible only to priests. On the outside, facing the vestibule, stood the sacrificial altar.

Christian churches have certain similarities to the architecture of the Egyptian temple of Luxor: the cathedral towers are similar to the two entrance pylons and the narthex is similar to the courtyard; the seven columns crowned with lotuses demarcate a nave and its aisles; a peristyle forms a transept; and finally, the covered temple corresponds to the sanctuary.

THE JEWISH TEMPLE

In the desert Yahweh was manifested in the tent of the ark of the covenant.

The site of the first Temple of Jerusalem was chosen by David (2 Sam 24:18) on Mount Moriah, which tradition identifies with the high place on which Abraham agreed to immolate Isaac (Gen 22). Solomon was to build it around 970 B.C.E. in the likeness of the pagan temples. The last edifice, which Jesus knew, was that of Herod.

SYMBOLISM OF THE TEMPLE ADOPTED BY THE CHURCH

The temple answered a need to understand the world, life, death, space and time. In order to master these cosmic forces it subjugated their image symbolically to the image of the deity which it held between its walls, at once sovereign and captive.

■ Sacred Space

For the Jews the vestibule of the temple corresponded to the sea, the Holy Place to the earth, the Holy of Holies to the sky, the ark of the covenant being at once the image and the center of the world. The Christian Church made sacred a space for worship. Adopting the symbols of the circle, the square and the cross which made of the temple a microcosm, it retained the broad outlines of the Jewish, Egyptian, Greek, or Roman temple, along with the steps giving access to the vestibule, and then the sanctuary, the columns and their leafy capitals.

Temple of Concord in Agrigento, Italy, fifth century B.C.E.

Saint-Thégonnec, France - The sacred space of the church arranged according to the course of the sun

Generally intersected by a transept, the ground level plan of the church symbolizes a human being with outstretched arms summing up the world in the One whose thought causes it to exist. In the perfect state this person is Christ, who made humanity into the body (nave) of which he himself is the head (sanctuary).

Marked out on the ground in order to embrace the world in the four directions of the compass, and also erected in the nave, the cross is the tree which links heaven and earth, the sign of the descent of the Son of God in his nativity and of his ascension into the glory into which he invites humanity.

■ Sacred Time

The one who steers the course of the sun has power over time and over life and death. The builders of the temple knew this and sought to situate themselves with regard to the star of the daytime and to punctuate its progress as well as that of time. Thus in the Egyptian temple of Abu-Simbel, where, on the anniversary day the first ray of light penetrated the sanctuary where the statue of the Pharaoh stood in the dark among three gods, two solar deities were lit up like the Pharaoh by the light of the star, and a third, the deity of the darkness, remained in the dark. In these temples the passage from night to day was also evoked by the capitals of the central nave which opened wide their plant-like *corolla,* whereas those of the lateral nave depicted lotus or papyrus flowers closed by the night.

In the center of the esplanade, the priest observing the sunrise and the farthest point of its orbit, defined beforehand the location of the columns of the vestibule. On the lintel borne up by these columns he marked out the sun's progress, the yearly calendar of seasons and days.

In front of Solomon's Temple stood a basin of water supported by twelve oxen, the bronze sea. In this mirror the priests studied the position of the night stars and the movement of the planets. These observations determined the return of the celebrations of the Passover and of the seasons.

Like the temple, the Christian church is oriented toward the rising sun, making of it a symbol of Christ himself, *"sol oriens,"* whose birth is celebrated at the winter solstice when the sun ascends again. The Church has maintained the date of the Jewish Passover which Jesus celebrated before dying on Friday and rising from the dead on Sunday morning. The Council of Nicaea set the anniversary of the resurrection for the Sunday after the full moon of the spring equinox. The liturgical calendar is determined in reference to this date; it invites Christians to sanctify time, in which humanity's cooperation with God unfolds with the days and the seasons.

The symbolism of the temple door opening up to the sun between the two columns and their architrave is also to be found in triumphal arches. It applies in a very particular sense to the gate of honor opening into a sacred site and to church portals, like an invitation to welcome the one who comes as Savior, *"Gates, lift up your heads, let him enter, the king of glory!"* (Ps 24:7).

TRANSPOSITION OF THE PARTS OF THE TEMPLE

Churches borrow their architectural organization from the Egyptian, Greek, or Jewish temples. In Syracuse it has been possible, by virtue of this common structure, to convert into a cathedral an ancient temple of Athena of the fifth century B.C.E.

D The temple stood in an enclosure in which was erected the bronze altar of the holocausts with its four corner horns, an image of the four compass points of the universe, and a basin of water, the bronze sea.

Greek temple	Jewish temple	Church
ieron	forecourt	atrium, enclosed grounds, cloister

C The temple consisted of a vestibule with two columns.

Greek temple	Jewish temple	Church
pronaos	ulam (vestibule)	narthex

B It also had a main room accessible to the priests, with the altar of incense, the table of loaves of proposition for earthly goods and ten candlesticks, replaced later on by the candlestick with seven branches for the heavenly goods.

Greek temple	Jewish temple	Church
naos	Holy Place	nave

A Finally, behind a veil, there was a last room that was raised up and in which the ark of the covenant resided.

Greek temple	Jewish temple	Church
naos	Holy of Holies	sanctuary

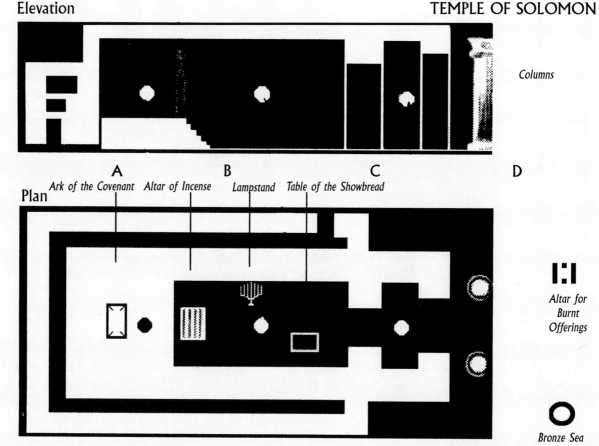

Elevation — TEMPLE OF SOLOMON

Columns

A — Ark of the Covenant — Altar of Incense — B — Lampstand — Table of the Showbread — C — D

Plan

Altar for Burnt Offerings

Bronze Sea

Door of the ancient synagogue of Ba'ram, Israel

TEARING OF THE VEIL OF THE TEMPLE

The death of Jesus on the cross was accompanied by a symbolic sign: the curtain of the Temple was torn from top to bottom (Matt 27:51). Thus came to an end the Old Covenant. In the Son, God came close to all God's children and the screen between God and the people was removed. The divine dwelling was opened to all. It was the hour of the revelation of the Savior, the authentic temple whose veil is taken away; the word comes from the Latin *velum*.

Inheriting the forms of the temple, the Christian church was given another purpose. It is the house which God inhabits with God's people. God summons this people to it, gathers them together, speaks to them, shares table fellowship with them, in expectation of the day when they will dispense with a stone edifice in order to live with God for good.

BESIDE THE TEMPLE, THE SYNAGOGUE

The Christians of Palestine were acquainted with a more familiar place than the temple, the Jewish synagogue. The word *synagogue* meant both the premises and the assembly itself that gathered there on the day of the Sabbath. The building was essentially a meeting place, a place for reading and studying the Torah (the Mosaic Law). It also served as a tribunal. It consisted of a room, facing the temple, which contained a cupboard for the scroll of the Law and a rostrum for its proclamation.

Like the synagogue, the first places of Christian worship were also opened up to diverse activities.

> *"I did not see a temple in the heavenly Jerusalem, because the Lord God Almighty is its temple, along with the Lamb."*
>
> Rev 21:22

Ruins of the ancient synagogue of Jerusalem

2. The First Places of Worship

PRIVATE HOMES

Until the third century Christians gathered most of all in private homes. They met in the dwelling of one or other of the brothers or sisters to teach, pray, and joyfully break the bread, as the Acts of the Apostles witnesses. In this domestic setting the sense of a familial community of which Christ is the binding factor developed (Acts 2:46; 5:42). When he was freed from prison, Peter went to the house of Mary, Mark's mother, *"where many people had gathered and were praying"* (Acts 12:12). In Philemon's house, according to Paul, the Church of Colossae gathered (Phlm 1:2; Col 4:9). In Troas the assembly, presided over by Paul, gathered on a Sunday night in the upper room of a house lit by many lamps (Acts 20:8). The same was true in Rome in the middle of the second century, as is indicated by Justin's response to the prefect who interrogated him about the Christians' place of worship: *"Where each person can and wants to worship. The God of the Christians is not imprisoned in any one place."*

The houses bore a title or notice on the outside, with the names mentioned by the Roman Liturgy. The configuration of the house, with the atrium, the peristyle, and the various rooms, can be recognized in the first churches.

The Christian house of Dura-Europos, discovered in Syria in 1922, dates back to the first half of the third century. It consists of five rooms on the ground floor, of which one was reserved as the baptistery and another for the eucharistic assembly. How was this room laid out? A Syrian document stipulates that the Church house must be turned toward the east in view of prayer and that a throne must be installed for the bishop, and surrounded by the priest's seats, facing the laypersons' seats. Saint Cyprian also speaks of the "altar of the Lord" and mentions the ambo at which the reader "visible to the whole people" reads the Gospel of Christ.

A synagogue was situated beside this place of Christian worship. The orientation and the layout of the two edifices resemble one another as do the Old Testament paintings to be found inside them.

CATACOMBS

Christians also gathered in the cemeteries, following the Roman custom of funeral meals. They celebrated the Eucharist close to the martyrs' burial places and decorated the gallery walls with iconography in which Hermes and Orpheus or animal symbols were to be seen side by side with biblical illustrations filled with anticipation. After the edict of Constantine some of these cemeteries were organized in view of the cult of the martyrs and retained sarcophagi whose bas-reliefs express Christian faith.

The experience of the catacombs explains the custom of collecting the venerable bones under the altars. The crypt, or *martyrium,* came into general use from the seventh century onward with the authorization given by Gregory III for the relics of the catacombs to be collected in Roman basilicas where they were safe from pillaging. This cult was very popular and led to a passionate quest for relics during the whole of the Middle Ages.

Eucharistic meal: Greek chapel of the Catacombs of St. Priscilla in Rome, second century © Scala

3. The Basilica

In the likeness of the Imperial court
from Constantine to Charlemagne

■ Society and the Church

Shortly after the Edict of Milan and freedom of worship, the date 325 marked a major event. At the Ecumenical Council of Nicaea the Church defined its creed, and belief in the Trinity, in which Jesus Christ, the Son, is equal to the Father and they are one in substance.

The inaugural session was presided over by the Emperor Constantine. He had just reunited the Roman Empire by his victory over Maxentius, then Licinius. Only twelve years after the persecution, the Church was officially recognized, and the bishops were granted a right to civil jurisdiction.

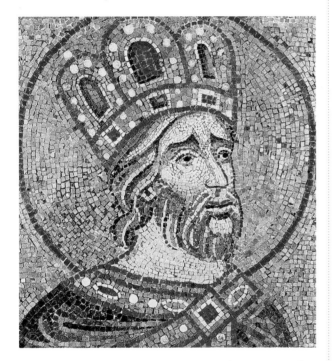

Mosaic of Constantine in the San Marco Basilica, Venice, Italy
The kingship of the saints is practiced in the Jerusalem on High

■ The Basilica

The basilica was the palace and edifice in which the sovereign assembled his people (the term *basilike* referred to the porticoed room designed for royal receptions). Thus it was suitable as a name for the edifice in which the king of heaven would reside among his own. This is why the emperor, in Rome or Byzantium, made the imperial basilicas into places for gathering in worship. They consisted of three naves separated by a double colonnade and opening out onto the open area intended for various activities; often a court of law found place in the apse.

Basilica of the Nativity in Bethlehem

■ Official Churches

Under the influence of his mother, Helena, Constantine and his successors had great churches built. In Jerusalem he erected a basilica with five naves on Golgotha, as well as a rotunda on the site of the Holy Sepulcher. In Bethlehem another basilica incorporated the crib into its chevet. In 331 at the imperial seat of Constantinople, the eponymous emperor of Constantinople inaugurated the first basilica which was to become Santa Sophia, Holy Wisdom.

Elsewhere throughout the empire, Constantine built vast places of Christian worship, as that of Trier (314) testifies. Imperial donations made it possible to raise the basilicas of the Lateran and Saint Peter in Rome in 337, Saint Paul-Outside-the-Walls in 386, and Saint Mary Major in the fifth century, after the Council of Ephesus had defined the divine maternity of Mary.

■ Authority by Divine Right

Imperial patronage had, however, a double effect. It supported the Church's activity, and in return the Church recognized the spiritual mission of the temporal leader.

The Christ in Majesty and the Byzantine emperor on his throne were clothed in the same insignia of power. The liturgical rites had certain similarities with the protocol of the imperial court. The Christian basilica depicted on its walls the splendor of the sovereign of heaven and its reflection in the person of the king *(basileus)*. Thus in 548 the mosaics of San Vitale of Ravenna evoked the theocracy of Justinian and his imperial liturgy.

■ Kings, Bishops and Monks

The Roman succession was realized in a confused fashion in the course of the invasions. Clovis, king of the Franks, was converted to Christian orthodoxy in 498, and then his successors unified their kingdom. Charlemagne was anointed king in

768 at Saint Denis. He was crowned emperor of the occidental world on December 25, 800, and behaved like a new Constantine.

However the bishops, who possessed ecclesiastical authority, had often taken over the temporal power during the troubled times of the invasions.

Monasticism developed under the auspices of Saint Benedict and his Rule. It was to spread throughout Europe, encouraged by Pope Gregory the Great; it contributed to the structuring of Christian society. The Irish monasteries of Iona and Bangor expanded among the Celts of Scotland or Armorica and, with Colomba, from Luxeuil, among the Franks and Burgundians.

■ Liturgical Adaptation

The places of Christian worship adopted the structure of these basilicas, and the liturgy was organized in them. The bishop presided in his *cathedra,* a seat built against the apse. The priests assisted him in a semicircle, whence the name *"presbyterium"* was given to this part of the church.

The altar, as the Ravenna mosaics illustrate, was covered in a cloth. Until the fifth century it was made of wood, with or without metal and enamel coatings. Then stone became widespread in the time of Gregory of Nyssa and Augustine and began to be obligatory in 517 at the Council of Epaone. Its table sometimes rested on a stone support which recalled the sacrificial altars or the tombs of the catacombs. A canopy *("ciborium")* or baldachin borne up by four columns of marble or precious metal sheltered it, according to the custom for pagan altars, and signified its power of intercession.

Between the bishop's **seat** and the congregation stood the cantors and clerics in the *chorum* or choir. This place was equipped with ambos for the reading of the epistle or the gospel. The roodbeam, an entablature on columns holding up the lamps, separated the sanctuary from the choir and was at the origin of the Oriental iconostasis and the closure or railing of Occidental churches.

The extra height of certain sanctuaries was due as much to the symbolism of the steps as to their location above the confession or *martyrium,* the crypt-reliquary of a martyr. The wings and tribunes of the basilica were reserved for the deacons, consacred virgins and widows. The nave belonged to the faithful, the men on the right, and the women on the left side of the bishop who presided facing the congregation.

In the Carolingian era the basilica sometimes had a double apse, one to the east and the other to the west, thus combining the Roman tradition of western-facing basilicas with the practice of 'orientation' (facing east) common to the whole of Christendom.

The atrium was equipped with a fountain for ablutions. Under its galleries stood the catechumens and penitents who awaited their admission. The area around the basilica included annexes: above all the baptistry, in a circular or octagonal form. Contiguous rooms served as sacristy, lodging for the bishop and his clergy, and accommodation for the poor.

INTRODUCTION OF IMAGES AND SCULPTURES

Embroidered hangings adorned the altar and the bishop's seat. Mosaics covered the walls, and especially the apsidal conch. What were they intended to represent?

The Jews rejected all representations of deity and had no images other than those of the cherubim of the temple. Moses had warned Israel, *"You saw no form of any kind on the day the Lord spoke to you at Horeb out of the fire. Therefore watch yourselves very carefully, so that you do not become corrupt and make for yourselves an idol, an image of any shape, whether formed like a man or a woman, or like any animal on earth or any bird that flies in the air, or like any creature that moves along the ground or any fish in the waters below the earth"* (Deut 4:15-18).

Muslims also abstained from all representations. Among Christians the Orthodox evoked the celestial world with two-dimensional images, icons, and mosaics, but excluded sculptures.

Later, Protestants rejected all images of Christ because his divinity eludes the senses, and of the saints for they do not accept veneration of the latter.

Save rare exceptions, *statues* are to be found only in Catholic churches and only since the tenth century. At first the graffiti of the catacombs were accepted: the symbols of the fish, the loaves or the *chi rho* and images borrowed from pagan art. The first images represented the glory of Christ as an imperial triumph. The Savior was concealed under the features of Helios or Orpheus, and the Good Shepherd was a Hermes Criophore (ram-bearer). Sculptors handled directly, but only in bas-reliefs, scenes from the Old and New Testaments on the sarcophagi. The sculpture work in the round was suited only to jewels and ivory statuettes whose scale cannot create an illusion of presence.

In every monastic scriptorium *illuminations* were painted as illustrations in the evangelistaries (gospel books), Sacramentaries, psalters, and Bibles. Thus the illustrations of the Apocalypse of *Beatus,* of which there are about twenty interpretations deriving from the Magius manuscript, handed down their sumptuous colors from 960 to 1109. *The Irish* adorned the word of God with the same arabesques, triskeles, or strange human and animal forms with which they adorned their arms (swords, shields) and their stone crosses.

"Those who cannot write cannot appreciate such work. So try yourselves and you will see how difficult a task it is, a grueling drudgery. It makes your sight fail, curves your spine, crushes your stomach and ribs, gives you backache and inflicts great hardship on the entire body. That is why, my readers, I ask you to turn these leaves over slowly and be careful not to touch the text with your fingers; the ignorant reader, like the hail which diminishes the fertility of the earth, deteriorates the writing and the book."
Petrus, prior of Santo Domingo de Silos

From the image of Hermes Criophore, the Good Shepherd

Sarcophagus with the monogram of the risen Christ © Scala

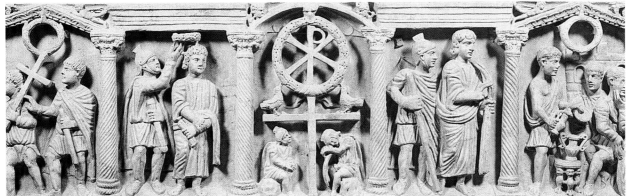

73

BYZANTINE ART

Until the Romanesque era it is difficult to distinguish between Byzantine, Greek, and Syrian expression; the mosaics of Ravenna, those of the post-iconoclasts of Santa Sophia, and the later ones of the San Marco Basilica or the Sicilian cathedrals are similar.

Besides this wall art, the late ninth-century cubic churches with a central dome had in common the cosmic symbolism of their architecture and the meaningful distribution of the paintings throughout the building. On their golden cupola they evoked the light of heaven and its inhabitants, the saints with eyes opened wide by the eternal vision; then in the choir they presented the faithful with the mysteries of the sacraments which give access to this heavenly world. While the Lord's salvation was reenacted on the eucharistic altar, the story of his activities unfolded before their eyes in the images on the secondary vaults and the southern wall.

"This iconographic transposition of the Mass came to take its place in a painted evocation of the ideal Universe. This was owing to a notion dear to the Byzantines, according to which the Christian liturgy was but a mere reflection on earth of an unin-

Cupolas of San Marco in Venice, Italy

terrupted Mass celebrated by the angels in heaven. The latter had only been able to offer to humanity the model for this Mass since the rehabilitation of humanity by the work of the incarnate Logos."

André Grabar, *L'iconoclaste byzantin*

■ Affinity of Christian Churches and of the Basilica

Thus from the very beginning churches drew their inspiration from the basilica, house of the king, house of the people, which was built at the center of human activity, to which the Church gave a meaning. The basilica was used as a model more than the temple, which was the unfamiliar dwelling of a solitary God.

Mosaic of the apse of San Vitale in Ravenna, Italy

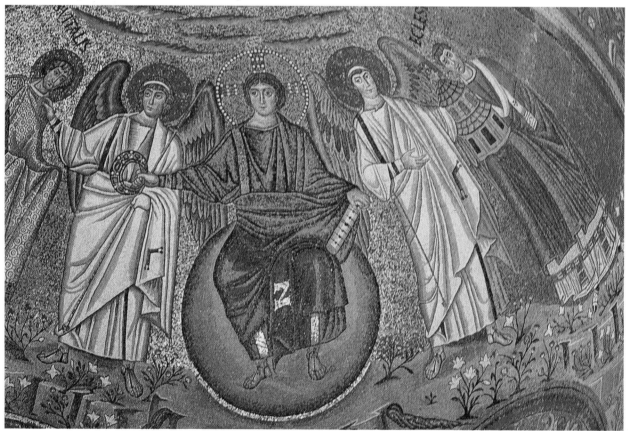

The strongholds of prayer

THE FACE OF SOCIETY AND OF THE CHURCH

The millennium of the redemption was celebrated in 1033. Religious art of the time was to bear its stamp. Shortly after the year 1000, the chronicler Raoul Glaber tells us, that the world was *to shake itself up in order to divest itself of the dilapidation of age and don in all quarters a white mantle of churches,* as if for a new spring.

On this solemn anniversary of the history of salvation, preachers exhorted their flocks to conversion with the harsh images of the Apocalypse and of Judgment.

Certain popes, Gregory VII among them, liberated the Church from imperial supervision and abuse.

In Cluny, founded in 909, Saint Odo and his successors reformed the Benedictine Order according to the Rule, with strict observance of poverty and chastity, making the spiritual life and the singing of the office the essential occupation of the monks. Ten thousand monks between Spain and Poland were subordinate to the abbey, whose architecture was unrivaled. It made its mark on the worship and culture of the Christian Western world. The pilgrimages of Compostela, Rome, and Jerusalem were linked to penance and the veneration of relics and were a quest for salvation. The Crusades could appear to be the grandiose fulfillment of this salvation. With the end of the invasions, the establishment of the feudal order and the *peace of God* imposed by the Council of Narbonne (*"The Christian who kills another Christian spills the blood of Christ"*), safer roads made traveling possible.

The result was an expansion of trade from which the kingdom profited. The peasant lacked resources, but the improvement of the plow and the harness collar made preparation of the ground less laborious and harvests less pitiful. The money of the nobles, the monks and the merchants financed the quarrying and cartage, the sweat of the stonecutters and the know-how of the artisans.

The whole of social and religious life was organized around the diocese and its parishes, which were the territorial units for all activities, whether economic, administrative, cultural, or educational, as well as hospital activities. This was especially true since the king himself, who was crowned by the Church, was responsible to guide his people toward salvation.

HOMAGE TO THE ETERNAL GOD

The church, which ensures an afterlife, is a better guarantee than fortified castles. It is in itself a fortress pitched against the devil, adversity, and eternal death. Consequently it was built securely in order to resist bad weather and fire, the scourge of the previous wooden edifices. Stone was cut and fitted in as precise a way as that of the Romans – whence the name "Romanesque," given to the new style.

It was there, in the unfolding of the liturgical feasts that the peasant, like his lord, discovered the threshold of paradise. Under this imposing architecture, in the light of candlesticks, orphreys (elaborately embroidered bands), precious stones and metals gleamed for the transcendent God, who is adored by the angels and the saints. The offering of these treasures acknowledged the divine origin of all prosperity and solicited its renewal.

The Last Judgment (detail), portal of the Roman church of Conques, France

FROM SQUARE TO CIRCLE, THE PILGRIM CHURCH

The architecture of the church, the basilical design, placed the faithful in the presence of the Invisible One. The weight of the stone edifice demanded the solid wedging of the vault of the crypt and, above that, of the aisles, the ambulatory and secondary apses, and, even higher, of the barrel vault of the nave or its series of cupolas and of the towers on the façade. Thus story by story these vaults of stone rose up toward the heavenly vault of which they were an image. Powerful cruciform pillars, punctuating the play of light and shadow, supported the nave which stretched out in the direction of the rising sun, the symbol of the One who dissipates the darkness of sin and death. A crown of radiating chapels magnified the choir, where the gaze of the faithful focused on the face of the Sovereign Lord Jesus.

The pilgrims paraded along the side aisles and ambulatory in order to bow before the treasure of the reliquaries. In the choir the celebration and the Gregorian chant praised the glory of the Eternal God.

From the cloister, the liturgical procession also unfurled behind the cross, imitating humanity's march through time toward the heavenly Jerusalem. From the narthex to the sanctuary it passed beneath the grandiose tympana of Christ in Majesty and the Last Judgment, progressed between the pillars whose capitals marked out the different stages of salvation, and under the vaults whose frescoes unfolded the long biblical history from creation to redemption. Then the procession gathered in the presence of the apsidal Pantocrator, who was portrayed on a gold background suggesting the glory of the other world.

SANCTUARY AND ALTAR

Until the thirteenth century the altar - a table or parallelepipedic block (having parallel surfaces) - was of limited dimensions, sufficient to hold only the bread, wine and evangelistary. It was sometimes decorated on the front side with an antependium of cloth or a painted wooden frontal. Behind the high altar a display shelf of reliquaries enriched with icons acted as a reredos. Above, a baldachin raised up its dome, and in front on either side small columns bore the sanctuary light.

The secondary altars, which appeared as early as the seventh century for the celebration of private Masses, were multiplied in a wreath in the ambulatory (Cluniac inspiration) or parallel to the high altar on the east wall of the transept (Cistercian style).

Under the full arch of the *baldachin,* the vault or the dome, the altar – table and block marked by the square – insured the passage from the earthly to the celestial world, from Creation to Redemption.

Primitive altar table with raised edges. St. Stephen's Cathedral in Metz, France

On the left, leading to the sanctuary, the nave and its vault adorned with biblical frescoes from the twelfth century. Abbey church of Saint-Savin-sur-Gartempe, France © Lauros-Giraudon

APPEARANCE OF STATUARY

In the darkness of some crypts, in the shifting glow of the lamps, a strange statuary revealed itself to the pilgrims. The cult of relics, widespread since the seventh century, had required the security of suitable reliquaries. Goldsmiths fashioned caskets in the shape of the precious relic: a foot, a hand, a head, or an entire skeleton. Thus in the eleventh century in Conques the skull of Saint Foy was fitted into a crowned head whose face was fashioned in gold plate with eyes of precious stones. Her entire body, covered with the same metal and the same sparkling gems, was presented seated on a throne, *in majesty.*

These "idols" and the suspect rituals which occurred around them in the crypts scandalized a master of the Episcopal schools of Angers in 1013:

"Ignorant as I may be, this seemed to me to be a perverse practice and contrary to the Christian law, when for the first time I caught sight of the statue of Saint Gerand placed on an altar, and fashioned exactly in the shape of a human face. For most of the peasants who were admiring it, it seemed to be studying them with a penetrating eye and, through the reflection in its gaze, seemed to be answering their prayers with all the more goodness."

Some *black Virgins,* antique Isis-Mothers brought back from the Crusades, kept in the shelter of Christian crypts and called *Thrones of Wisdom,* exerted a sacred attraction which drew people toward Chartres, Rocamadour, and Marseille.

THE LANGUAGE OF ROMANESQUE SCULPTURE

Carving in low relief developed on the capitals and the western tympana of churches. In the course of the twelfth century it resulted in works which had a coded language and broke with natural-

Cupola of the church of Conques, France

ism, becoming more suggestive than representative, as for example in the personages with strange faces whose fascination was emphasized by eyes made of glass pearls. *"A spirit inhabits sculpture… but it inhabits sculpture because sculpture eludes appearance"* (Malraux). The inspiration of the time was oriented toward the world to come, focusing people's gaze on the Pantocrator around whom the saints of the Old Covenant, kings and prophets, were aligned in rows. They were apocalypse, that is *"revelation."* The Last Judgment of the portal of Conques, that of Gislebertus of Autun, the tympana of Moissac, Vézelay and the royal portal of Chartres, the columnar statues of low or high relief closely linked to the architecture are examples of this.

Just as a reflection of the inner light of the evangelistary shows through by its precious binding, so the churches, receptacles of revelation, proclaimed this inner light on their façades with grandiose scenes carved in stone with the sharpness of repoussé metal.

**The Majesty of Sainte Foy (983–1013),
Saint Foy, Conques, France,
treasures of the ancient abbey.
Reliquary statue made of wood covered
with metal and gemstones,
glorified bodies being the precious
stones of the heavenly Jerusalem**

NOVELTY OF STAINED GLASS

An ancient invention, stained glass is from now on adopted to invest space with the same sacred character as that imparted by frescoes and mosaics.

The narrative subject was arranged in a legendary order from top to bottom, in medallions sometimes alternating with squares. The light blue and white frames were decorated, in the same way as oriental cloth, with foliage, flowers, or monsters. The backgrounds were alternately red or blue.

The sparkle of the glass fragments, arranged like gemstones in a piece of gold plate, characterized the Romanesque symbolism which anticipated the vision of the heavenly Jerusalem by portraying the saints as precious gemstones.

Stained-glass window of the Three Kings, St. Denis, France
© Lauros-Giraudon

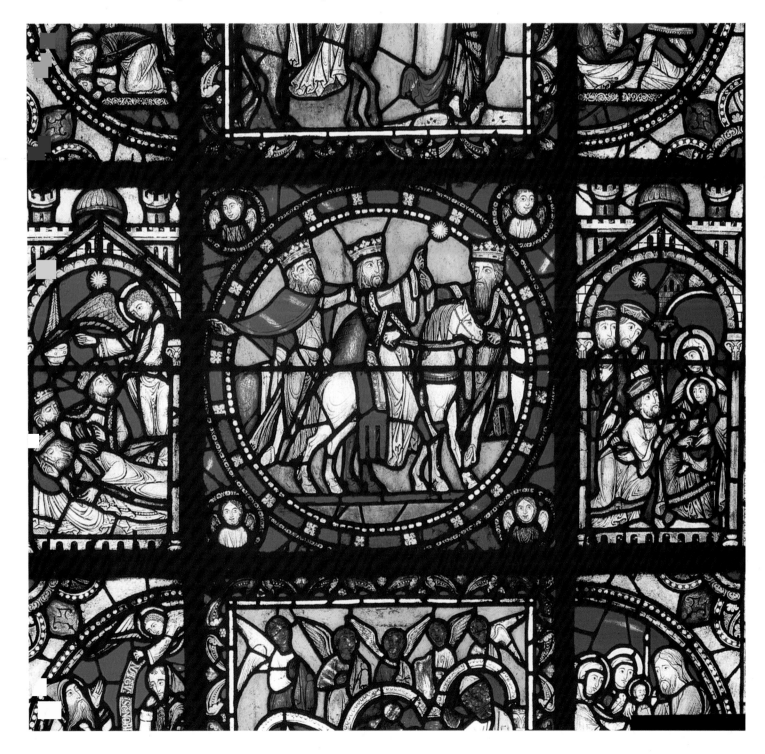

CISTERCIAN REFORM

Renouncing the comfort of Cluny, *"neither chausses nor pelisse... nor fat, nor meat,"* the monasteries born of Cîteaux, through the impetus given by Robert de Molesme and Saint Bernard, lodged their communities in the countryside or the woods near a river, in order to give themselves to prayer but also to manual work.

This reform of the monastic life left its mark on architecture. The rigorous stone structure and the clarity of the lines dispensed with the luxury of embellishment. Unhesitatingly, Saint Bernard reduced the height of the buildings and limited the number of windows in the gables to favor contemplation. He advocated an austere architecture, relinquishing the marvelous polychrome of the stained glass for white glass in which the graphic art of the lead, forming flowers, lacework, and palmettes was the only, if elegant, embellishment. He restrained energetically the imagination of the stonecutters.

He became indignant at their extravagance : *"What are these grotesque monsters doing here? What significance can these hideous monkeys, fierce lions and strange centaurs have here? Here a quadruped drags a reptile's tail behind it, there a fish bears a quadruped's body. There again an animal on horseback. In the end the variety of their forms is so marvelous and immense that one spends the day contemplating these curiosities instead of meditating the law of God. Lord ! If we do not blush before these absurdities, may we at least deplore what they cost. ... The Church is resplendent in its walls but lacks everything for its poor.... We have left the world, we have given up all precious and beautiful things for Jesus Christ, so we hold as mud all that charms with its glitter, seduces with its harmony, inebriates with its scent, gratifies with its taste... in short all that enchants the flesh, whose piety we, for our part, wish to stimulate"* (Apology to Guillaume).

The Christ on the cross is dead. His face is that of the Man-God. His eyes are closed. The pain is suppressed; instead of rendering the physical suffering of the crucified man perceptible by the thorns and the blood, the sculptor discovers the royal dignity of this death freely accepted. The body is sustained by a horizontal ledge on which the two feet are nailed separately, which spares the arms from being stretched up to heaven. The latter open out in a voluntary gift of self.

St. Bernard, left wing of the triptych of St. Erasmus, Church of Saint-Pierre in Louvain, Belgium. Dirck Bouts © Giraudon

ROMANESQUE VISION

And I heard a loud voice from the throne saying,
"Now the dwelling of God is with men, and he will live with them.
They will be his people and God himself will be with them and be their God.
He will wipe every tear from their eyes. There will be no more death
or mourning or crying of pain, for the order of things has passed away."
One of the seven angels came and said to me,
"Come, I will show you the bride, the spouse of the Lamb."
And he carried me away in the spirit to a great and high mountain
and showed me the Holy City, Jerusalem,
coming down out of heaven from God.
It shone with the glory of God
and its brilliance was like that of a very precious jewel,
like a jasper clear as crystal.
It had a great, high wall with twelve gates
and with twelve angels at the gates.
On the gates were written the names of the twelve tribes of Israel.
There were three gates on the east, three on the north,
three on the south and three on the west.
The wall of the city had twelve foundations
and on them were the names of the twelve apostles of the Lamb.
The angel who was talking to me had a measuring rod of gold
to measure the city, its gates and its walls.
The city was laid out like a square, as long as it was wide.
He measured the city with the rod and found it to be 12,000 stadia
in length and as wide and high as it was long.
He measured its wall and it was 144 cubits thick.
The angel was using a human measurement.
The wall was made of jasper and the city of pure gold, as pure as crystal.
The foundations of the city walls were decorated with every kind of precious stone.
The first foundation was jasper, the second sapphire, the third chalcedony,
the fourth emerald, the fifth sardonyx, the sixth carnelian,
the seventh chrysolite, the eighth beryl, the ninth topaz,
the tenth chrysoprase, the eleventh jacinth, and the twelfth amethyst.
And the twelve gates were twelve pearls, each gate made of a single pearl.
The great street of the city was of pure gold, transparent like glass.
I did not see a temple in the city, because the Lord God Almighty and the Lamb are its temple.
The city does not need the sun or the moon to shine on it
for the glory of God gives it light, and the Lamb is its lamp.
The nations will walk by its light
and the kings of the earth will bring their treasures to it.
I, John am the one who heard and saw these things.
Once the vision and words were over
I fell down at the feet of the Angel who had shown me them to worship.

Revelation 21:3ff.

These lines of the Apocalypse are transcribed in the painted manuscript of Beatus. (Cover page)

4. Gothic Symbolism

The élan of faith

THE GOTHIC WORLD

One discovers the Gothic world on the porch of Amiens; the work of the peasants who sow, harvest, lay the swaths, thresh with the flail, and tread the grapes in the wine press is familiar to the builders of the cathedral. Yet the cathedral was built in the city, where the thirteenth century saw the growth of a population of nobles, bourgeois, merchants, and artisans of everyday objects, precious clothing, and works of art.

A student world gathered around masters of liberal arts, who were responsible for communicating divine knowledge. Thanks to Abelard, Albert the Great, and Thomas Aquinas, the construction of a Gothic cathedral was accompanied by an art of reasoning, of sound thought and the development of a luminous theology which reigned supreme in the face of the Cathars, the Vaudois and all erring ways.

The mendicant religious orders, the preacher sons of Dominic and the sons of Francis of Assisi, spread out in the towns of Europe immediately after the deaths of their founders and proclaimed, in the vernacular, a gospel of detachment and brotherly love. The brotherhoods, linked to guilds, fostered their own prayer life.

The first Gothic monuments had their origin in a monastic initiative like that of the abbot of Saint Remy of Reims. However, the promoter of the cathedral was the king of France. With the support of Louis VI, his adviser, the monk Suger, undertook the renewal of Saint Denis. In his prestigious town of Paris, Louis IX, with the wealth at his disposal, and with his wisdom and sanctity, proved to be the ideal contractor. He led his knights into another form of witness to the faith, a Crusade, from which he brought back the crown of thorns of the Savior.

Each of the bishops, the pillars of royalty and of society, made it a point of honor to build a prestigious cathedral. Their chapter studied the plans and entrusted their construction to lay guilds, contractors, stonecutters and sculptors of figurines. It managed the financing by means of tithes, duty on merchandise and gifts from the king himself, and from rich bourgeois who were concerned for their salvation and jealous of the glamor of their city. For the cathedral, a symbol of the dwelling of God in the center of the town, was an emblem of the city's renown and of its prerogatives and franchises. The cathedral was the fruit of economic prosperity and a shared spirit of faith.

Cathedral of Chartres, elevation of the transept

OPENING UP TO THE WORLD

The cathedral revealed the elevation and internal plan on its façade. It also opened itself wide to the outer world through its three or five deeply splayed doors. However, it still presented itself as a fortress with its two mighty towers guarded at the entrance by the kings of Judah or the apostles. For if the house of God was welcoming to believers, Satan's henchmen were turned away.

<div align="right">

Right page:
Cathedral Notre-Dame in Amiens,
France, thirteenth century © Giraudon

</div>

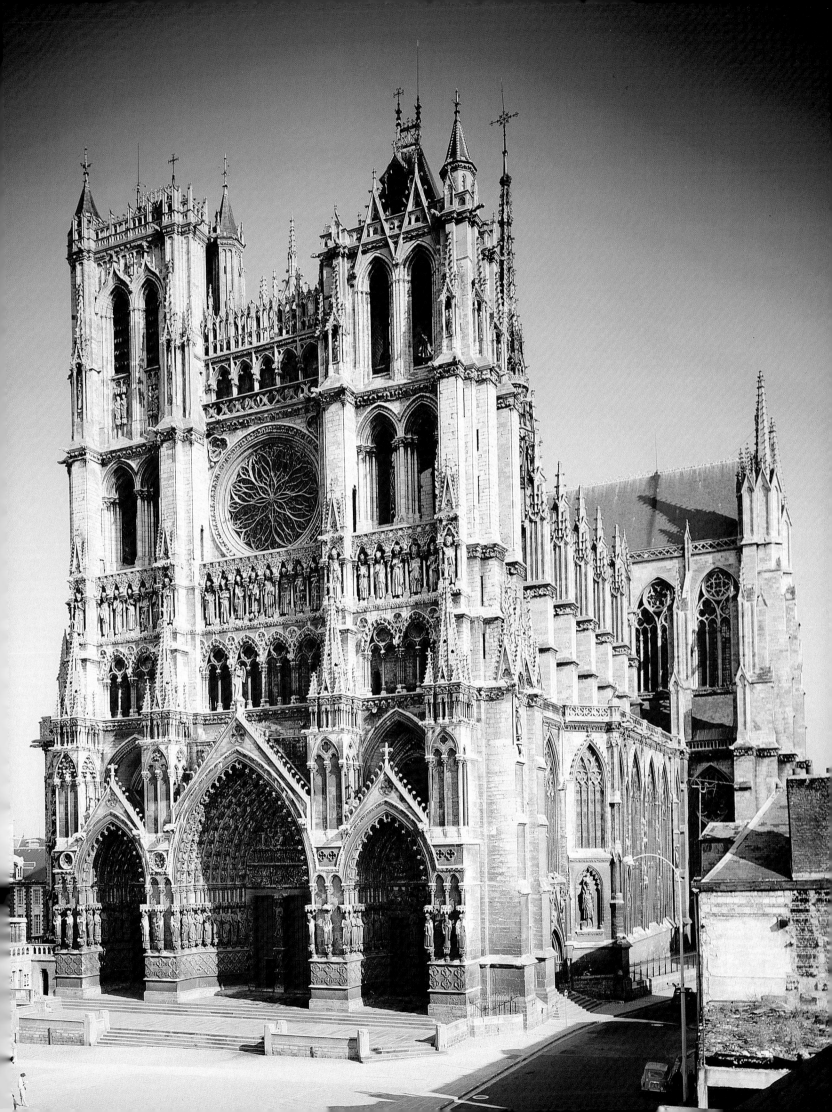

HEAVENLY CONSTRUCTION

The Gothic arch attempted by the Romans and the Arabs topped the doors and windows. It emphasized the back-bone of the groined vaults. On the latter were grafted the diagonal arches of the intersecting ribs which formed the skeleton of the building, braced once again by longitudinal and transversal lierne ribs. The stone partitioning wedged in by this framework rested not on the walls but on the columns of the nave. On the outside, arches pressing against the wall of the aisle propped up the thrust of the vaults and stabilized them. This armature made possible the elevation of the naves above the city roofs. This was all the more effective since the wall hollowed itself out into a gallery, the *triforium*, which passed from one bay to the next on the back of the columns in great webbed and mullioned windows and widely spread rose windows in order to lighten the high parts and brace the gables. Thus the nave, by its proportions, by the number and boldness of its ascending lines and by the vigorous upward thrust of its arches, was conducive to the spiritual elevation of prayer.

PLAN DEVISED FOR A HIERARCHICAL GATHERING

For ordinary services the citizens did not lack local or convent churches, but it was in the cathedral that the entire people gathered on feast days.

The design of the long nave with a deep choir underlined the hierarchical nature of the assembly whose different members were spread out from the narthex to the sanctuary. The chapter of canons celebrated daily the Liturgy of the Hours there, in the rows of high canopied stalls which enclosed the choir on either side. A railing or chancel topped with a rood screen stood between clerics and laity, between the episcopal cathedra and the faithful in the nave.

ALTAR OF THE GOTHIC SANCTUARY

In the thirteenth century the altar of stone or precious metal retained its former shape, but the table, resting on columns or the parallelepipedic block embellished with arches in bas-relief, lengthened. The predella, a tier placed on the altar table, was sculpted and supported a decorated panel which was to become a polyptych – many paneled – in the fifteenth century.

Beneath these winged panels, which were opened or closed according to the different liturgical occasions, or which were surrounded by stained-glass windows depicting the passion, the altar linked the lot of pilgrim humanity with that of Jesus, Son of Mary and Son of God, who lived through the passage from death to the resurrection.

The élan of the columns at the crossing of the nave and the transept, which formed an aerial canopy at an inaccessible height above the altar, symbolized the upward movement of the Eucharistic Prayer toward the Almighty.

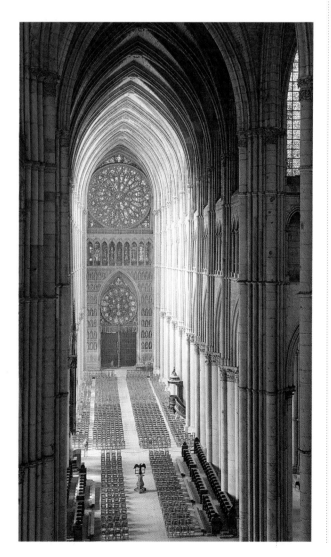

The nave seen from the choir of the cathedral of Reims, France © Lauros-Giraudon

Stained-glass window of the Chevet, cathedral of Bourges.
Announced by the sound of trumpets, the judgment of Michael, who weighs the souls, is executed by angels and devils. The angels gather the crowned elect into the tablecloth of the banquet; the devils hurl the damned, from all walks of life, into the maw of Leviathan.

THE ILLUSTRATION OF THE STAINED-GLASS WINDOW: LIGHT CAME INTO THE WORLD

Art always strives to approach the transcendent God, but also the God who communicates God's very self. Suger defined its spirit: *God is light and the divine dwelling must radiate this presence so that each of God's disciples may be illuminated by the trinitarian dwelling of the Father, the Word who is light, and the Spirit of fire.*

To back up this theology, thirteenth-century cathedrals flowered with magnificent stained-glass windows. Sparkling like the gemstones on the evangelistaries, they symbolized the cortege of the elect who advance toward the throne of the Lamb, as Van Eyck in Saint-Bavon in Ghent depicted them.

In the place of the earlier narrow windows the Gothic picture windows continually encroached on the stone walls. This was not meant to intensify useful light but was intended to spiritualize it and spread it in a sort of emanation of the sa-

cred images. The extension of the illuminated surface, the richness of the palette and its modulations belonged to a symbolism expressive of the divine world. The terrestrial element yielded its place to the ethereal, the luminous, the celestial element.

The color, in which blue and red dominated, underlined with white and then with gold (from the invention of yellow gold in the fourteenth century), was not ornamental. It was the bearer of symbols. Thus, in the series of the Apocalypse of Bourges, a galaxy of red blots around Christ evokes the saving blood and angels bear a green cross, the hope of humanity, whose center is red with divine love.

■ The Great Book of the Church Was Thus Opened Up to All Gazes

The Bible's narratives of the Old Testament faced the cold clarity of the North; the coming of the Messiah, his death and resurrection belonged to the sunny South. The link between annunciation and fulfillment was affirmed by the parallel between the prophesies and their fulfillment.

It is thus that one can find on a lancet of Bourges Cathedral the keys to a reading of each stage of the salvation brought about by Christ, in the episodes which anticipated them prophetically at a distance. Around the quatrefoil of Jesus weighed down by his cross are added the episodes of the sacrifice of Isaac loaded with the wood for the holocaust. Two lateral scenes frame the medallion of the crucifixion, depicting Moses striking the rock to make water spring out of it and lifting up the bronze serpent in the desert in order to save the Hebrews from poisonous bites.

This link asserts itself powerfully, in a strange symbolic language, in the southern transept of the Chartres Cathedral. On either side of the Virgin-Church the four great prophets bear on their shoulders the four evangelists, signifying thereby, says E. Male, *"that the latter lean on the authority of their predecessors"* but *"that they see from a higher viewpoint, and farther than the former."*

The martyrology or life of the saints can be read all along the lateral naves and the chapels of the ambulatory. A series of medallions unfolds the edifying account which a guild had ordered by way of an ex-voto to venerate its patron. The high windows present great ethereal figures, isolated under their canopy modeled after architectural motifs, which the separation of the mullions does not prevent one from reading as an uninterrupted series of witnesses.

In the transepts and on the western wall, the radiating rose windows recapitulate the march of time and its apocalyptic outcome: the Lord of Judgment and the Crowning of the Virgin.

Right side of the west portal. Annunciation and Visitation, cathedral of Reims, France © Lauros-Giraudon

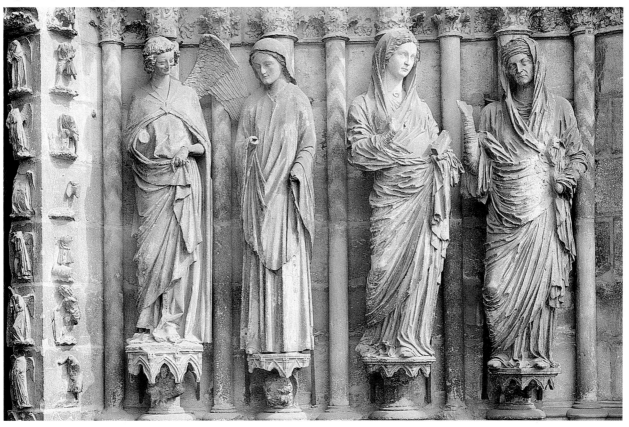

Incarnation Statuary: from the Transcendent God to the Word Become Flesh

The prologue of Saint John concerning the Word announces that he became flesh to dwell among us. The thirteenth-century cathedral was intended to reflect the mystery of the incarnation. Since the Romanesque mosaicists and fresco painters of the Pantocrator, the world had changed; the crusaders had discovered the Orient. In Palestine they had discovered in the footsteps of Jesus of Nazareth a God who was more sensitive to human life and death, both of which he accepted to the bitter end. Love and mercy could now be read in his face, and also the marks of suffering and death. Mary, who brought him into the world through the workings of the Holy Spirit, occupied the most important place after him as a Blessed Mother or weeping Pietà and Virgin of Compassion.

With the opening of the cathedral doors out to the world, statuary sculpted in the round appeared and became more and more frequent. Therefore the faithful were welcomed by Christ, the mother of God or the cathedral's patron saint, both solemnly present on the pier, and by the witnesses to the faith standing on either side of the double doors. The vision of the Word made flesh, the Lord of Glory but also bearer of Good News for his brothers and sisters, replaced the vision of the otherworldly God. The book which the teaching Christ held forward at the entrance to the cathedral contained the key to the invisible universe, but also the key to that visible creation which was entrusted to human beings at the dawn of the world.

This sacred statuary reflected contemporary theological and psychological experience. Aligned under their canopies on the walls of the edifice, the city of God, the statues evoked on the north and south sides respectively the Old and the New Testaments, and on the west side the Apocalypse. As they emerged from the column (in Chartres they still have something of the nature of columns) their proportions adjusted to the human body like the folds of the clothes in which they were draped. The features of their faces acquired an identity of their own and managed to express the gravity of the prophet or the smile of the angel.

The question which since time immemorial had kept humanity prostrate before the mystery of the world and before its own anguish - what is God's face like? - found its answer in the science of the theologians of

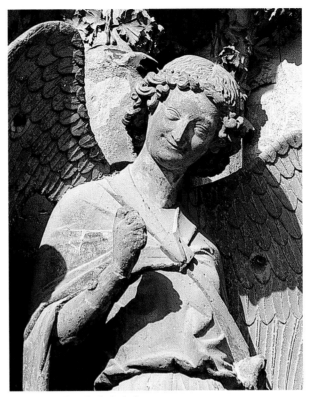

Smiling angel, cathedral of Rheims

France: God's face is a human face. On the royal portal of Chartres, as we have seen, this answer caused the features of the Romanesque faces, until then frozen in a hieratic rigidity by a sacred abstraction, to quiver with the first signs of life. A breath broke through their lips, their eyelids sheltered a gaze which was no longer hidden by their ecstasies. From then on this same life burst forth on all sides, liberated the sculpted bodies from the straitjacket of the column and settled them into the flexibility of real postures, under the folds of those linen robes which were finished in Flanders for the nobles. Right from the moment when the characters of liturgical drama started to grow in number on the theater erected at the porches of the cathedrals, it was necessary to make each one of them conspicuous. Doubtless they bore distinctive insignia, the particular attributes which Christian iconography gave to each prophet, each precursor, each apostle. Yet soon they were endowed with a personal face capable of expressing an individual psychology.

Duby, The Middle Ages I (Skira)

At first confined to the portals and their tympana, on which it projected its vision of the world to come, the statuary spread to the façades from the gallery of kings as far as the flight of angels on the top of the pinnacles. Henceforth it also populated the interior of the church.

Star of the sea, here is the heavy cloth
And the deep swell and the ocean of wheat
And the shifting foam and our laden granaries,
Here is your view of this immense cope.

A man from our midst, from the fruitful glebe,
Made spring up here in a single capture
And from a single source and a single bearing,
Towards your assumption, the spire unique in the world.

Tower of David, here is your tower of the Beauce:
It is the hardest ear of wheat that ever grew up
Towards a sky of clemency and of serenity
And the most beautiful floweret within your crown.

A man from our midst made spring up here,
From the level of the ground right up to the foot of the Cross,
Higher than all the saints, higher than all the kings,
The faultless spire which cannot flinch or fall.

Péguy, The Tapestries, 1913

THE SOARING GOTHIC STYLE

It is well known that until 1250 the evolution of architecture... can rightfully be interpreted according to the evolution of building techniques. Yet the technique which made possible the nave of Amiens and the choir of Beauvais did not make them necessary. If the vault continued to rise higher, if the glass windows continued to spread, was it merely to be pleasing to the eye, or for the pride of the bishop or city alone, or rather because art ceaselessly perfects the trap which is to capture the uncapturable promise. This art is no more separable from the impulse which sustained it, nor more "immobilizable" than the aeroplane in flight is separable from its flight. It is only the expression of the divine because it is the conquest of the divine, always unfinished.

Malraux, *Métamorphose des dieux I*

Vault of the cathedral of Reims, France, twelfth century
© Lauros-Giraudon

FROM THE FOURTEENTH TO THE EARLY SIXTEENTH CENTURY

From high to flamboyant

■ The Fourteenth Century

In the fourteenth century the world was discovered with Marco Polo, and the literary treasures of antiquity with the Arabs. This century revealed its creative urge in Italy, as Dante illustrates in *The Divine Comedy*. The Franciscans spread the science of their *subtle doctor,* Duns Scotus, along with the charity of Saint Rock.

However, great trials came to disrupt the games of courtly love and remind people of the presence of death in the midst of diversion: the disasters in war (Crécy 1346, Agincourt 1415), the scourge of the terrible Black Plague (1347–49) which struck one third of the population of Europe, and the sorrow of the Great Western Schism which left two pretenders for the See of Peter (1378–1411).

Yet the building of great cathedrals begun in the previous century continued with the same skill: Rouen, Sées; then in England, Exeter, York, Gloucester; in Spain, Gerona; in Italy, Siena, along with the great churches of Nuremberg and Fribourg.

The fourteenth-century virgins and statuary are distinguishable by their quality.

Grisaille (gray) compositions and the use of golden yellow attenuated the glare of the lights and simplified the composition of the stained glass.

■ The Fifteenth Century

The fifteenth century saw the invention of printing and ended with the discovery of America. A succession of contrasting events characterized it: the epic story and martyrdom of Joan of Arc, the brilliant Italian Renaissance, but also the burning at the stake of Savonarola.

In this late summer of the Middle Ages which broke up the foundations of feudal society, a new place was being sought for human beings in the universe and in the organization of society. The Burgundian and Flemish influence of the Van Eycks, R. Van der Weydens and Memlings prevailed in the Western art of the time. It was sensitive to the framework of daily life, to the rendering of material substances, and to the effects of light.

Matthias Grünewald, Retable of Issenheim when closed © Giraudon-Unterlinden Museum, Colmar, France.
By the light of the prophecies, John the Baptist points to the Lamb which, through harrowing torments, saves humankind.

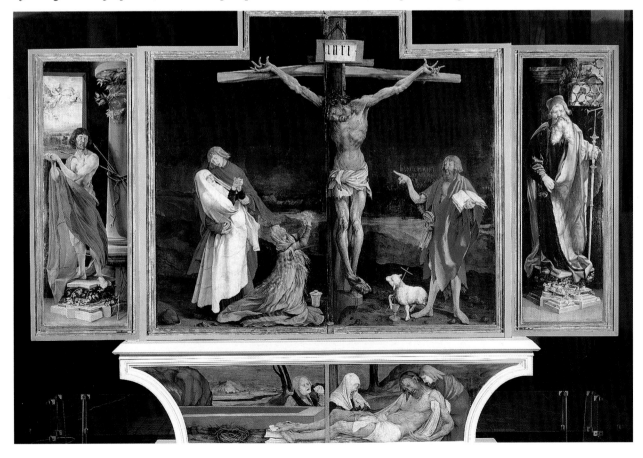

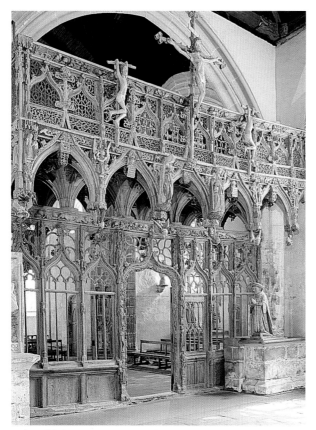

Jube of Saint-Fiacre, France © Pix-J.P. Lescourret

■ Affective Piety

The movement of ideas affected thought as much as the arts in search of novelty: *devotio moderna* of Meister Eckhart, *ars nova* in music.

The *Meditations on the Life of Jesus Christ* spread by the Franciscans inspired painters and sculptors.

In Brittany, the monumental calvaries of the fifteenth and sixteenth centuries depicted the mysteries of Christ's childhood and, in contrast, the unfolding of the passion, the Way of the Cross, the entombment, the descent into hell, and the resurrection.

Franciscan spirituality brought a more sensitive expression of the Virgin Mother. She was still the Mother of the Word who adores her newborn son and who is crowned by the Trinity, but also a young woman happy to envelop with tenderness the nursing infant whom she cradled and invited to smile.

■ Pathos

The religious themes and their artistic treatment felt the effects of the repeated threat of death. When death struck, Christians recalled with Mathias Grünewald and his Issenheim reredos, for example, that for their salvation Christ went through agony and desolation. The expression on this face in which suffering humanity revealed the divinity of the crucified man became powerfully moving. Wounded by the woes of the time, sculptors

were sensitive to the affliction of those close to him, to the lamentations of his mother, to the participants in the entombment, whom they captured in the postures of those acting in the Passion plays in the cathedral squares.

The sculpture of the recumbent statues accentuated the realism of the faces (whose imprint had been taken from the very face of the deceased), the copying of their clothing and the effect of compassion given by the procession of weeping mourners.

At the same time the architectural forms evolved. The capitals were scaled down and the arches merged into the cylindrical pillars. The ribs of the vault subdivided into ribs which were more and more slender, as is illustrated by the Anglo-Norman arborization. The network of windows formed shapes like shifting flames which caused this autumnal period of Gothic architecture to be described as flamboyant. Architectural rigor was forgotten to the advantage of the decor. The decorative wealth, the intricacy of forms, the search for expression conveyed a certain mannerism.

Monumental sculpture carved in the stone of the porches was abandoned, while interest focused on the polychrome wooden reredos, the painting of faces, familiar scenes, and landscapes.

"Art and history can reveal to our being the depth and simplicity of Christianity… If one remembers that gold in medieval painting represented the world of the divine, of the invisible Trinity, what do we see? At the top of the painting is written in gold on gold, "O vos qui transitis per viam, attendite et videte si est dolor sicut dolor meus" ("All of you who pass by this way, see if there is a pain like my pain"). In the heart of the Blessed Trinity resounds eternally the song of infinite pain of the Virgin Mother who, below, holds the body of her dead son. We penetrate into the very center of the wound which is inscribed in the heart of the Trinity and in human suffering…"

Dominique Ponneau

Pietà from Villeneuve-lès-Avignon, Quarton Enguerrand, Louvre Museum, France © RMN - R.G. Ojeda

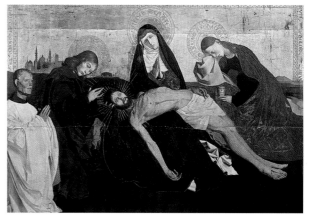

6. Sixteenth-Century Churches

New symbiosis between ancient culture and faith

QUATTROCENTO

While the rest of Europe was still exploring the possibilities of Gothic art, Italy, after Giotto, Simone Martini, and the Lorenzettis, was already discovering in the fifteenth century the ways of the Renaissance with the painters Masaccio, Fra Angelico, Ucello, Piero della Francesca and Boticelli and the sculptors Ghiberti and Donatello.

The latter had broken away from the scholastic vision of the world and been won over to Platonic ideas. They sought to reconcile humanism and faith, like Ficino who declared himself *"ex pagano miles factus sum,"* "from the pagan that I was, I have changed to being the soldier of Christ." They sought an objective knowledge of the natural world of which the human person is the center. The studies of the unique central perspective of Ucello and Piero and the optical box of Brunelleschi led to an accurate perception and reproduction of bodies in space. The same preoccupation with harmony and proportion guided architects in Florence. Moreover, the rediscovered treatises of Vitruvius revealed their reference points in antiquity. Brunelleschi in San Lorenzo and Alberti in Santa Maria Novella re-adopted with order and reason the classical modules : the pilasters and capitals, the ancient architraves and pediments for the new basilical or 'hall-like' churches.

San Lorenzo, Florence, Italy

THE ITALIAN SIXTEENTH CENTURY

These innovators had the same humanistic ideal and were conscious of handling the legacy of Rome, the center and head of

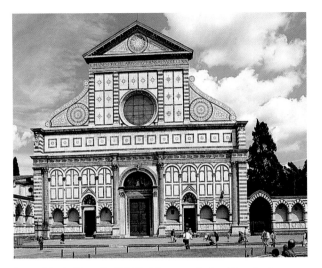

Santa Maria Novella (1470), Florence, Italy. Alberti takes advantage of classical clarity and elegance.

the world, at a time when the Papal States were regaining vitality. The promotion of the new art shifted from Florence to Rome with Leonardo da Vinci, Michelangelo and Raphael, whose paintings of churches, of the Sistine Chapel, and of private rooms made their mark on the entire century. Certain people were to give substance to the plans of Nicolas V proposed by Alberti and to the wishes of Julius II and Leo X.

"There, in this contrasted world of the popes and their entourage, in which licentiousness and the desire for reform rubbed shoulders, over and above these vicissitudes, this fermentation and this astonishing mixture of good and evil, an Olympian art of a grandeur and serenity in keeping with the purest ideal of Classical Antiquity was becoming firmly established in Rome with the authority and fervor of a new religion" (Maurice Denis).

In 1502, Bramante, after his creation of the *Tempietto,* which was inspired by the Roman antiquities but decorated with metopes symbolizing the liturgical instruments, endeavored to build a new Basilica of Saint Peter. It was a monument comparable to the arches and columns of the monuments to imperial triumphs, but this time it was to the glory of their most glorious martyr and of the Church founded on him and the apostles. At first designed in the form of a Greek cross on a square, flanked by four towers and topped by a dome, it used the cosmic symbols again. Raphael, the successor of Bramante, and the Florentine San Gallo then adopted the Latin cross design; finally, Michelangelo raised up the emblematic dome of the Roman Church.

SHADOWS THROWN ON NEIGHBORING COUNTRIES

The Italian wars won the royal court of France over to the new art and, between 1509 and 1589, the court applied it

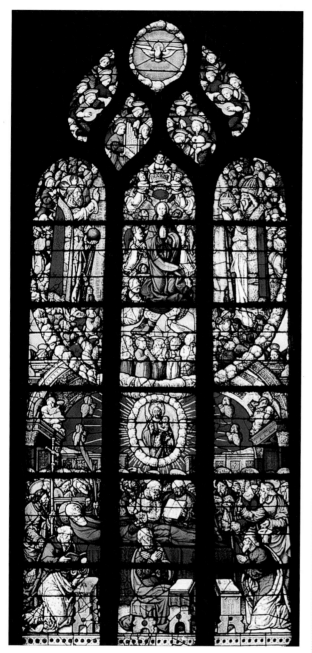

Death and Crowning of the Virgin, Notre Dame du Cran

Rome. The political and religious disputes became exacerbated to the point of provoking the wars of the League.

And yet this century was also the century of Teresa of Avila, the reformer of the Carmel; of Ignatius of Loyola, the founder of the Jesuits; and of Francis Xavier, the evangelizer of Japan. It was the century of the Council of Trent (1545–63), which vigorously outlined a reform of the Catholic Church based on a theology of the sacraments, the formation of the clergy, and the education of the faithful. This council had a powerful impact which bore fruit until the eighteenth century and beyond.

THE FORMS

In most Western countries the new architecture did not show its worth in religious art. An ornamentalist period continued to build Gothic edifices with intersecting ribs and flying buttresses, adorning them with medallions and pilasters, balusters, arabesques, and grotesque decoration. There was a preference for basket-handle arches, domed or lantern steeples. Then, in the time of Henry II of France, there was a more systematic application of the Greco-Roman orders and of domes which, all the same, did not yet produce a new type of church.

The art of the stained-glass window underwent a renewal. In the place of the fragmentation of the mosaic and the cutting up of its legends, artists composed in great tableaux, and applied themselves to the finesse of painting and to less dense shades of color. The subjects were still those of the passion, the tree of Jesse, and the lives of the saints.

Calvaire de Guimiliau, France. The torments of the passion

to its buildings, mansions, and country chateaux rather than to the churches. It is true that the French provinces had renewed their cathedrals whose Gothic forms were to survive for a very long time. The court of Francis I, where the things of antiquity delighted an élite enamored with the joys of the spirit and with Epicureanism, called preconceived ideas into question.

Outside Italy the church buildings, statuary, and images, as well as Church society, were subjected to the criticism of Protestantism. Martin Luther "protested" against indulgences. Henry VIII of England went as far as another schism. Calvin established his theocracy in Geneva in opposition to

7. Classical and Baroque

The splendor and majesty of the Catholic Church

THE CATHOLIC REFORMATION

The effect of the Council of Trent, its definitions and decrees, little by little affected the entire Church. Faith, revived by the parish renewal and the preaching of missions, roused the Christian world. The archetypal figure of the Tridentine renewal, Saint Charles Borromeo; the founder of the Oratorians, Saint Philip Neri; and the theologian Saint Robert Bellarmine all contributed to this spiritual momentum. After the expansion of the Company of Jesus and the reform of the Carmelite Order came the Sulpicians, the Maurist Benedictines, and the congregations founded by Francis de Sales, Vincent de Paul, Bérulle, and John Eudes. In its own way the Jansenist movement of Port-Royal fostered the profound religious preoccupations of the time. The conciliar movement oriented artistic creation. Chapter six of the twenty-second session of the council, which treated of the celebration of the Mass, recommended the solemnity of Catholic worship, whose grandeur encouraged the faithful to contemplate the most lofty realities.

BIRTH AND EXPANSON OF THE BAROQUE

Italy, which had introduced the Western world to the Renaissance, was the first to be affected and gave expression to a new current accentuated the reformist movement and reacted against its harshness. This current involved an opening up to the imagination and simultaneously an art of living and a setting for this life. Several architects of genius such as Bernini, Borromini, and Caravaggio made Rome into a great theater, typified in the Piazza Navona. Saint Peter's was adorned with its baldachin, its glory, and its colonnade which opened out its arms maternally to welcome the Christian world on *ad limina* visits, and then strewed it with works of similar spirit. These works won over Venice, making of the *Salute* an intercession against the plague. Vienna and the Empire, Poland and the south of Spain and thereby America, blossomed with many churches in anticipation of the expansion to the east through Prague in the eighteenth century. The brilliant and voluptuous works of Rubens and those of Rembrandt, interiorized by *chiaroscuro,* expressed on canvas the same Christian glory and faith.

The baldachin of Bernini, Basilica of Saint Peter, Rome, Italy
© Alinari-Giraudon

IN FRANCE

In France the *grand siècle* (seventeenth century) opened with political and social unrest, the revolt of those in high places, the ambition of the bourgeoisie, and rural turbulence… above all a deep aspiration after grandeur, the achievement of honor, and scientific discovery. It was the century of "El Cid," and the "Discourse of the Method," that of Pascal, a century of a vigorous surge of thought.

However, at the court of the Sun King in Versailles, the sensibility inherited from the princes of the Renaissance, with its dazzling celebrations, splendor, and enthusiasm for renewal was expressed in architecture, music, and painting by an escape from constraint, a sweeping movement, and a free expression and theatrical utilization of the imagination. Ostentation did not dull the feeling of insecurity and transience and did not mask the inescapable approach of death. The striking portrayal of the latter belonged to the conventions of funeral orations.

The inebriating practice of *"Do as you will"* provoked the reaction of the monarchy in a call to order. This engendered in the arts and letters the rule of the three unities, architectural symmetry, and the axis which organized the single object or image into a hierarchy – a taste which was called Classical. It ordered works in which sober adornment punctuated a static and severe architecture.

In the course of the seventeenth century, artistic creation oscillated between two poles – excess and moderation. These two tendencies, Baroque and Classical (not always easily distinguishable), were the motors of religious art. Sometimes the inebriation of flights of fancy, of the straight line eluded, of volutes and of color prevailed. Sometimes the predominance of a stable and balanced architecture satisfied the more Cartesian spirit which raised its eyebrows at the movement which "disrupted the lines." Be that as it may, this religious art was always in tune with the preaching of a Bossuet or a Bourdaloue, for it had the same sense of the grandeur of the Church and of its faith.

The Church of Saint-Nicolas-de-Véroce, France © Pix-V. d'Amboise

VOCABULARY OF BAROQUE ARCHITECTURE AND FURNITURE

Outwardly, it was the art of accentuating the effects of sun and shadows through the projections of the porches and sacristies, the relief of the columns and pilasters all along the edifice, and on high, by the orders, their superimposed pediments, and then the lamps and lanterns of a powerful dome.

A similar concern for brightness influenced interior architecture.

The oval, the ellipse, the spiral and the volutes prevailed over the circle and the straight line. The decor was enriched with crosses and a thousand symbols, surrounded by *putti*, arcades and pediments.

The congregations were given access to the liturgical celebrations. For the benefit of the faithful the rood screens were taken down, the choir and lateral chapels opened widely onto the nave. Under a ceiling painted in *trompe-l'oeil*, the spacious nave opened almost directly onto a choir which was wider than it was deep, and lined with low stalls, with a simple bench for the liturgical presider. Thus this organization of space asserted the unity of the place.

Choir of the church of the Gesú, Rome, Italy © Alinari-Giraudon

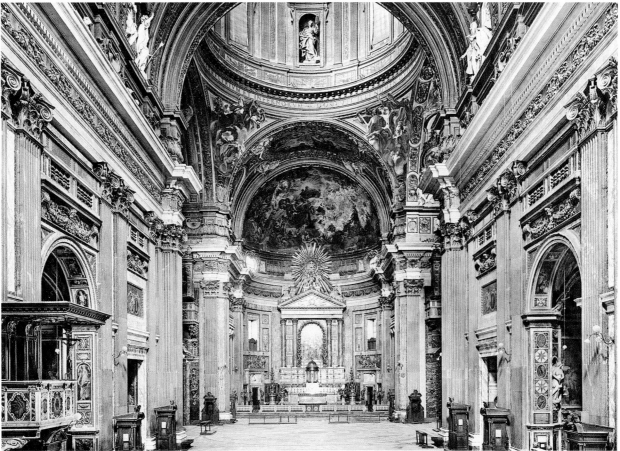

Baroque Choir and Altar

With a profusion of gold, the wall of the chevet was decorated entirely with high paneling or polychrome marbles. Painted canvasses and statues imposing in both size and movement depicted the mysteries of Christ or the triumph of the saints in the center of the monumental reredos.

Tridentine faith in the saving mission of the Church of Peter was expressed in the imposing unfolding of the eucharistic celebration. Emphasized by a baldachin or a monumental reredos, the altar, in the form of a long beautifully shaped and inlaid tomb, occupied the center of this widely opened choir. A focal point for the faithful, this altar presented itself as the instrument of the victory of the Catholic Church over error and the rallying point of the churches militant and triumphant.

In answer to the "Protestants," who reduced the Last Supper to a pious remembrance, the heightening of the tabernacle and the throne of exposition on the high altar asserted the Real Presence of Christ both in the Consecration and the Communion at Mass and in his continual presence for perpetual adoration.

The Catholic Reformation and the Baroque style illustrated by Bernini in Rome introduced even into rural churches a sculpture which conveyed the majesty of the Church and its saints. All along the lateral chapels, and equally behind the high altar, retables depicted the heroes of the Catholic faith and, following Tridentine recommendations, the mysteries of Jesus and Mary. With this same aim, the architectural constructions, splendid with golds and colors, framed a central tableau of figures with sweeping gestures under a pediment and its support of quadruple columns. Daylight, no longer filtered by stained-glass windows, accentuated the reliefs with its oblique lighting. This theatrical art was organized to depict an edifying theological theme. The thrust of the marble shafts, the twisted movement of the cabled columns and, high above, the angels, the glories, and the Eternal Father in the clouds expressed the triumph of the heavenly and earthly Church better than the oratorical art. Or rather they accompanied it. For the doctrine of

Retable of Our Lady of Mount Carmel from Trémaouezan, France

the faith was explained and commented upon from a majestic pulpit installed for the preacher, just as the council had stipulated.

For the renewal of the sacrament of penance, furniture was lined up along the aisles. An octagonal canopy erected on columns emphasized the grandeur of baptism.

If the new educational method and taste were primarily directed at vision and the mind, they also aimed at captivating all the senses. The organ was the requisite instrument for linking the decor and the liturgical production with the effects of the new music of the Couperins, Charpentier and Bach.

ROCOCO AND NEOCLASSICISM

■ Influences

The rationalism of the Age of Enlightenment, the philosophical spirit of the influential bourgeoisie, hampered the surge of faith. Furthermore, economic difficulties restricted the splendor of religious buildings. Yet Christian faith still sustained a large part of society and marked it with a deep spiritual life. The new congregations of the Brothers of Christian Schools, of women religious devoted to works of charity and the Conference of Saint Vincent de Paul were a factor in this resistance to change.

■ Evolution of the Arts

Italian art spread throughout Europe as far as Prague and Poland. Beyond Vilna, it was to make its mark on the new capital of Peter the Great in Saint Petersburg with the touch of Rastrelli.

Organ of the church of Weingarten, Germany

As they spread to different countries the plastic arts prolonged the finely shaded styles of the previous century, which are illustrated in the Baroque of Versailles and the Classical colonnade of the Louvre. This double expression was to differentiate itself more and more in the rococo style, heir to the Baroque, and in an abstract Neoclassicism. It was also noticeable that, if the belfries and palaces had previously drawn inspiration from church architecture, from now on it was the churches which imitated the princely residence.

The rococo exuberance blossomed especially in the palaces and their salons, for a sophisticated society. It shunned symmetry, the straight lines and their intersections, and level surfaces in order to get tangled up in the arabesques, undula-

Church of Saint Isaac, nineteenth century, Saint Petersburg, Russia

tions and clouds of the ceilings, as well as the embellishments everywhere of a careless extravagance of feminine grace whose colors had the delicate shades of pastel and watercolor instead of the contrasted brightness of the royal golds, blues, and reds. It was an art which was more in harmony with fashionable and worldly receptions than with sacred liturgy.

With the exception of Germanic or Praguian churches like the monastery of Ottobeuren or the pilgrimage of Einsiedeln, this style was not often adopted. There, as in the Bavarian church of Wies, the curved line brought rippling façades, designed onion-shaped domes above the towers, and gave an oval shape to cupolas and bays. Above the whitewashed walls, which in their simplicity represented the celestial square, a dazzling decoration of gilding, stucco and luminous frescoes, along with the changing forms, evoked the celestial world.

■ Neoclassicism

Rather than the spruce rococo and the rocaille (shell-patterned) decor of the salons, religious architecture exploited a Neoclassical trend. Engineer architects designed spacious churches like the great market halls, with Doric columns and regular archways, uniformly arched windows without stained glass, and string course paneling and pilasters replacing the retables. On the outside there were façades with columns and Greek pediments.

■ Sculpture

The religious sculpture of the Classical eighteenth century also produced elegant masterpieces of distinction which were often devoid of spiritual inspiration. *"The taste for the styles of antiquity which followed the French Revolution was foreign to the efforts of a Christian renewal. The angels have become victories for the first time, or once again"* (M. Denis).

Nostalgia and borrowed art

THE CURRENT CLIMATE

The aftermath of the French Revolution deprived religious art of means and often of inspiration, when the Concordat and the new map of dioceses and parishes were set up. The politico-religious confusion, practical or self-confessed unbelief, the anticlerical laws of Combes following those of Jules Ferry (closing of convents in 1880, and of religious schools in 1902) and the de-Christianization of the working class sorely tried the Christian world.

Yet the situation was not as gloomy as it seemed. A certain renewal touched the Church in France, including the Catholic movement of 1830, the preaching of parish missions, the activity of Xavier de Maistre, Lamennais, and the influence of Montalembert, Lacordaire, and Ozanam. Social action groups moderated the disaffection of the proletariat. The sanctity of the Curé of Ars and the liturgical work of Dom Guéranger were oases of spiritual life. Female religious congregations were founded and vocations to the priesthood and the missions increased right up to the Second World War. A burst of missionary zeal fostered by the Congregation for the Propagation of the Faith took many priests off to North America and Africa. Religious devotions flourished; the dogma of the Immaculate Conception was proclaimed in 1854, and the appearances of the Virgin Mary to Catherine Labouré, and then to Bernadette in Lourdes (1858) revived the pious brotherhoods of the "Children of Mary." After the ordeal of the 1870 war, bishops encouraged the devotion to the Sacred Heart linked with the appearances to Margaret Mary Alacoque.

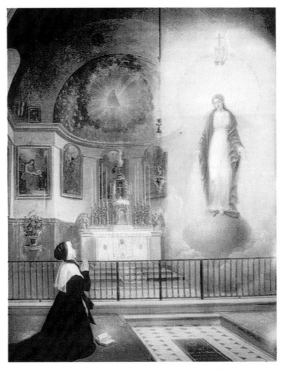

Scene of the appearances of the miraculous Virgin to Catherine Labouré

These sources of Christian vitality explain the rebuilding and enlargement of numerous churches, which nevertheless did not inspire new forms. The century of rationalism and archeology did not have an art of its own.

ROMANTIC INSPIRATION

In the second half of the nineteenth century, the fascination with the Middle Ages communicated by Chateaubriand, Victor Hugo and the like, gave rise to a nostalgia for the Christendom of bygone days in the hearts of Christians wounded by the atheism of the previous century. These muddled aspirations and the archeological work of Viollet le Duc were to produce churches in medieval style in the regions which had recovered from the revolutionary upheaval.

However, religious art gave only a pale reflection of the authentic spirituality underlying this past. For lack of inspiration or commissions, painters and sculptors such as Corot, Delacroix, Puvis de Chavannes, and then Gauguin, Van Gogh, Rude or Rodin, produced very few religious works. Musset had already written, *"We have not placed the seal of our time on our houses, or our gardens, or on anything. We look upon the styles of all centuries save our own."* The patronage of the Academies, of the administration of the Beaux-Arts, the mechanical reproductions of a piously sentimental statuary, known as "Saint Sulpice" art, expressed the divorce between Christian society and living art.

Research at the end of the millennium

CONTEXT

Scientific and technical progress and the increase in the means of communication modified living conditions without reducing inequality. Yet, from the beginning of the century, the competition among ideologies had given way to new perspectives. The Church's apostolic life was not limited to the clergy's activity. Catholic action developed in all the sectors of social life. The philosophy of Bergson opened out onto the spiritual world. Péguy, Claudel, Mauriac, Bernanos, Pierre Emmanuel indicated their faith as the deep source of their inspiration. Similarly, in the domain of painting Rouault, Maurice Denis, Desvallières, then Bazaine, and Manessier were at the origin of a renewal of sacred art.

The Second Vatican Council, convened by John XXIII in 1962, assembled more than two thousand conciliar Fathers and outlined the *"aggiornamento"* of the Church and the updating of the Christian message in the present-day world, along with its liturgy, ecumenism, and religious freedom.

Now it was a matter of communicating its spirit to the confused world at the end of a millennium which has been overtaken by sects, fundamentalism, syncretism, as well as practical materialism. The situation of religious practice, vocations to the priesthood and the visibility of the Church in society, its cultural component, have raised worrying questions and prompted Christians to make the effort to go back to their roots.

■ Materials and Forms

In the suburbs and in towns which have been the victims of war new churches have been built. Their design was inspired by the directives of the Second Vatican Council, which encouraged the active participation of the faithful in the liturgy. Thus the structures tend to have forms which encircle the altar more closely with a shorter rectangular, semicircular, or trapezoid form.

Breaking with academism, religious architecture and stained glass have striven to renew themselves, just as secular painting has done. The use of new materials has favored this

Notre Dame du Haut, Ronchamp, Le Corbusier, 1952-55, France

Church of the plain of Assy, France
with the litanies of F. Léger

Stained glass by A. Manessier, Notre Dame
de Bonne Nouvelle, Locronan, France

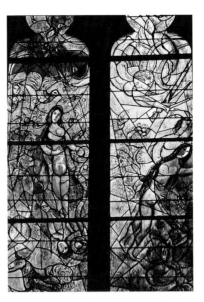

Stained-glass window of the cathedral of
Metz, France, 1960. Marc Chagall
evokes the lights and the shadows of the
first days

change. Auguste Perret innovated with the use of concrete at Le Raincy in 1922. Dom Bellot, Emil Steffan, and the Swiss architects have broken new ground. Church art has been nourished by contemporary painting and sculpture. The church of Audincourt on the plateau of Assy, graced with the works of Rouault, Chagall, Germaine Richier, Braque, Bonnard, Léger, and the chapel of Vence by those of Matisse, Ronchamp, and Le Corbusier are manifestos of contemporary sacred art. The review of Fathers Couturier and Régamey has made them known to the public, acting at the same time as a means for educating and purifying religious tastes.

Villon, Bissière, and Chagall designed the stained-glass windows in Metz; Bazaine, Manessier, Le Moal in Saint Séverin, in the Cathedral of Saint Dié, and in Brittany; Ubac, F. Rouan, Albérola in Nevers. Barnett Newman and Mark Rothko combined their talent as sculptors and painters in building the Rothko chapel in Houston in 1971. Tadao Ando built a church of contemplation and light in the Japanese tradition in Osaka.

Will the new blossoming of architecture illustrated by the Arche de la Défense or the Pyramid of the Louvre, or the creations of Portzamparc or Nouvel, also be expressed in the creation of churches adapted to the art and the liturgy of today, as living signs of the faith for our contemporaries?

A SPIRITUAL EDIFICE, ORGANIZER OF SPACE AND TIME

After the edifices whose modesty was imposed by economic constraints, the recent cathedral of Evry by the architect Mario Botta illustrates the return to monumental forms and the concern for the existence of religious landmarks in the city. In the form of a vast cylinder almost forty meters in diameter it is situated in the midst of administrative buildings. Starting at their level, its oblique section raises its crown of trees and its cross up to twice their height. A center for the organization of urban space, it situates the new town in time:

"Historical time: the brick dressing underpins ancient forms of brickwork in a contemporary composition… seasonal time, indicated by the crown of trees, solar time for the sun turns around the edifice and its light is reflected by the regular rough patches on the wall, hourly time marked by the bells. Time passes peacefully here; it is regular, consistent. Aging is not a problem, each hour is different. Such a serene relationship with time which passes and in which continuity and perpetuity dominate. 'The vessel of the Church holds its course in a whirlwind of an epoch, certain of the promises of eternity and immersed in time…' At the same time as the cathedral gives cohesion, it affirms a separation: It presents itself as an impregnable keep with a dense, impenetrable, high wall. The cylindrical form has no façade. The ground floor is closed, our eyes slide off the outer wall. The edifice indeed introduces an event in equilibrium with its summit and with the cross, a projection which breaks the cylinder, but this projection does not indicate any access. It is more of a monumental and weighty prow. Its geometry and weight thus powerfully define this place as if to resist…

Why what appears at a distance to be an austere and impenetrable fortress? If I now approach the circular wall and walk alongside its brick dressing in staggered rows, it seems to me that this wall is not hostile, but that it is 'flesh,' a substance more moving than a glass surface, for example, which would allow one to see the inside through a cold and delicate material. The surface gives closely the reassuring and pacifying feeling of a presence, of an attentiveness...

In the interior the light is natural, the material of the inner wall is the same as that of the outer one, voices and faces are not distorted. The universe of the cathedral is not therefore a flight from reality, whereas perhaps the universe of the town is in search of artifice and illusion... Is it due to the smoothness of this hull which rises up above the congregation? Is it due to the intensification of light which at one and the same time reinforces the feeling of being enveloped and the focusing of our gazes on the low vault of the altar? Is it the feeling that everything has been built with care, attention and discretion? Is it the feeling of weight and density which peacefully return to the earth? The fact remains that this luminous and spiritual inner space enables man to find himself again, in his reality and in his heart, in the midst of a congregation..."

Nicolas Westphal, *Etudes* 1, 1996

INSERTION IN NATURE

■ Hokkaido
Nature and the sacred temple are one. A glass cube fitted with four crosses rests on another cement cube which serves as a nave, and whose fourth wall opens out completely onto the water of a lake into which a cross plunges before the eyes of the faithful. Thus earth, water, light, time and the seasons, the square and the cross, are the first symbols which invite to meditation on creation and redemption.

■ Osaka
This church is made up of a right-angled parallelepiped corresponding to three spheres of 5.9 meters in diameter. This volume is intersected at 15 degrees by an oblique wall which traverses it without ever fully joining the main volume. A shaft of light separates them and distributes a low-angled light along the cement walls causing the matter to shimmer. This light is accentuated by the intersection of the two open-

ings in the form of a cross, which carve up the east wall completely. This light illuminates the nave and is its sole embellishment.

REPRESENTATIONAL OR NONREPRESENTATIONAL ART?

"In a Christian perspective of non-representation I prefer to mention one image only. Everyone knows that of the Turin Shroud... Its symbolic power remains and for many it represents the face of Christ. Now this image of the Crucified with closed eyes was photographed for the first time in 1898, at a time when figurative representation was to wear itself out and then burst out in art, at the time when war was going to have everyone be a witness to the worst possible deformations of humanity. Everything happened as though, all at once, in the domain of art, of thought, of religion, a threshold had been reached where, perhaps momentarily, the possibilities of figurative representation of a humanity of whom nobody knew any longer exactly who he was had been exhausted. Then this image of man among men, the Son of Man, just before the moment either of his definitive decomposition or of his glorious Resurrection, suddenly appeared.

As if from then on there was therein the sign of another quest, and the faith of the Church no longer needed to innovate in the domain of forms and images.

And yet the Church believes and will always believe that the human person is a holy, sacred, eternal creature in the image of God. But after so many horrors must God still be represented as a man, with a face and a body? Anthropology, for its part, would no doubt need to make strange progress so that the Church be able once again to represent humanity in a way that is not twisted by a grimace..."

Dominique Ponnau

Notes taken by J. F. Pouse for *Techniques and Architecture* no. 405.

*P*ermanent Church Signs

Concelebration in the abbey church of Landévennec, France. The Church is convoked and gathered by Christ, through his Eucharist, around the altar that represents him.

Church architecture and furnishings have become more or less perma-
nent signs linked to their liturgical function and to the continuity of the
faith. They have done this through their forms and their successive sym-
bolisms. Consequently it is necessary to consider each of the elements
common to the old and new structures and to interpret them symboli-
cally. The ritual for the consecration of churches calls on the foundations
of their symbolism. The different parts of churches and their functions
are recognized from the outside inward in the following manner:

1. Symbolic consecration of a church
2. The surroundings which are considered to be sacred
3. The church in its setting
4. Voices of the church
5. The gates
6. The baptistry
7. The nave
8. The organ
9. The meaning of the paintings, the stained-glass windows and the
 statues
10. The choir and the presider's place
11. Celebration of the Word
12. The altar
13. The lamp
14. The reserved Eucharist
15. The sacred vessels
16. The liturgical vestments

STONES OF THE EDIFICE

Through his death and resurrection the Savior became the true and perfect temple of the New Covenant. The Church considers itself to be the edifice of which Christ is both the architect and the cornerstone (Matt 21:42; 1 Pet 2:8). The apostles are its pillars (Eph 2:6). As Vicar of Christ, Simon received the mission of becoming Peter, the rock on whom Jesus built (Matt 16:18). Each member of the Church is, in turn, one of the stones which make up the city of God (1 Pet 2:5).

Because it is a visible edifice, the house in which the church assembles to hear the Word of God, pray in common, celebrate the sacraments, and celebrate the Eucharist, offers a distinctive sign of the pilgrim church on earth, and an image of the church in heaven.

When a church is erected… it is good to consecrate it to the Lord through a solemn rite, according to the very ancient custom of the Church.

Rite for the Dedication of a Church

Spiritually, the Church is also built of living stones

OPENING OF THE DOOR

The procession of the faithful and the clergy gathers at a distance from the new edifice; its doors are closed. Those who worked on the construction of the building present to the bishop the keys, the plan, or a model of the church. The bishop strikes the door with his crozier while everyone sings, *"Open up, eternal doors, let the king of glory enter"* (Ps 24).

Left: Choir of the cathedral of Beauvais opening to the light of the rising sun

On the invitation of the bishop the procession enters the church singing the psalm which accompanied the Jews' ascent to the temple:
"Now our feet are standing at your gates, O Jerusalem!" (Ps 121).

The first rites are modeled on those of baptism. The bishop traces on the ground the sign of the cross whose arms embrace the universe. Formerly he would inscribe letters of the Greek and Latin alphabets; Greek and Latin were the two languages of the Empire and, at that time, of the universe.

SPRINKLING WITH HOLY WATER

This sprinkling of the faithful, the walls and the altar recalls the sanctity of Christ to which all the baptized are called: *With your blessing, sanctify this water which you created. When it is sprinkled on us and on the walls of this church, may it be the sign of the saving bath which washed us in Christ so that we may become the temple of his Spirit.*

The faithful give thanks, evoking the vision of John in the Apocalypse:
I saw living water flowing out of the heart of Christ, alleluia!
All those who are cleansed by this water will be saved and will sing, alleluia!
I saw the spring becoming an immense river, alleluia!
The children of God assembled there sang out their joy at being saved, alleluia!
I saw living water flowing from the heart of Christ, alleluia!
All those who are cleansed by this water will be saved and will sing, alleluia!

CELEBRATION OF THE WORD

"May the word of God resound in this place. May you discover here the mystery of Christ and the promise of your salvation in the Church," says the bishop, before the reading of the account of the inauguration of the Temple on the return from Exile (Neh 1-10) and a passage from the Gospel of Saint Luke (Jesus calling Zacchaeus down from where he was perched in a tree: *"Come down quickly, today I must stay in your house!"*).

PRAYER FOR THE DEDICATION AND ANOINTINGS

After having invoked all the saints who make up the heavenly Church,
and placed in a cavity in the altar the relics of some of these saints,
the bishop says this prayer:

This temple reflects the mystery of the Church.
The Church is fruitful, made holy by the blood of Christ,
a bride made radiant with his glory,
a virgin splendid in the wholeness of her faith,
a mother blessed through the power of the Spirit.
The Church is holy, your chosen vineyard:
its branches envelop the world,
its tendrils, carried upon the tree of the cross,
reach up to the kingdom of heaven.

The Church is favored, the dwelling place of God on earth,
a temple built of living stones,
founded on the apostles
with Jesus Christ as cornerstone.

The Church is exalted, a city set on a mountain,
a beacon to the whole world,
forever shining with the glory of the Lamb,
and resounding with the joyful songs of the blessed.

Therefore we humbly beseech you, Lord,
send your Spirit down from heaven to bless this church;
may it forever be a holy place;
send your blessing down on this altar,
that it may be a table always prepared for the sacrifice of Christ.

Here may your children, gathered around your altar,
celebrate the memorial of the Paschal Lamb
and be nourished at the banquet of the Word and Body of Christ.

Here may the poor discover your mercy,
the victims of oppression true freedom,
and all humanity be clothed with the dignity of the children of God
and enter with gladness your city of peace.

ANOINTINGS

The anointing of the altar stone recalls the one done by Jacob at Bethel. The bishop, accompanied by his ministers, proceeds to anoint the altar with holy oil (chrism) on its four corners and in the center, to symbolize Christ and the five wounds of the crucifixion, and then the walls of the church (the pillars as a rule), which symbolize the apostles, who are the pillars of the Church.

God of glory and holiness, all growth in faith and love comes from you.
Just as this oil anoints this altar and the walls of this church,
permeate with your grace and your joy
the living stones, which are the faithful who will come here
to live in communion with the mystery of Christ and his Church...

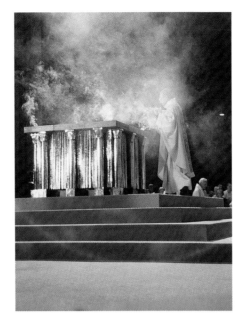

**Altar consecration
in the cathedral of Chartres, France**

INCENSING AND ILLUMINATION OF THE ALTAR AND THE CHURCH

The altar and then the walls of the church are incensed, and then all the lights are turned on:

Lord, may our prayer rise up to you
as this incense in your sight,
and as its fragrance fills this your dwelling,
so may your Church fill the world with the fragrance,
the joy and the grace of Christ.
May the light of Christ shine in the Church
and the fullness of truth be given to all peoples!

EUCHARISTIC CELEBRATION

The church and the altar were built in view of this continuous celebration. The altar is consecrated with the following words, but it becomes holy only after having received the Body of Christ. The prayer begins with a preface of thanksgiving to the Father:

Truly, it is right and fitting to give you thanks and praise;
you have made of the universe the temple of your glory,
so that your name may be glorified throughout.
Yet you do not disapprove that churches be consecrated to you
for the celebration of your mysteries.
Therefore we joyfully dedicate to you
this house of prayer, the work of our hands.
It is the reflection of the true Temple and the image of the heavenly Jerusalem;
for the temple which you consecrated yourself, in which the fullness of divinity resides,
is the body of your son, born of the Virgin Mary;
and the Church is the holy city which you have built,
founded on the apostles with Christ as the cornerstone.

You continue to shape it, adding new stones alive with the Spirit and united by charity
in order to realize the mystery of your dwelling in which you will be all in all
and the light of Christ will shine eternally.

Thus is the living presence of Christ asserted in the edifice built for the Christian assembly, to the glory of God.

Eucharistic celebration instituted on Holy Thursday

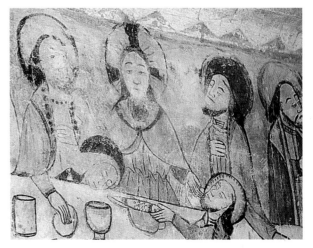

My house will be called a house of prayer.
Antiphon of the Dedication

2. Surroundings Which Are Considered Sacred

A monumental ensemble, a replica of the atrium and peristyle, surrounded early churches. It has survived in the case of rural churches and certain renowned urban complexes such as those of Pisa or Saint Peter's in Rome.

St. Peter's Square and its peristyle designed by Bernini open unto the basilica

THE ENCLOSURE AND ITS GATE

A low wall sometimes marks off the church enclosure and its outbuildings. It is inherited from the temple precinct (*temenos,* separated) and its forecourts which sheltered its holiness. It was perhaps a rural souvenir of the *burgus castral* (fortified enclosure around a castle or a town) intended for the protection of the people scattered over the surrounding countryside, and also of its sanctuary and cemetery. On either side of the doors a flat stone standing edgewise, the stile, was an obstacle to keep livestock out, but over which human beings could step and thus cross the boundary between the profane and the sacred. However, processions for weddings, baptisms, and funerals passed solemnly under the entrance arch of this main courtyard. For this atrium, around which everyone marches in procession on the feast day of the church or village's patron saint, is intended for the celebration of the beginning of life and the new life after death.

THE CLOISTER, AN ANNOUNCEMENT AND REMINDER OF PARADISE

A closed courtyard also flanked monastic churches or cathedrals. Bordered on four sides by a portico or covered gallery, it was attached to the buildings in which the monks, nuns, or canons lived. This cloister gave access to the church, the chapter room, the library, and the refectory. It was a place for walking and meditating around a garden, in which flowers and a basin of fresh water suggested the original paradise under the heavenly vault. Better still, its square shape was a reminder of the Jerusalem to come. The square design of the cloister under the dome of the sky, and the repetitive interplay of columns and arches made visible the invitation to pass from the earthly world to the heavenly one, and thus to climb through the different stages of the world from the depths right up to the highest heaven. Mural paintings and the sculptures of the capitals fostered this desire even further. The basin recalled the rivers which water the trees of life at the beginning or the end of the world; it sometimes enclosed a well which plunged into the depths of the water below.

FOUNTAINS OF LIFE

Just as in the basin of the atrium, in the vicinity of certain churches water welled up from a spring. A vestige of an ancient religion, it was assimilated into the Christian religion and could be identified by an unpretentious monument which sheltered under a canopy a narrow pool whose pediment bore the statue of Our Lady or of the local saint. One or several basins collected the running water as it spilled over so that it might not be wasted. Benches invited the pious to linger long enough to quench their thirst and pray... These fountains kept alive the cult of this primeval element *"which came up from the earth and watered the whole surface of the ground"* (Gen 2:6). Christians purified the magic rites intended to procure healing, the favor of walking or talking, seeing or hearing. They addressed their prayers to the

Reminder and announcement of the waters of paradise, the fountain in front of the church symbolizes the baptismal font nearby

God who caused the four rivers to flow out from Eden, and to the One who promised living water welling up to eternal life to the Samaritan woman, for he is the Fountain of Life of the Apocalypse (John 4:14 and Rev 22:1). The Church saw in sacred fountains a prefiguration of the baptismal font and Christian baptism, which is both purification and salvation, death and life.

A CLOISTER IN THE ELEVENTH AND TWELFTH CENTURIES

The cloister offered to the monks and nuns a contemplation of redeemed creation: *This natural oasis was a sanctified one, separated from the evil world surrounding it. It was a place in which the air, the sun, the trees, the birds, and the running waters regained the freshness and purity of the first days of the world. The proportions of this inner courtyard conveyed their participation in the perfection that the earth has not known since the Fall of Adam. Square, coordinated with the four points of the compass and the four elements of created matter, the cloister snatched a patch of the cosmos away from the disruption which naturally affected it. The cloister reestablished it in its harmonious proportions. To those who had chosen to retire there, it spoke the perfect, fulfilled language of the other world. Images ... sculpted on*

Peaceful space, the cloister evokes Eden for those who are going to celebrate the salvation of the heavenly Jerusalem

the cloister capitals were principally warnings.... Indeed the soul must not slack off in its tranquillity: the cloister was not an impregnable sanctuary. The soul had to stay attentive, alert for danger. For the omnipotence of God can come up against an adversary who resists it: Satan, the Devil, the Enemy.

Duby, *The Time of the Cathedrals*

PERSPECTIVES ON LIFE AND DEATH: CEMETERY AND OSSUARY

Nowadays the space surrounding the church is no longer reserved for tombs as was originally the case. Already at the end of the Middle Ages and up to the seventeenth century the cemetery was

Near the church, the cemetery, and the ossuary, in the expectation of salvation

used only occasionally. Nobles, priests, and everyone else after them wanted to be laid to rest in the church, in a funeral recess or under flagstones, as close as possible to the altar. It was necessary to free up space and collect the bones in a reliquary within the enclosure around the church. As a health measure, a court judgment of October 19, 1758, ordered that all burials take place outside the churches. The results of town planning moved them even farther away. The direction of the setting sun, associated with the idea of the end-times, had often determined the location of the ossuaries to the southwest. Thus a certain symmetry with regard to the church's axis disposed the baptistry, the place of birth, and the ossuary, that of death, on either side of the building. On the façade a narrow arcade and a recess hollowed out in the base of the wall made it possible to set relics down and bless them. Subsequently the ossuary was built separately in the church enclosure, with the same layout and openings on one or two sides. A utilitarian shelter evolved into a symbolic monument which changed in dimensions and purpose. The reliquary became a mortuary chapel for vigils for the deceased or for the eucharistic celebration offered for them. The decor of these funerary facilities was quite

in harmony with the Baroque spirit. Already after the Black Death of 1348 and the calamities of the time, the fifteenth century had expressed its obsessive fear of death in the frescoes of the *danses macabres*. Deep anxiety was stirred up by the preaching of the Catholic reform whose language and effects left their mark on the ossuaries: the skeleton of the *ankou* (death) and the warning inscribed: *HODIE MIHI, CRAS TIBI* (Today it's my turn, tomorrow it will be yours). The aim was not only to make an impression but also to incline people to conversion. As a reaction against Protestant opposition to the veneration of relics, the Catholic Church earnestly invited people to honor the remains of the dead as a sign of faith in eternal life: *"It is a good and holy thought to pray for the dead."* Brotherhoods set up to foster this cult had Masses celebrated for the souls in purgatory at an altar which gave an indulgence. The last funerary chapels associated the Entombment of Christ with the death and resurrection of human beings.

THE CHRIST OF THE CALVARIES, THE CONQUEROR OF DEATH

If the ossuary was placed to the west, toward the setting sun, the cemetery calvary stood in the light of the rising sun. In the enclosure as well as at the altar, Christ on the cross was situated to the eastern side so that the faithful, dead or alive, be turned toward the Savior. This calvary was the only cross to be found in the cemetery until the nineteenth century, when a cross was erected on every tomb.

From the fifteenth century, the calvary sometimes took on monumental proportions, particularly in Brittany. In the Church's concern for evangelization, it recalled the life of Christ from his conception right up to his resurrection, just as these events are celebrated in the liturgical cycles of Christmas and Easter. These calvaries, which are catechisms in image form, were useful for preaching during parish missions, and perhaps on the feast of All Souls.

The Calvary recalls the death and resurrection of Christ, the hope of the living and the dead

The towers of Jerusalem will be gemstones.

Antiphon of the Dedication

3. The Church in Its Setting

ORIENTATION

The nave of the building had a deliberate orientation. The sanctuary faced the direction in which the rising sun appears, the sun being the celestial symbol of the risen Christ, the Light which dispels the darkness. Origen wrote, *"You are invited always to look toward the east, where the sun of justice rises for you, where the light always appears for you. Thus… you will always live in the light of knowledge, you will keep the daylight of faith, you will always possess the light of love and peace."*

As a high place lifted up as a standard, the church calls the people together

The symbolic intention became clearly apparent in the Romanesque and Gothic epochs. The choir was built facing in the exact direction in which the sun appeared on the feast day of the church's dedication. The point at which its first ray fell on this particular day was marked on the floor of some cathedrals. Thus, for example, the different orientation of the abbey church and the parish church of Mont-Saint-Michel was due to the fact that they were consecrated on two different feasts of the Archangel.

The displacement of the nave in relation to the oriented choir of various buildings no doubt has several explanations; it could have been an adaptation to the stability of the ground, or to the site and its earlier buildings. Other theories, more appealing than they are confirmable, see in this the symbolic imitation of the bowed head of Christ on the cross.

The entrance to ancient temples, their peristyle, opened out to the rising sun. Would it be by association that in the Roman basilica the vestibule opened in the same direction?

In fact, contrary to the general custom, the chevet of the basilica was west-facing. At the altar the celebrant faced the faithful as the liturgical reform of Vatican II has mandated since then for the whole church. Thus the celebrant alone looked toward the east, whereas the faithful in the nave turned toward the west. Some Carolingian churches adopted the Roman custom of rounding the western wall into a semicircle, without relinquishing the primitive orientation. For this reason they had a double chevet.

Be that as it may, the physical orientation never diverted attention from the liturgical signs of the presence of Christ. The faithful turned their gaze toward the book of the Word and the eucharistic table.

If the monks or the clergy in the stalls did not turn toward the east, but instead prayed together in the choir, that is, facing each other, it was not only for convenience in song. It was also in recognition of that other form of presence of the Lord: *where two or three gather in my name.*

HIGH PLACES

Like many a temple, churches were often built on the heights. Their elevated position symbolized access to the celestial world. Mount Sinai (Mount Horeb), Mount Sion, Mount Tabor, and Golgotha itself were privileged places for encounter with God and for divine manifestations for Moses, Elijah, and Jesus.

Nonetheless, since human beings worship in the places where their life unfolds, churches increased in number, particularly in the plains. Gathering urban dwellings closely around them, the churches became the heart and soul of the city. By their towers, they continue to remind us of their origin as high places.

Verticality of the Gables, Towers, and Spires

Height was a characteristic of Christian edifices well before the building of skyscrapers. The ascending lines of the columns, buttresses, flying buttresses, windows, and pinnacles became more and more frequent. The towers, their spires or domes, corresponded with this vertical symbolism. Arches of all sorts, vaults, and cupolas outlined the shape of the heavens.

Like the tree and the ladder, the megaliths and Babel, these forms expressed a striving toward contact with the divinity.

Steeples and Bells

A symbol of worship, the steeple is a guiding landmark on the countryside's horizon. It stands out above the roofs of the town as a sign of recognition and of rallying of the local church. It reminds the Christian where home is. For every person who is conscious of an expectation, it is a call or a reminder.

Nowadays in new urban zones, high-rise blocks mask this landmark's physical and spiritual orientation. However, the new town of Evry in France has wished to endow the tight and confused network of its new agglomeration with this same reference point.

A church in the Spanish colonial style and town square in Mexico. Credit: Corel Photos

The material and shape of the steeples were inspired by the region and the epoch. They are topped with a crenelated shape or crowned with a balustrade, or sym-

Church of Saint Jerome, Taos Pueblo, New Mexico, U.S.A. Credit: Corel Photos

bolically in a four- or eight-sided spire which appears to penetrate the heavens, or with a dome whose shape is framed by the canopy of heaven.

Above the western portal the cathedral towers are the double vertical sign of life facing the horizontal rays of a dying sun. They recall as counterpoint the two columns of the temple which formed a gate for the sun. From their belfries the bells ring out, announcing joyfully the return of the light, or the celebration of the Liturgy of the Hours, or peace of heart when the night shadows lengthen.

A Bell Speaks:

It is good to pray from the bottom upwards, but it is also good to wrest with both hands from one's heart the blessing, the doctrine and the word and scatter them in great handfuls underneath one as one throws grain to fowl... Thanks to that angel whose lifting wings are ceaselessly at my disposition... here comes an entire diocese beneath me, of which I have become the momentary pastor... I say hello from up there to sixty thousand souls all at once. How good they would become if they knew that there was someone up there who is looking at them all at once!

And I hail my vertical colleagues there in the distance and the mist, like petrified landmarks on whose façade a ray of sunlight by turns causes a golden point to gleam.

Paul Claudel, *Letter to the Guardian Angel*

I praise the true God, I call the people,
I assemble the clergy, I weep for the dead, I put the plague
to flight, I make the feast days more beautiful.

Inscription on a bell of the cathedral of Metz

4. Voices of the Churches

THE CALL OF THE BELLS

The bell is a musical and symbolic instrument, which, according to Vincent de Beauvais, dates back to Tubalcain, a descendant of Cain and the ancestor of blacksmiths and founders. The use of small bells several centuries before Christianity, particularly in the East, is proved. In the Pentateuch they were fixed to the vestment of the high priest as an indication of his presence:

He gave numerous pomegranates and little golden bells to the high priest for him to cover his vestment all over. They tinkled with his every step, making themselves heard in the Temple as a memorial for the children of his people (Eccl 45:9).

Bell banner of Saint John's Abbey and University Church, Collegeville, Minnesota, U.S.A. Photo: Peregrin Berres, O.S.B.

In Rome the sacrificial rites, processions, and funeral processions were performed with the accompaniment of little bells. The Christian Church first followed the Roman custom. Criers equipped with trumpets, rattles or clappers sum-

moned the congregation. Similarly, hand bells of iron or bronze assembled the monks of the West, especially in Ireland and Armorica.

As early as the twelfth century massive bells were used. The latter hung from the belfries of the towers or open-work steeples and became the voice of each church. From the fifteenth and sixteenth centuries onward 15,000- and even 23,000-pound bells were cast and rung together in order to produce the harmonious tunes of a carillon.

BLESSING

The religious function of this instrument is plain; on each bell is inscribed its own name, along with the name of its godparents as well as a dedication or invocations such as *AVE MARIA, IHS, CREDO, PAX VOBIS.*

The ritual for its blessing, modeled on the rite of baptism, formerly consisted of the pouring of water, seven anointings with chrism on the outside followed by four others on the inside, and clothing with a white vestment. Incensing followed a prayer requesting that the bell's sound summon to prayer or remind those who are prevented from answering its call to pray, and drive away the spirit of evil, storms, and lightning. The ritual was simplified by the *Book of Blessings* in 1988:

Lord God...
With silver trumpets Moses your servant summoned Israel
to gather us your people.
Now you are pleased that in the Church
the sound of bronze bells
should summon your people to prayer...
Send your blessing down from heaven on this bell
so that its voice may be like an echo of your call
and assemble us around you;
may its ringing remind us throughout the day
of your invisible presence around us.
May it be the vibrant expression
of our joys and our sorrows.
May it always sing the praise of your glory.
For all that you do,
in union with all that sings,
through all that we are,
praise and glory to you, our God, most holy Father,
in unity with the Son and the Holy Spirit.

The Book of Blessings

The bell-towers of Tournai, Belgium, uniting their spires and their voices, announce the hours of prayer and of gathering together

RINGING OF THE BELLS

The ringing of one or several bells announces the Hours of the Divine Office and expresses the joy of feast days. The tolling of the knell for funerals is an invitation to pray for the deceased. The silence from the evening of Holy Thursday and the joyful pealing of the Holy Saturday Vigil of the Resurrection, accompany the paschal celebrations.

Bells were rung daily for morning and evening prayer on the instructions of Urban II in 1096, and then at midday from 1225 onwards. These three bell rings corresponded to the ringing of the Angelus which was codified in the fifteenth century.

LITTLE BELLS

In Germany from the end of the twelfth century the ringing of a bell signaled the elevation of the host. Little bells joined with the great bells for the congregation's acclamation at the "Sanctus" and at the elevation of the con-

secrated species. Sets of chiming bells served to signal the beginning of the Mass and the elevation or to accompany the singing of the *Gloria in excelsis* or the *Te Deum*.

ANGELUS

The three verses of this prayer, each followed by the *Ave Maria*, correspond to the trinitarian series of three rings of the bell, repeated three times and followed by a peal of the bells, or their joyful ringing, which celebrate the incarnation or the resurrection.

The Angel of the Lord declared unto Mary, / And she conceived by the Holy Spirit. / Hail Mary, full of grace, the Lord is with you, / blessed are you among women and blessed is the fruit of your womb, Jesus. / Holy Mary, Mother of God, pray for us sinners, now and at the hour of our death. Amen.

Behold the handmaid of the Lord, / Be it done to me according to your word. / Hail Mary… / And the Word was made flesh, / and dwelt among us. / Hail Mary… / Pray for us, O holy Mother of God, / That we may be made worthy of the promises of Christ.

At Easter the prayer is different:

Queen of heaven, rejoice. Alleluia! / For he whom you deserved to bear, Alleluia! / Has risen as he said. Alleluia! / Pray for us to God. Alleluia! / Rejoice and be glad, O Virgin Mary. Alleluia! / For Our Lord is truly risen! Alleluia!

5. The Gates

The gates open to welcome people of goodwill, but like the fortified gates of a town, the holy place defends itself against the powers of evil, according to a biblical and liturgical symbolism.

HEAVENLY GATES

The symbolism of the gates is that of paradise lost and regained. The gates of the Garden of Eden sheltered Adam and Eve in their intimacy with God, *who was walking in the cool of the day.* These gates secured for them divine vigilance over water, the fruits of the earth, mastery over the animals, the springs of life, and preservation from death. However,

The Christ in majesty situated at the doors of the narthex where he welcomes the catechumens

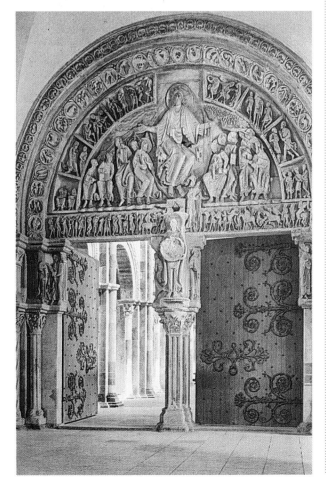

tempted by the serpent, they broke the pact of friendship. Then the cherubim with the flashing sword posted beside the tree of knowledge drove them out and closed the gates (Gen 2:8–3:23).

God did not abandon humanity to its fate. God saved it from a devastating flood in an ark whose doors Noah closed on his family and two of each species of animal. After the cataclysm, God made a sign for Noah to open the doors up to a pacified sky and land (Gen 7:1–8:22).

The Garden of Eden and the ark were the prefiguration of a permanent city, the *heavenly Jerusalem* which will open its twelve gates to all humanity gathered from the four corners of the universe. Close to the source of life regained, and shielded from suffering and death, it will dwell eternally with its God and share God's table and God's glory (Rev 21–22).

JESUS AT THE GATES

In the course of time the Son of God, like a good shepherd, stands at the gate of the sheepfold, pushing aside the mercenaries and gathering together the sheep. *He alone holds the key. What he opens nobody can shut and what he shuts nobody can open* (Rev 3:7).

When the hour came to conclude his covenant with his people, the Savior processed solemnly through the gates of the Holy City. There a crowd awaited him waving palms: *Hosanna to the new David!* The liturgy which evokes Jesus' entry into Jerusalem invites the faithful gathered outside to take part in the procession of palms. Led by the celebrant, who represents the Lord, the faithful will go through the doors in their turn before commemorating the days of the passion. Formerly, while the cantors inside acclaimed *"Glory, praise and honor to you, King, Messiah and Redeemer!"* the celebrant outside struck the door three times with the foot of the cross to demand the opening of the double doors.

Does this rite allude to the Savior's penetration into hell? Tradition has it that between his death on the cross and his rising from the tomb, the Savior descended into hell. Byzantine mosaics depict the victorious Christ knocking down the gates of hell with a blow of the cross in order to liberate Adam and Eve and their descendants who were plunged into the darkness of death while awaiting their salvation.

The Beautiful God of Amiens

Standing on the pier of the central door of the cathedral of Amiens, Christ welcomes us into his house. He is an example of an art in no way inferior to that of the masters of antiquity, a perfect accord of posture and subject: the Lord, Way, Truth, and Life. The magnificence of this art lies in
- the simplicity of his gesture: his right hand raised with three fingers blessing in the name of the Father, the Son and the Spirit, the left hand holding the sealed book;
- the posture of a monarch who tramples underfoot the lion (the Antichrist), the dragon (the devil), the basilisk (death), the asp (sin);
- the bearing of his head and the expression on his face; the majesty, authority, and possession of the truth do not stand in the way of the goodness of him whose lips half open to reveal the Father, for he is the divine incarnate Word.

In Amiens, for the first time, a representation of Christ is called the Beautiful God… Saint Augustine is said to have considered the expression "beautiful God" as derisory or sacrilegious… It is difficult to imagine Moses speaking of the beauty of the Burning Bush. Can the expression be applied to Jesus? When did the evangelists make the slightest allusion to his face? For all the Fathers of the Church his beauty was of a supernatural nature. "It is not in the fortunate proportion of limbs," said Saint Basil, "but only in the thought purified to the highest level that the beauty of the Lord is recognizable." The beauty which the sculptor gives to Jesus is no less foreign to a living being than the beauty of the Virgin is foreign to that of pretty girls. In the world of the cathedral and of prayer the word *beauty* has a meaning for the sculptor, whose purpose is not to make the work appealing but to reveal the divine world. Let us be careful to note that this beauty, at the time when the people of Amiens discover and admire it, belongs solely to the religious world. The admiration it arouses impacts the viewers' faith, not their judgment. It is an unusual religious emotion, not an aesthetic emotion. If one does not admire the Beautiful God as a beautiful man, one does not admire it any more as a statue, but as a convincing portrayal of Christ. Among the cathedral's images, the faithful call "beautiful" that which makes the world which the sculptors dedicate to Christ worthy of him.*

Malraux, *Métamorphose des dieux*

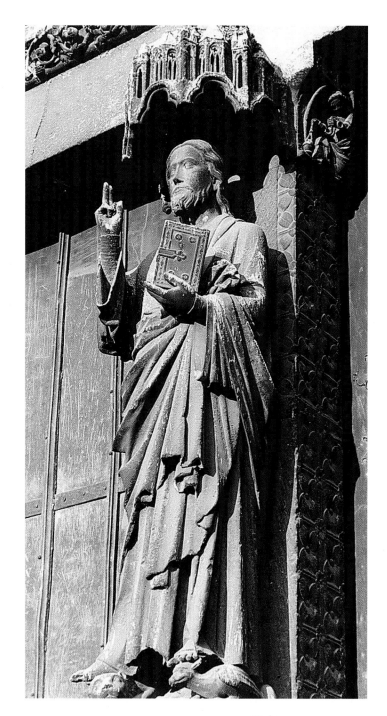

Right:
The doors open upon the assembly of believers

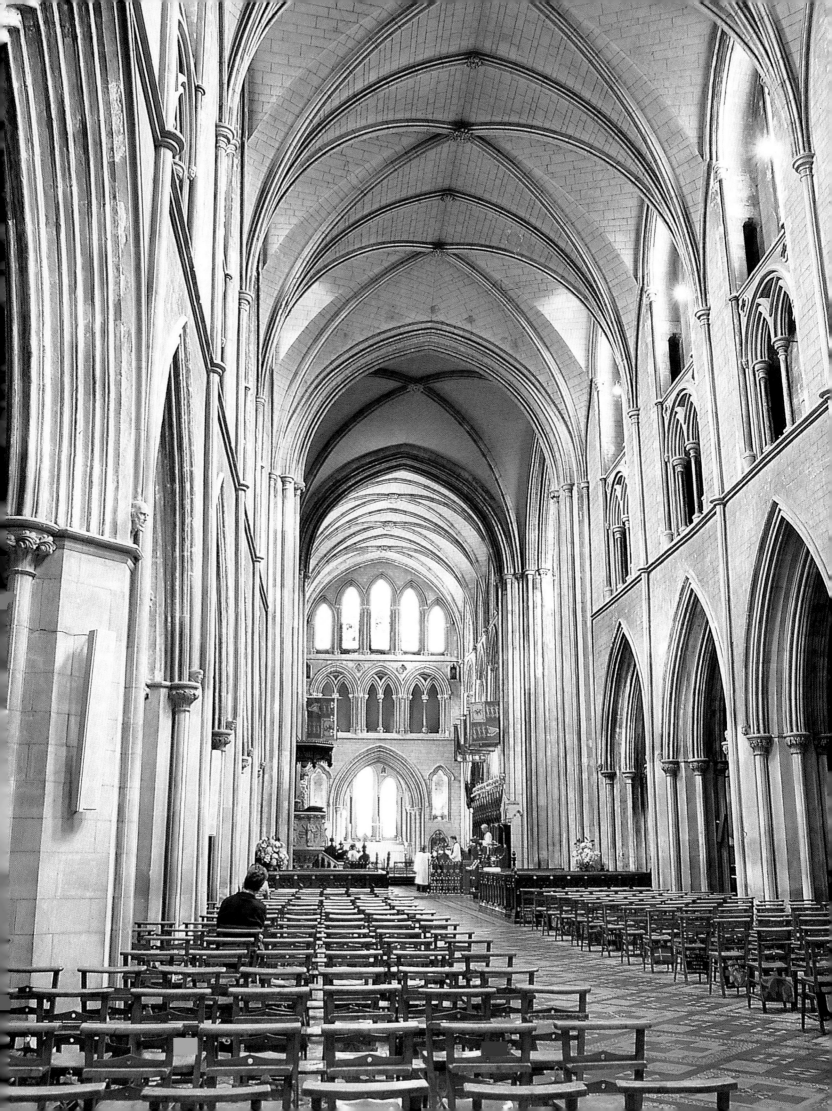

The Church as Guardian of the Gates

Jesus gave the keys of the City of God to Peter, whose image beneath the porches sometimes portrays symbolically what Jesus declared to the holy apostle, *"You are Peter, and on this rock I will build my Church and the gates of Hades (= of death and evil) will not overcome it. I will give you the keys of the kingdom of heaven; whatever you bind on earth will be bound in heaven, and whatever you loose on earth will be loosed in heaven"* (Matt 16:18).

Formerly the first step which prepared clerics for the priesthood was the role of doorkeeper. The candidate received the keys of the building and was to be a watchful keeper, with the responsibility of opening the doors for the congregation and closing them again. It fell to him to summon the Christian people by ringing the bells.

Each person has access to the Church through **baptism.** Fortified and initiated by the sacrament, the catechumens can cross the threshold and pass through the doors of the narthex in order to participate in the assembly.

The celebration of **marriage** begins with the welcoming of the bride and groom at the threshold of the church. The ritual of mutual consent in front of the door was introduced in order to give a better guarantee of the young woman's commitment, which previously she had expressed in her parents' home. Next she entered the church with her bridal procession for the celebration of the Eucharist.

The Gargoyles

Stone figures intended to evacuate the water from the gutters far from the walls, the gargoyles had freakish shapes. Scattered around the outside of the edifice, they can be considered to symbolize the evil forces which the sanctity of the sacred place throws out and wards off. The Church welcomes the just and sinners. It excludes Satan and his henchmen.

Reflections on the Threshold - The Porch

Cathedrals or rural churches proclaimed on the outside the meaning of the mysteries celebrated within. On the façade, sculptures exhibited in broad daylight the scenes of the gospel. Designed to welcome the faithful, both the more solemn images at the western portal and the more familiar ones at the southern portal were aimed equally at every passer-by.

If the tympanum evoked heaven, the lower parts represented the earthly world, the labors, the days, and the unfolding of time. There life, death, and original sin unfold. Yet higher up, as if at the gate of history, the sculpture proclaimed the salvation brought down by Gabriel's annunciation to the Virgin and the encounter between Elizabeth and Mary, pregnant with the last of the prophets and the Savior of the world. In the doorway or under the shelter of the porch were lined up the witnesses of the faith, reciting the Creed on their phylacteries and holding the instruments of their martyrdom.

The saints were depicted as being close to peoples' lives. Formerly, children from the church school played in front of a sculpted crucifixion scene or porch in which Jesus taught the Scriptures to the Doctors of the Law. On the fairground, along the enclosure wall, peasants discussed the price of a horse a few steps away from the apostles and the donkey of Palm Sunday, or from Judas clutching the betrayal money in his purse.

This religious art, steeped in rural life, concentrated the thoughts of the passers-by on death and life, love or selfishness. Moreover, they found again, scattered over the old dwellings or at the crossroads or in their hamlet, the chapels and crosses which made their daily life sacred. Thus the mysteries celebrated in the nave were recalled outside in the enclosure and beyond. Christ, his mother, the apostles, the hallowed participants of the nativity, the passion, and the resurrection, rubbed shoulders with urban and village life and mingled their images with the ever-changing picture of labors day by day.

The rural world has changed. Yet images still offer here and there a transition between our immediate preoccupations and the meaning of existence. They are at once a reflection of present-day life and the announcement of the other world. They unite the two poles of past time and time to come, the visible and the invisible.

When we were baptized we went into the tomb with him and joined him in death… so that we too might live a new life.

Rom 6:4

6. The Baptistry, a Door onto Another Life

*I saw living water flowing out of the heart of Christ.
Alleluia, alleluia!
All those who are cleansed by this water will be saved.
They will sing:
alleluia, alleluia, alleluia!
I saw the spring becoming an immense river.
Alleluia, alleluia!
The sons of God assembled there sang out their joy at being saved.
Alleluia, alleluia, alleluia!*

Liturgical acclamation

Baptism means "submersion into the waters." Its ritual symbolizes descent into death and rebirth into a new life. Thus this sacrament identifies Christians with the death and resurrection of Christ.

THE WATER

The baptismal water is solemnly blessed during the Easter Vigil, for this feast celebrates Christ's passage from death to life. In celebrating Easter, Christians also celebrate their rebirth.

Water is one of the four elements and a symbol of life. The book of Genesis describes the Spirit hovering over the mother-

From the water of the baptismal font, Christians emerge invested with priestly, prophetic, and regal power. The sphere bearing a cross is the sign of this transformation. Baptistry, Dôle, France

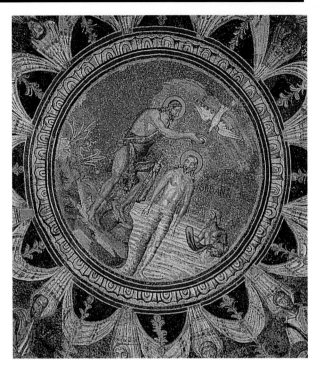

John the Baptist is the witness of the divine manifestation which anoints the Beloved Son. Neoni Baptistry, Ravenna, Italy

waters out of which God drew creation. Jesus, who came to save this world, declared to the Samaritan woman that he was the sole source of living water (John 4). The pierced heart of Christ on the cross, out of which water and blood flowed, also recalls this source of life, drawn from Saving Love.

THE BAPTISTRY

The baptistry is essentially a *fountain* of baptismal water, the font.

When the sacrament is administered by ablution the blessed water is poured over the catechumen's head as a sign of purification. In order to represent immersion into the water as a descent into death which gives access to the new life of Christ, certain baptistries were hollowed out into a bath into which the catechumen descended.

The font's basin sometimes had a dome-shaped cover, an image sometimes accentuated by a canopy erected on four columns. The symbolism of the number eight is often to be found in the octagonal form of the basin itself, the octagon being an intermediate shape between the square and the circle. Thus the effect of baptism is expressed – the passage

117

The glory of the stained-glass window envelops the newly baptized as they come out of the water. Baptistry of Bazaine, Audincourt, France

ICONOGRAPHY

The iconography of the baptistry evoked the scene in which John baptized Jesus in the Jordan while the Father and the Spirit designated him as the Son of God. The sculpture of the baptismal basin can recall the rivers of paradise flowing from Eden out to the four corners of the earth, and equally the spring gushing forth from the heavenly Jerusalem, an apocalyptic image of the redeemed world. There too the sculptors portrayed certain symbolic animals: the deer which drink at the source of living water, fish amid the waves that signify the nourishing water, and the apostles fishing.

PASCHAL CANDLE AND LIGHT

The light of the stars and the rising of the morning star are permanent signs of the victory of Christ over darkness. Close to the font a candle burns on a candleholder. By blessing it during the Pascal Vigil, the Church recalls the column of fire which guided the Hebrews' walk toward freedom. The liturgy makes of the light of the candle a symbol of the risen Christ, the guide of his people and their light and path. During the celebration of baptism, the transmission of this flame to the baptized person, and to his or her parents and godparents, carries this meaning.

HOLY CHRISM

Chrism is made of scented oil which is blessed on Holy Thursday. It recalls the consecration of prophets or kings. The anointing of the baptized makes them members of Christ (*Christ* = anointed one), and they become priests, prophets, and kings through him. This oil is reserved in precious vessels called *ampullae* and kept in a little wall cupboard called an *ambrey.*

HOLY WATER BASINS

At the entrances to the church a basin of holy water invites Christians to make the Sign of the Cross and recall the grace of their baptism. Sometimes a supply of water can be found near the font.

from the earthly world, the square, to the heavenly world, the circle. This passage, or "passover" which takes effect through the baptismal water as a reminder of the passage through the Red Sea, is also linked to the eighth day, the return of Sunday, the day of celebration of the risen Lord. With the number eight, as with the eighth note of the scale, everything is renewed.

In the times when only the bishop could baptize, there was only one baptistry in a whole diocese. Initially this round or octagonal edifice was separate from the cathedral, as is the case in Pisa and Florence. Each year the faithful came there to commemorate their entry into the Church. Later, each parish was made into the maternal womb of the Church: this was symbolized by the integration of the baptistry into the parish church.

Symbolically, the baptistry was situated close to the western portal, on the north side. This was the direction from which the pagan peoples who were called to faith came. Moreover, the old missal stipulated that the deacon should face west to proclaim the Good News. Under the narthex, or western porch, the preliminary exorcisms took place.
When the southern porch became the main point of access to a church, the baptistry found its place to the west of this door.

Baptism is the outcome of an initiation of the catechumen or of a preparation made by parents in view of their role as teachers of the faith. Nowadays an entrance procession and the reading of a passage from the gospel summarize the different steps in the catechumenate which sometimes take place during Lent.

THE CAREFULLY CHOSEN BAPTISMAL LITURGY

A thirteenth-century treatise draws attention to the liturgical symbolism of the Paschal Vigil:

At the beginning of the liturgy, all the lights in the church are turned off in order to indicate that the Old Covenant which illuminated the world is abrogated from now on. Then the celebrant blesses the new fire, an image of the New Covenant. He uses the spark from a flint to light this fire, as a reminder that Jesus Christ, as Saint Paul tells us, is the cornerstone of the world. Then the bishop, the deacon and all the faithful make their way towards the choir and stop before the Paschal candle. This candle is a triple symbol. Unlit, it symbolizes the obscure column which guided the Hebrews during the day, the Old Covenant, and the body of Jesus Christ. When it is lit, it signifies the column of light Israel saw during the night, the New Covenant, and the glorified body of the risen Christ. The deacon alludes to this triple symbolism when he sings the Exultet *before the candle. Yet he insists above all on the likeness between the candle and the body of Jesus Christ. He recalls that the immaculate wax was produced by the bee, which is both chaste and fruitful like the Virgin who gave birth to the Savior. To emphasize the likeness between the wax and the divine body, he pushes five grains of incense into the candle, recalling both the five wounds of Christ and the perfumes bought by the*

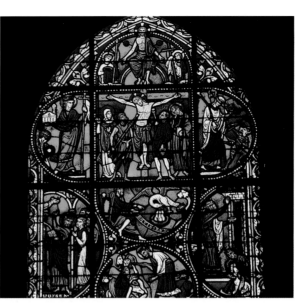

The paschal symbolism is expressed in the cross. Christ is submerged into death in order to enter into glory and give life to his own like the pelican. Upper part of a stained-glass window, church of Saint-Pierre, Chartres, France

holy women for his embalming. Finally, he lights the candle with the new fire, and all the lights in the church are lit again to represent the spreading of the New Law throughout the world.

Baptismal water

The second part of the Paschal Vigil is devoted to the baptism of neophytes, for whom the Church has chosen this day, because it has seen a mysterious relationship between the death of Jesus Christ and the symbolic death of the new Christian. Through baptism the Christian dies to the world and rises again with the Savior. Before the catechumens are led to the baptistry, twelve extracts from the Scriptures connected with the sacrament they are to receive are proclaimed to them. Examples of these are the story of the Flood, whose waters purified the world; the account of the Hebrews' passage through the Red Sea, a symbol of baptism; and the Canticle of Isaiah about those who are thirsty. When the readings are over the bishop blesses the water. First he makes the Sign of the Cross over it; then he divides it into four parts and pours some in the directions of the four points of the compass as a reminder of the four rivers of the earthly Paradise. Then he plunges the Paschal candle, the image of the Savior, into the water to remind us that Jesus Christ was baptized in the Jordan and through his baptism sanctified all the waters of the world. He plunges the candle three times into the baptismal font to recall the three days which Jesus Christ spent in the tomb. Then the baptism begins and it is the turn of the neophytes to be plunged three times into the pool, so that they know that they die to the world with Christ, are buried with him and rise again with him into eternal life.

(William Durandus, bishop of Mende, thirteenth cent.: *Ration. Div. Offic.*)

By the Sign of the Cross and the holy water, the faithful remember their baptism. Holy water font, Ronchamp, France

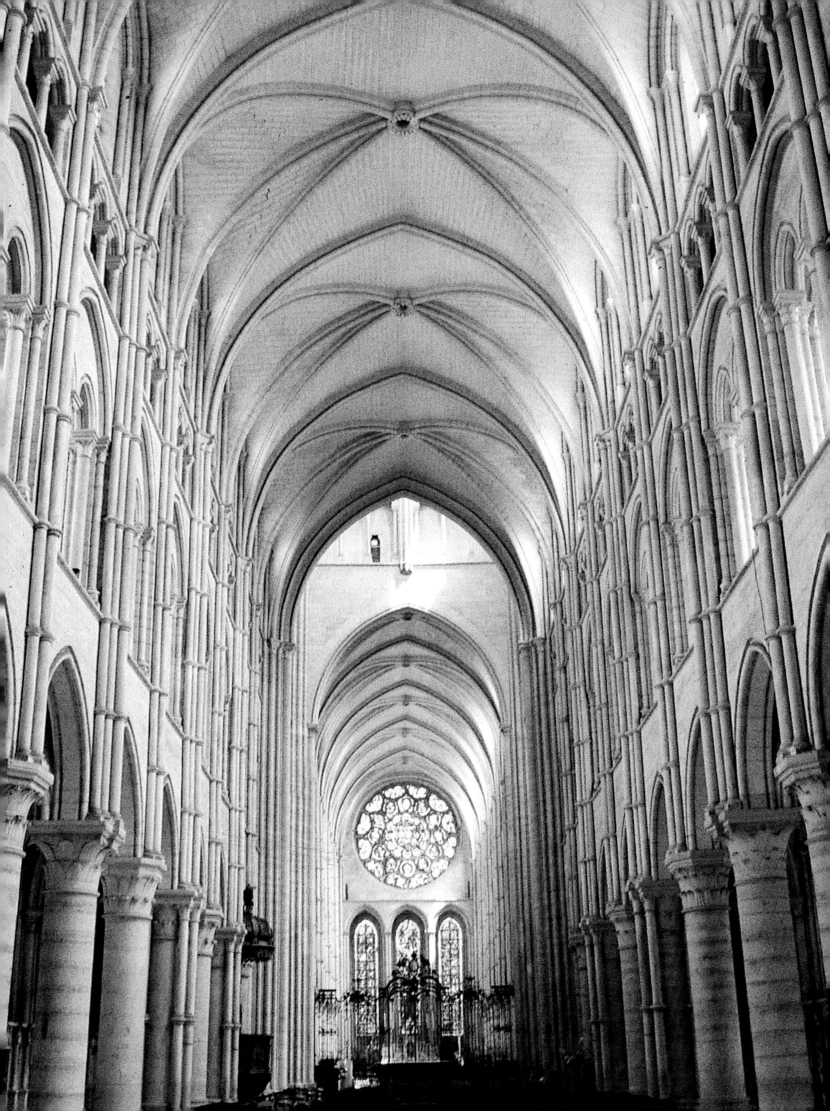

7. The Nave

A progressive presentation of symbols (shapes, lights and songs) expresses the faith in order to orient the minds of the faithful. Worship, prayer, song, and movement constitute their response to these symbolic signs. The sacraments stand out as efficacious signs of the encounter with Christ, which the liturgy celebrates in response to the faith of believers.

SYMBOLISM OF THE DESIGN

As the evolution of churches has demonstrated, the Church's reflection about itself, pursued from council to council, modified the layout of naves and choirs, which were adapted alternately to a monastic liturgy, to the canonical office in the deep Gothic choirs and to a hierarchical arrangement of the faithful and the ordained clergy with its orders: clerics, deacons, priests, bishop. The Tridentine reform was concerned to make celebrations visible and audible to all. Vatican II, by emphasizing the royal priesthood of the faithful and their active participation in the liturgy, inspired the construction of naves widened out into a fan- or semicircular shape, which symbolized the gathering of the People of God, no longer in front of the eucharistic table, but around it.

Therefore, churches do not have a uniform design. Some are **circular**, like the Church of the Resurrection in Jerusalem, or the recent Cathedral of Evry, **rectangular** like the Church of the Crucifixion, or in the shape of a **Greek cross** like the Palatine Chapel.

Left page:
The nave is structured like an organ fugue. Ascending by stages, it alternates, above each great arch, the twin openings of the tribunes, the triforium, and the high window, according to the series of the numbers 1, 2, and 3 followed again by 1, after a symbolism proper to a God at once one and trinitarian and to God's dual image, man and woman.

Whether the columns are adorned or unadorned, from them rise groups of three and five small columns segmented into six elements.

This architectural music is an accompaniment to the liturgy which unfolds its gestures, its hymns, its alternating responses as presider and faithful are united through their baptismal faith in one unique God, Father, Son, and Spirit. Cathedral of Laon, France

IMAGE OF A HUMAN BEING

Yet most of them have interpreted the basilical design of a long, drawn-out nave fitted with a transept or transverse nave above the choir. The cruciform church pointing to the points of the compass signifies the catholicity of Christian worship. In such an edifice, in its columns, its arches, its vault, and possibly its dome, the elementary structures of the square of the earth and the celestial circle are found again as well as the axis which links them, all of which made the temple a microcosm in itself.

This design evokes a human being stretched out, whose head is the sanctuary, whose body is the nave, and whose arms are the transept: an image of humanity, summit of creation, but most especially an image of Christ outstretched on the wood of the cross in expectation of the resurrection.

SIGN OF THE ASSEMBLED CHURCHES

The construction of a church is the symbolic expression of building the Church of the baptized. If this edifice favors the personal encounter of each of the faithful with God, it is first of all intended for the **assembly** gathered in the name of Christ the Lord, which bears, in the literal sense of the word, the name of church *(ecclesia)*. It shelters under the same roof the sanctuary and the nave: God and the people. *"What I call a temple,"* wrote Clement of Alexandria, *"is not a building but the gathering of the elect."* The place of assembly, often covered by a stone or wooden vault, is in the shape of an upturned hull or a ship whose tip

Crucifixion on a "beam of glory." Lampaul, Guimiliau, France

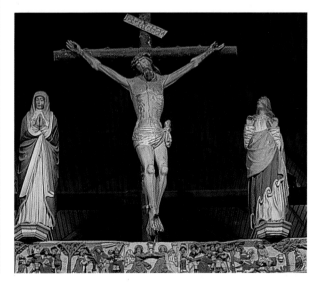

is circular or has the point cut off and takes on the shape of a prow. This shape earned for it the name of nave (Latin *navis*). It evokes Noah's Ark and those saved from the flood, and also Peter's boat with those saved by the Church.

The tip of the building forms the sanctuary, whose name recalls the "Holy of Holies" of the Temple of Solomon.

Along the aisles of the nave, processions sometimes take place around the assembly of baptized Christians, thus acknowledging it as the body of Christ.

The dignity of the nave is made explicit in the rites for the consecration of the edifice and is recalled by twelve crosses on the pillars or the walls. The number of the crosses is that of the apostles who are the columns of the Church.

SYMBOL OF THE VAULT

The vault... introduced the circle into the architectural rhythms, that is, an image of circular time, a perfect infinite line, and therefore the clearest symbol of eternity, of that heaven of which the monastic church claims to be the antechamber...

At a time when the monastic church extended its funerary functions and thus gained the favor of the peoples, per-

haps the Benedictine abbots sought to spread throughout the whole of the Church the obscure, matrix atmosphere in which under the vaults of the crypt or the porch, funeral rites, heralds of the resurrection, were conducted.

Duby, *The Time of the Cathedrals*

NUMBERS AND HARMONY OF THE ARCHITECTURE

The monk Guzo who built Cluny with the art of the psalmist had composed the sanctuary as later on the polyphonists were to compose motets and fugues. A module unit of five Roman feet served as a basis for complex combinations of arithmetical relationships. These numerical relationships expressed the ineffable. The number seven determined the proportions of the apse. The proportions of the great portal were based on the progression one, three, nine, and twenty-seven.

Above all the series of perfect numbers of Isidore of Seville and the Pythagorean series of harmonic numbers played a great part. This was an eminently musical notion regarded as an expression of the universal order, on which was founded the whole equilibrium of the monument.

Duby, *The Time of the Cathedrals*

The upturned hull is the image of the ark, of the church as a ship (nave). Vaults in Florence, Italy

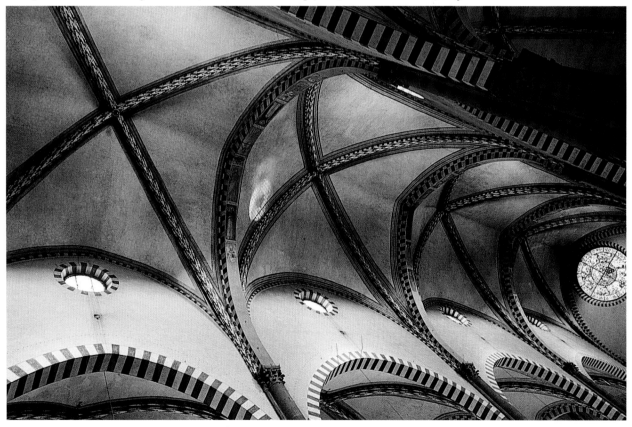

THE SIDE AISLES, A WAY OF INTERCESSION

The side aisles and ambulatories were ideal for the unfolding of the circular processions made around the assembly and the choir in order to manifest their holiness, and also for the solemn entry and exit of the celebrants.

PLACES OF RECONCILIATION

The sacrament of penance or reconciliation is an appeal made to the grace of baptism for the forgiveness of personal sins. After the Council of Trent, confessionals were fitted all along the lateral naves for hearing individual confessions. The priest, seated in the center, and the penitent, kneeling on one side or the other, could converse in a dialogue which consisted of an admission of the person's sins, faith in God's mercy, and the granting of forgiveness. Today the sacrament is sometimes celebrated as a community, yet little rooms set up in view of a pastoral dialogue are available for individual initiatives.

Secondary altars became the setting for specific devotions; here that to Mary's Assumption.
Altar, Saint Martin de Belleville, France

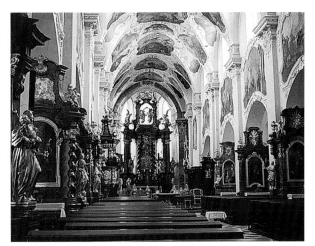

In this church in Prague, Czechoslovakia, the chapels, which open laterally, offer models of heroic faith and charity or the veneration of believers

SIDE CHAPELS AND ALTARS

Chapels with iconography appropriate to a particular saint or devotion open out along the aisles, in the transept or the ambulatory. They are evidence of a time prior to concelebration, when each priest or chaplain celebrated Mass for private intentions, or the intentions of brotherhoods. For example, the brotherhood of the "Souls of Purgatory" had the Eucharist celebrated on an altar bearing the mention that it was a privileged altar for intercession on behalf of the dead.

FUNERAL RECESSES AND BURIAL PLACES

From the fifteenth to the eighteenth century the normal place for burial was the church floor. This is still so in the case of bishops in their cathedrals. Funeral recesses, low alcoves which sheltered a tomb, were hollowed out in the thickness of the wall along the lateral naves or transept. Vaulted with basket-handle arches, they suggested the passage from the square to the circle in the expectation of heaven. During the funeral a catafalque (a draped table with or without a canopy and surrounded by candles) was set up at the entrance to the choir in order to place the deceased person's body facing the altar cross.

The harmonious accompaniment of prayer.

8. The Organ

Prayer

Prayer, the breath of the soul, links the physical and spiritual faculties. Music and even dance can accompany the expression of prayer. Vocal and instrumental music join their vibrations to those of the light, its pauses, and its rhythms in accompanying the harmonious unfolding of the celebration.

The Song of the Chosen Soul Accompanying the Prayer of the Church

"Come then, my love, let me hear your voice as I taught you to hear mine, for it is sweet" (Cant). The soul has become entirely praise. It is the daughter of song, according to the expression of Ecclesiastes (12:40), of that melodious and resonant quality of the breath or neume (pneuma) the need for which has been suggested to the soul in the night. The soul has become wholly a musical in-strument. But it is not the harp in the hands; the soul itself is the harp, which finds the scale in itself, and from octave to octave can with an infinite variety elevate itself from lowest to highest. "Awake," says David, "awake, my muse, harp, and lyre!" (Ps 57:8). It is not for nothing that one speaks of a person who is "true" or of a lute which is "true."

Paul Claudel, *Poet,* 177

Organs

Pipe organs, organa, invented by the hydraulics specialist Ctesibios of Alexandria in the third century B.C.E., were adopted as early as the tenth century by many cathedral and monastic churches and played an irreplaceable role in the Christian liturgy of the West. Already, before the lute, these polyphonic instruments were endowed with air pumps, reeds, and mutations whose stops were then arranged by level in an ornate organ case with display pipes. They were installed in the gallery, as a swallow's nest, or close to the choir according to their principal liturgical, orchestral or accompanying function.

"The organ, sacred instrument, sings the Holy Spirit who animates our lives with God's breath."

BLESSING OF THE ORGAN

The celebrant invites the organ to play. On each invitation
the organist responds with a suitable improvisation.

Come to life organ, sacred instrument,
and strike up the praise of God, our Creator and our Father.
Organ, sacred instrument,
celebrate Jesus our Lord, who died for us and rose again.
Organ, sacred instrument,
sing to the Holy Spirit who quickens our lives with the breath of God.
Organ, sacred instrument,
lift up our songs and supplications to Mary, the mother of Jesus.
Organ, sacred instrument,
have the assembly of the faithful join in the thanksgiving of Christ.
Organ, sacred instrument,
bring the comfort of faith to those who are in distress.
Organ, sacred instrument,
sustain the prayer of Christians.
Organ, sacred instrument,
proclaim the glory of the Father, the Son and the Holy Spirit.

Lord our God,
Beauty which is ever old and ever new,
your wisdom maintains the harmony of the universe,
your grace gives the earth its beauty.
For you is the unceasing praise
of the choirs of angels
who contemplate the splendor of your face.
For you is the song of the stars
in their regular journey through the universe.
For you the unanimous acclamation of the redeemed
who sing to you, holy God,
in their hearts, with their lips and with their lives.
We too, your holy people gathered in this church,
we wish to join our voices
to this universal concert,
and so that our song rising up to you
be worthy of your glory,
we ask you to bless this organ
that it may accompany our praise and our prayer,
and so that our hearts may sing
in the Holy Spirit.

Book of Blessings

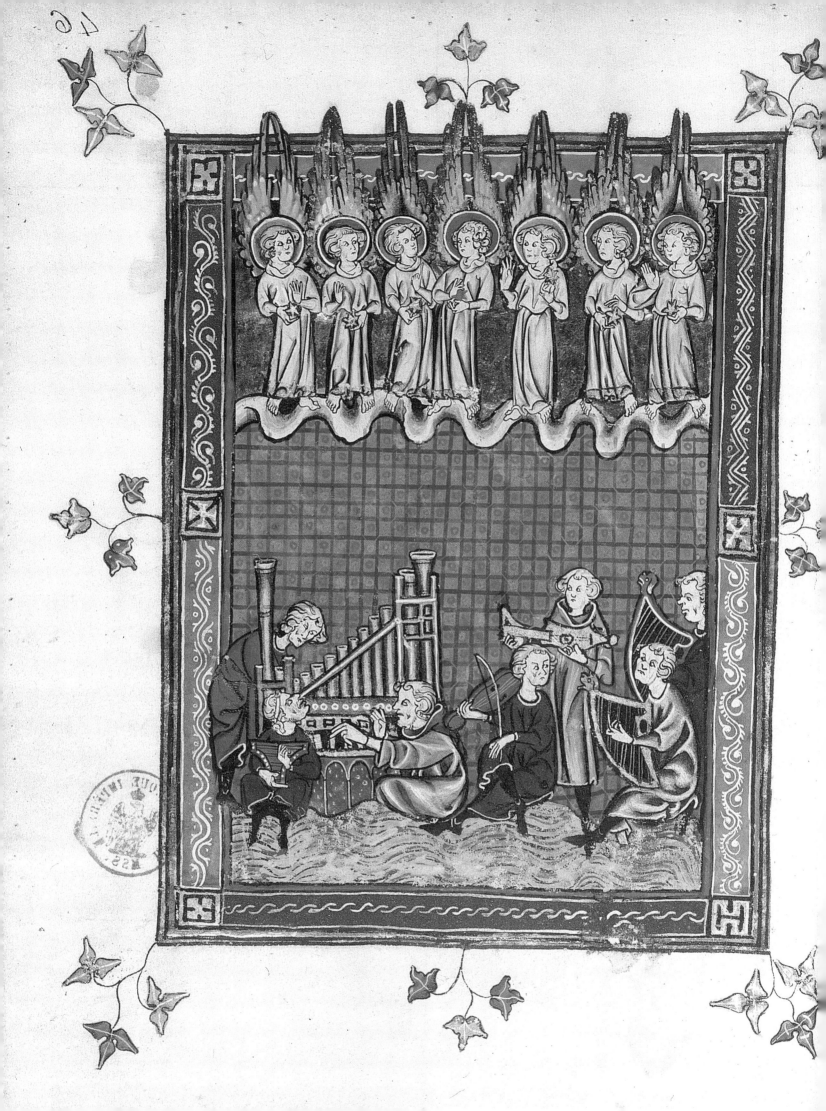

BACH AND MUSICAL SYMBOLISM

Sensitive to the relationships among sounds, numbers, and colors, between keys and the most elevated sentiments, between beings and their musical expression, J. S. Bach found in the poem of the chorale or cantata the suggestion of the sound symbol:

Repetition of the same note: it is the close of the day, and, by extension, the end of life or the funeral ceremonial (the knells for example). Chromatic designs: it is anxiety and its cause (inner conflict) and consequence (instability, obsessive suffering). The saving Lamb is the harmonious equilibrium of the double nature and, by extension, the masculine rhythm balanced and made tender by the feminine ternary rhythm. Each time that Bach wishes to lead us as it were to the gates of happiness and of paradise, he expresses himself instinctively by feminizing his rhythms and his curves: a profound avowal which shows to what extent this man had the sense of the complementarity of the two natures. This richly symbolic fabric reveals one of Bach's most mysterious aspects, his prophetic quality, which should be studied at length.

SYMBOLS OF OLIVIER MESSIAEN

Messiaen comments on the "visible and invisible aspects" of his Pentecost Mass.

Herald and musician angels. Torcello, Italy

King David, psalmist with a harp. Oloron Sainte Marie, France

The invisible, the domain of the Holy Spirit: *The Spirit of truth which the world cannot receive because it does not see it or know it (Gospel of Saint John).*
Things visible and invisible! But everything is contained in these words! The known and unknown dimensions: from the possible diameter of the universe to that of the proton. The known and unknown lengths of time: from the age of the galaxies to that of the wave associated with the proton. The spiritual world and the material world, grace and sin, angels and humans, the powers of light and the powers of darkness. The vibrations of the atmosphere, liturgical song, bird song, the melodiousness of drops of water, and the black growling of the monstrous beast of the Apocalypse. In short all that is clear and palpable, and all that is obscure, mysterious, supernatural, all that transcends science and reasoning, all that we can discover and all that we will never understand…

O. Messiaen

Left page:
The choir of angels

9. The Signs of the Paintings, Stained-Glass Windows and Statues

Mary at Calvary. Saint Jean de Maurienne, France

The multiplication of iconographic symbols introduces us into the invisible world. Such was the conviction of a fifth-century pope preaching in the Lateran. *There are the head and shoulders of the Savior appearing in the clouds in the midst of the seraphim. Above him the Dove spreads his wings and is the source of a stream of light which flows down the Cross studded with precious stones and planted on a mountain. The stream divides into four rivers at which two deer drink. At the foot of the mountain, between the arms of the river of life, one can glimpse a town sur-rounded by ramparts. The archangel Michael guards its gate. Between the battlements the busts of Peter and Paul stand as sentinels while the Tree of Life on which the bird of immortality has come to perch rises up from the center of the town.* Such was the brightly shining image which the audience of Leo the Great looked upon while they listened to the pontiff explaining to them that what was visible in our Redeemer has henceforth become part of a mystery.

PAINTINGS

All the resources of the arts – painted canvasses or tapestries, framed, mounted in retables, or displayed on the walls on feast days – recapitulated in the nave the history of salvation and announced the world beyond. Certain paintings directly embellished church walls – frescoes (paintings done on fresh plaster coating) or nineteenth-century mural paintings, and, more rarely, mosaics (made of small cubes of glazed stone) of Byzantine tradition. They evoked biblical or hagiographic scenes and illustrated the liturgy.

STAINED-GLASS WINDOWS

More than any other form of artistic expression, stained-glass windows favor prayer. They shed throughout the building an ethereal light which radiates out from a divine source: *"The Word was the light of men."* Sharing St. Augustine's sense of wonder at light as an emanation of the one who is *"Light from light,"* a medieval commission explained, *"The glass windows are the divine Scriptures which pour the light of the true sun, that is God, into the Church, that is into the hearts of the faithful, at the same time illuminating and enlightening them."* The monk Theophilus of Cologne, before describing the fabrication of stained glass, extolled its spiritual effects: its abundance of light and its sparkle as well as the images of the Savior and the saints which it replicates.

Besides their concern, inherited from the Middle Ages, to open up in the naves the great illustrated Bible (the Old Testament with its prophetic figures, the New Testament, with the mysteries of Christ), the martyrology of the Church and the marvelous witness of the saints, painters on glass expressed faith in the figurative or abstract but lyrical language of their time. The night fell and the book closed again; the sun rose and spread its rays, and an irradiated world with its sacred history revealed itself.

One has to admit that the beauty of these compositions elevates the soul more than their theological message elevates the intelligence. Though the unfolding of sacred history may be difficult to decipher in the heights, the fascination of these colorful illustrations casts a heavenly enchantment.

Stained-glass window, Cathedral of Chartres, France

STATUARY

As in the portals, statues of Christ, of men and women saints, apostles, confessors, martyrs stand all along the nave and in the side chapels. Most frequent amid the statuary is the cross of Christ.

THE CRUCIFIX

As the symbol of the death of Christ, the Cross is the token of divine love. The cross is evoked horizontally in the cruciform design of the church and represented vertically in the nave, as the sign of salvation. Even more clearly than the capitals decorated with foliage, the cross is linked to the Tree of Life in the Garden of Eden. Through the Cross, Jesus gives access to the fruit of immortality. By its place in the nave it also recalls the bronze serpent, the sight of which healed the Hebrew people who were mortally wounded.

A sculpture of Christ, crowned and clothed in the royal tunic, first marked the place of the eucharistic celebration.

In the nave, the cross of Christ is raised, with Mary, representing the Church, and John. Crucifixion, Termignon, France

Later, a crucifix was erected at the entrance to the choir, above the rood screen or on a "beam of glory," as an image of suffering either accompanied by Mary and John or alone. Since the Catholic Reform, its place has been opposite the pulpit, as a point of reference for the preacher.

On the altar, or close by, another cross is visible, no longer as a realistic representation of the death of Christ, but as a precious and glorious sign of the victory of the risen Christ who brings salvation to his people. This processional cross of wood, gold or silver gilt, carried from the sacristy to the sanctuary, introduces the liturgical celebration.

Behind the altar, in the chevet, the main stained-glass window or the retable often depicts the term toward which the eucharistic offering leads us: Christ in majesty, Christ transfigured, risen or ascending to heaven, the radiance of a promised glory.

THE CHRIST OF THE RESURRECTION

The Cathedral of Evry bears the title of the Church of the Resurrection. *The sculpture representing Christ is of human size. It stands on the circular wall as if he generated the circle with his open arms; it lies at the summit of an arch which embraces the choir, at the point of origin of the hull which stretches out above the assembly. Christ is thus on a sort of multiple "keystone," from which flow forms which embrace and hold together the entire assembly. Nobody is left out of this circle. Christ is at a height which has me barely raise my eyes above people; he is not on high in heaven; he is just in front of the assembly, in a face-to-face relationship of belonging. Here the resurrection is a peaceful and enveloping event between Christ and the assembly.*

N. Westphal

WAY OF THE CROSS

Along the lateral naves, simple crosses, paintings or low reliefs evoke fourteen moments of the road of the passion *(via dolorosa)* which took Christ from Pilate's praetorium to the tomb. These stations illustrate the gospel narratives and also some traditions drawn from mystical visions or the Apocrypha, such as the meeting with Veronica. These traditions sustain the meditation of the faithful during the Way of the Cross, a paraliturgy which was encouraged by the Franciscan Order and is a widespread practice on Good Friday.

The standards of the King advance
It is the mystery of the cross
Wherein life was put to death,
Bringing, through death, new life…

Marvelous tree all shining
Adorned with royal purple,
Wood of noble race, alone worthy
To touch the very holy limbs.

Blessed cross, whose arms
Sustained the price of the world
Scales on which was weighed the body
Which robbed hell of its prey!
Hymn of the Cross

CRISTMAS CRIB

There is evidence of Christians' pilgrimages to Bethlehem as early as the fourth century. In the West, as in Byzantium, the birth of Christ was depicted very early on in paintings and mosaics. Francis of Assisi created a crib of the nativity in Grecio. The crèche, very popular in the fifteenth century, spread everywhere during Christmastide, distinctively portraying characters and objects proper to each of the countries which welcomed Jesus the Emmanuel, "God in our midst."

SAINTS OF HEAVEN

These individuals are canonized (that is, officially proposed for the veneration of the faithful) for the eminent holiness of their lives. They are our predecessors in faith, those who have been saved and who intercede for the living, and who, through their example, encourage them to follow Christ, the way to salvation.

Their statues are placed above the altars, incorporated in the retables or fixed on pillars, with the attire of their epoch and posture suggestive of their witness. The closeness of these still-living members of the Church recalls the intimate link between the terrestrial Church and the heavenly Church.

MARY, MOTHER OF GOD

Before dying on the cross, Jesus entrusted his disciple John to his mother. This testament inaugurated the filial bond between all Christians and Mary. There is no church or chapel which does not contain an image or statue of Mary.

The sculptors represent Mary seated in majesty and serving as a throne for her son as a child, or else kneeling before the child in the crib. Sometimes she presents him to the faithful in her arms as the Good News, or she is standing at the foot of the cross. She can also be sitting, holding the body of her son who has been taken down from his gibbet or stretched out dead amid the apostles. Finally, she is depicted carried off by the angels to heaven. As the Virgin of Mercy, she welcomes under her mantle all those who come to her.

In John's apocalyptic vision, the woman clothed with the sun, with the moon under her feet and crowned with stars, represents both the Church and Mary.

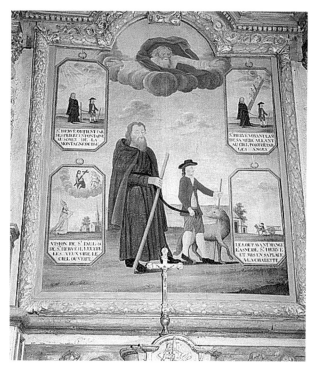

The Saint's image is displayed for the prayer and imitation of the faithful. Retable of Saint Hervé, Locmélar, France

"A majestic queen of sorrows, Mary holds on her knees the body of her dead son."

*The full and active participation
of all the holy people of God in a single prayer
before the altar at which the bishop presides.*
Sacrosanctum concilium 41

10. Sanctuary, Choir

The priest and his ministers will take their places in the sanctuary, that is in the part of the church which will manifest their hierarchical function, and in which each one of them, respectively, will preside over the prayers, proclaim the word of God, and serve at the altar. These arrangements, as well as expressing the hierarchical order and diversity of functions, will also ensure a profound and organic unity in the edifice, which will throw light on the unity of the entire People of God. The nature and the beauty of the place of all the furnishings will encourage piety and manifest the sanctity of the mysteries celebrated therein.

Preliminaries of the Missal, 257

The part of the building reserved for the sanctuary, the president of the assembly, and the clergy's stalls, bears the name choir because originally the **choir** *(schola cantorum)* had its place there, between the faithful and the altar.

Its arrangement, organization, and dimensions have evolved through the centuries. Destined for the eucharistic celebration, the eastern part of the church is raised. The celebrant and the ministers have to climb one or two steps in order to reach the presider's seat, the ambo, and above all the altar. This elevation of the sanctuary ensures greater visibility of the celebration but also has a symbolic meaning, for the sanctuary is a high point in the pilgrimage of the Church on earth.

The cathedra of the bishop as presider

In his cathedral it is the bishop who summons, gathers, and *presides at the unique altar… surrounded by his presbyterium and his ministers* (Vatican II, Constitution on the Holy Liturgy). His seat is permanently reserved for him and called the **cathedra**. It gave its name to the episcopal church, or **cathedral**. In the absence of the bishop the presiding priest occupies another seat.

The location of the presider's seat varies. In the basilicas of Constantine the president was seated at the far end of the edifice and the clergy took their places around him, behind the altar. Nowadays this location is required for communication with the assembly which is arranged around the place of the word and the altar.

THE PRESIDENCY

The assembly gathers on the invitation of Christ to hear the word of God and to participate in the Eucharist. *In persona Christi,* it is said, for the ancient actor bearing the mask (*persona* in Latin) speaks in the name of another. The priest who unites the community in a common prayer presides over it as a minister of the Lord, of his Word and of the Eucharist.

In the assembly the presider occupies a distinctive seat but not a throne.

THE CLERGY AND THE FAITHFUL

In old churches the clergy occupied stalls (joined seats with raised backs, armrests, and kneeling stools). The seat itself could be raised up, providing a support called a *misericord* because it made possible an intermediary position between the standing and sitting position during the long canonical offices. Since the choir is no longer closed in by a Communion rail, the faithful are gathered in such a way that they can see, hear, and take part in the liturgical activity, not as spectators, but as participants invited to the meal which anticipates the eternal wedding feast.

11. Celebration of the Word

The Second Vatican Council, drawing a parallel between the two acts in which the Lord gives himself to his people (the gift of his Word first of all, then that of his flesh and blood), speaks of the two tables, the altar, and the ambo.

EVANGELISTARY

The evangelistary is the compendium of excerpts of the gospel used for each Sunday celebration. In the East, its square shape symbolizes the revelation of the meaning of the universe, which it contains. This book with a precious binding, a symbol of the Word of God and an icon of Christ, can be permanently exposed on a lectern.

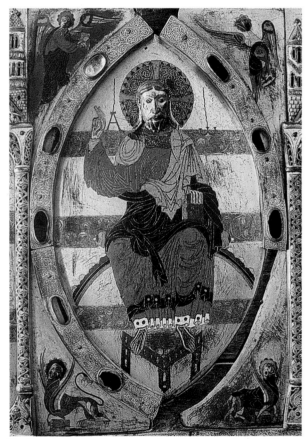

The front of the binding is treated as richly as an icon of Christ, Word of God

Imposition of the Evangelistary
During the ordination of a bishop, after the imposition of hands on the chosen man, the presider places the open book of the Gospels above his head, and two deacons hold it thus until the end of the consecratory prayer. This rite signifies that God will take possession of this chosen one by the out-pouring of the Spirit, and that the ministry of the bishop is subject to the gospel of Christ.

Liturgical Procession with the Gospel
The introduction of the book into the choir *represents the advent of the Son of God* (Germanus of Constantinople).

Out of veneration for this Christ-like sign, the entrance procession solemnly bears the book as far as the altar: *And I saw standing between the throne with its four animals – the evangelists – a Lamb that seemed to have been sacrificed... You are worthy to take the book and break its seals for you were sacrificed and with your blood you ransomed for God people of every race, language, people, and nation. You made them a line of kings and priests to serve our God.*

Rev 5:6-10

PROCLAMATION OF THE GOSPEL

After the first readings, amid the singing of "alleluia," the deacon, accompanied by the candle-bearer and the incense-bearer, carries the evangelistary from the altar to the ambo for the proclamation of the gospel. *The gospel procession advances like the power of Christ triumphing over death* (Germain of Paris).

The book is incensed and solemnly acclaimed. The Word written in the book is that of the "Living Christ"; it must therefore be proclaimed by a voice in the name of the Word, and responded to by the voices of the faithful.

The deacon lifts up the evangelistary which the assembly acclaims

AMBO

The liturgy of Vatican II makes provision for a rostrum set up in front of the assembly – *and not a mere movable lectern* – which gives a visible importance to the celebration of the Word (Preliminaries of the Roman Missal, 272).

The dignity of the Word of God calls for a place in the church which favors the proclamation of this Word, and to which the attention of the faithful is spontaneously drawn during the Liturgy of the Word. From the ambo the readings, the responsorial psalm, and the paschal Exultet *are proclaimed. The homily and Prayers of the Faithful can also take place here.*

Blessing of the Ambo

*God our Father who have called out humanity
from the darkness
to enter your admirable light,
it is good that we give you thanks
for you do not permit that we ever lack
the nourishment of your word,
and you have us hear ceaselessly
the marvels which you proclaimed.
We beseech you, O Lord,
may the voice of your Son resound in this place
and reach our ears
in order that on the inner invitation of the Holy Spirit
we may not only be the hearers of your word,
but may also put it into practice.
May those who proclaim your word here
show us the path to life
so that we may progress on it joyfully in Christ's footsteps
and obtain eternal life in him.*

CHOIR SCREEN AND PULPIT

In the Gothic era the choir was separated from the nave by an enclosure topped by the rostrum for the readings. It took the name of **jube** (choir screen) from the first Latin word uttered by the deacon when he asked for the presiding priest's blessing before the proclamation of the gospel (*Jube Domine benedicere:* Deign to bless me, Lord).

In certain Eastern churches a dais, the **bema,** was raised for the bishop and the clergy in the middle of the assembly, whereas the altar was at the eastern extremity.

From the Council of Trent onward this place which was suitable for a familiar teaching of the faith was occupied by a *pulpit* – a little preacher's rostrum which was already in use in the thirteenth century in the mendicant orders for preaching outdoors. The faithful could sit all around. The railing and approach ramp were decorated with low reliefs of the messengers of the Word: either the four evangelists with their symbols, or the Doctors of the Church, or even the parish evangelizer. The book of the Scriptures or the tablets of the Law are sometimes depicted behind the preacher. The canopy bore a dove on its ceiling, the Holy Spirit who inspires and helps the Word to be heard. Above the dome the herald-angel rises up, summoning the assembly with the sound of his trumpet, anticipating the final assembly in which fidelity to the gospel will distinguish those *blessed by the Father.*

For the gatherings at Ronchamp, the pulpit, or teachers seat, was made in the shape of a rostrum. Pulpit, church of Ronchamp, France

Traveler, enter peacefully. Pain has petrified the threshold,
but beyond glisten bread and wine in pure clarity
on the table.

G. Trakl

12. The Altar

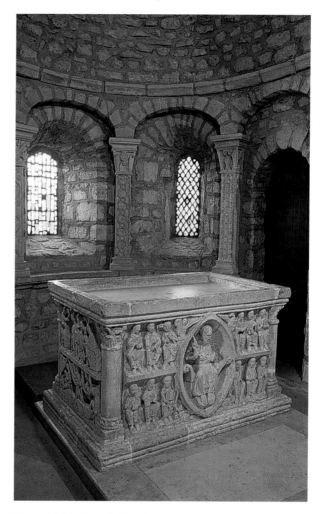

Figure of the Church, the Twelve join in the Eucharist of the Lord.

The altar standing in the sanctuary recalls both the Last Supper and the Cross. It announces the gathering of saved humanity around the eternal wedding feast. It is the symbol of the eucharistic mystery celebrated by Christ in his Church. *The altar, on which the* **sacrifice of the Cross** *is made present in the sacramental signs ("This is my body given up for you... This is my blood poured out for the remission of sins"), is also the table of the Lord, at which the People of God are invited to participate at Mass ("Take and eat... Take and drink"). It is also the center of the thanksgiving which is fulfilled in plenitude in the Eucharist* (Preliminaries of the Roman Missal, 259). Finally, it is an anticipation of the table of the heavenly banquet.

EUCHARISTIC MYSTERY

During the Last Supper, on the night he was betrayed, our Lord instituted the eucharistic sacrifice of his body and his blood in order to perpetuate the sacrifice of the cross throughout the centuries until his return. In addition he did so in order to entrust to

In this stained-glass window, the sacrifice of the cross is depicted; its announcement – the sacrifice of Isaac and the cluster of grapes brought back from the Promised Land – and its fulfillment – the glory of the Lord symbolized by the resurrection of the lion cubs. Stained-glass window, Church of Saint-Pierre Le Vieux, Chartres, France

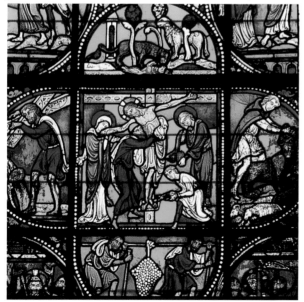

the Church, his beloved spouse, the memorial of his death and resurrection: sacrament of love, sign of unity, bond of charity, Paschal banquet, in which Christ is eaten, the soul is showered with grace and the token of future glory is given to us.

Vatican II, Constitution on the Liturgy 47

MEANING AND SYMBOLISM OF THE ALTAR

The altar... is Christ himself, according to the witness of Saint John. In the Apocalypse, he sees before the throne of the Almighty the golden altar, on which and through which are consecrated the offerings of the faithful to God the Father (ancient Roman Pontifical).

The identification of the altar with Christ (cornerstone) explains its fundamental location on the axis of the edifice, either at the cruciform point of the transept, or at the pole of the chevet. It is raised by one or several steps.

ORIGINS

The *ara* of the Romans was the domestic altar intended for libations and banquets for the dead. The *altare* (from *altus*, high up, elevated) was the altar of the temple on which sacrifices were made to the gods of the city. For the Jews, the altar was a memorial consecrated to this end.

God said to Jacob, "Move on now and go to Bethel and settle there. Make an altar there for the God who appeared to you."... Jacob built a monument on which he made a libation and poured oil on it. Jacob named the place where God had spoken to him Bethel (= house of God) (Gen 35:1, 14). Thus Jacob had built this altar to mark a divine manifestation, his vision of a heavenly ladder and his struggle with God. *How awe-inspiring this place is! This is nothing less than a house of God and the gate of heaven!* (Gen 28:18).

For bloody **sacrifices,** Moses had specified the shape and orientation of an altar for holocausts: *You must build the altar to Yahweh your God with undressed stone... you will immolate communion sacrifices of peace and you will eat them there, rejoicing in the sight of Yahweh your God* (Deut 27:6).

A living animal's throat was cut on the stone, as an acknowledgment of the master of all life. In this pact of blood the covenant between Yahweh and humanity was sealed; it was concluded with the dividing of the victim. Fire consumed God's share and the faithful ate the other part in communion with God.

In the name of the Church, the celebrants and concelebrants offer the Eucharist on the altar of Christ

The altar was the table for this sacrificial meal. The altar of the New Covenant, announced by Melchizedek (Gen 14:17), is that of the Last Supper on Holy Thursday (Matt 26:26). This altar did not receive sacrificed animals but Christ in the form of bread and wine.

RITUAL OF THE CONSECRATION OF THE ALTAR

An inaugural consecration makes explicit the altar's link with the Last Supper and the death of Christ. This rite takes place during the very consecration of the church, or separately during a Eucharist whose action in itself consecrates. The ritual involves sprinkling the people and the altar, covering the altar with the white cloth, and anointing the four corners and the center. This signifies the messianic anointing of Christ, his priesthood and royalty. The number five recalls the five wounds of the crucifixion. Then follow the incensing, the dressing, and preparation of the altar, the illumination of the altar, and the celebration of the Eucharist.

In mounting the wood of the cross, he surrendered himself to you, Father, as a pure offering, to take away the sins of the whole world and conclude with you the new and eternal Covenant.

Therefore we beseech you, Lord, to send your blessing on the altar which has been built in this church. May it be dedicated for ever to the sacrifice of Christ; may it be the table of the Lord to which your people will come to renew its strength.

May this altar (hewn in stone) always be for us the symbol of Christ, for it is from his pierced side that he let flow the water and blood which were the source of the sacraments of the Church.

May this altar be the table for the feast to which the guests of Christ will joyfully flock, unloading themselves in your presence, Father, of their worries and burdens.

May they find new courage here for a new beginning.

May this altar be a place of peace and deep communion with you so that your children, nourished by the Body and Blood of your Son, and quenched in their thirst by his Spirit, may grow in your love. May it be a source of unity for the Church and a source of union among brothers and sisters. May the faithful gathered around it experience a spirit of true charity.

May it be the center of our praise and thanksgiving until the day when we will reach, rejoicing, the dwellings of heaven, where we will endlessly offer up to you the sacrifice of praise with Christ, sovereign priest and living altar…

Shape and Placement of the Altar in the Sanctuary

The shape and placement of the altar adapted themselves to the liturgy defined by the successive councils up to the Second Vatican Council.

The altar took on a different shape according to its different uses and the different buildings. Before the invention of a place and appropriate furnishings of its own, the altar was first the *Roman table* where the guests were installed on one side on semicircular benches as an early second-century painting from the Greek chapel of Saint Priscilla shows.

At the time of the persecutions, in order to link the martyrs with the sacrifice of Christ, the Eucharist was celebrated on the place of their burial. Altars in the shape of a sarcophagus, at once tables and tombs, preserved the memory of the

Ancient high altar with a baldachin, in the medieval manner. Cathedral of Saint-Corentin, France

Modern altar made of one single granite block like the stone of Bethel

time in which the worship of relics was closely linked to the altar. Subsequently, the shape of a parallelepipedic block loaded with sculptures prevailed. Later on it came to bear superstructures (at first adapted for the exposition of reliquaries, then of the images of polyptychs and retables, and erected at the back of the choir), and its volume increased and lengthened.

With its liturgical reform, Vatican II imposed a new arrangement of the sanctuary and the new altar. In all churches, as in the ancient tradition in Roman basilicas, the priest from then on celebrated the eucharistic liturgy facing the faithful.

Thus, the altar, stripped of its steps and retables and reduced to its essential symbolism was a sign of Christ in his sacrificial meal. It was detached from the back of the choir and brought forward to the middle of the sanctuary, which itself moved forward as far as the transept. Its dimensions were reduced in order better to suggest that it is the gathering point of the assembly. The assembly was situated symbolically in a less frontal but more enveloping position around a shorter table.

Whatever its shape and material throughout the centuries, the altar has been the piece of furniture treated with the most honor and wealth. Through the altar canopy, the baldachin, the fabric altar frontal and the painted wood retable, and through its position on the axis of the choir with the steps which raise it up, the altar occupies the most important place in the edifice in which everything converges towards it.

Credo in Jesum Christum, Deum de Deo, lumen de lumine.

13. The Luminary

The light of a flame is rich in meaning. The Law of Moses considered light to be a sign of the divine presence. In the tent, and later in the temple, a lamp of virgin oil was kept alight along with the seven-branched golden candelabrum (Exod 25:31-40; 27:20).

Oil lamps

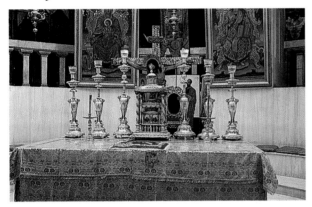

The early Church used candle flames with the same symbolism (cf. Acts 20:8), recommending beeswax, which gives light as it is consumed. In this sign the Church recognized the presence of the One who made and illumined heaven and earth. *The ineffable and prodigious fire hidden in the essence of things as in the burning bush is the fire of divine love – the dazzling brightness of its beauty within things* (Isaac the Syrian). Saint John saw the majesty of the Father and the Son of Man encircled by the seven lamps of fire and the seven golden lampstands (Rev 1:12-13).

In the dark of night, the Easter liturgy celebrates the **paschal candle** as a symbol of the new day, that of the risen Christ. This candle is then lit at each Mass until the Ascension to recall the presence of the Lord, who appeared to his disciples until he ascended into heaven.

This candle signifies the inspiration of the Spirit when its flame is given to the newly baptized. A reminder of this occurs in the profession of faith.

Candlemas, the feast of the Presentation of Jesus in the Temple, when Simeon recognized the Messiah, is a feast of light on which candles are blessed.

The office of **lucernarium** (compline) celebrates this symbol of light which keeps watch at the hour of nightfall.

Christians adopted the Roman custom of the procession of torchbearers at funerals, giving it an appropriate symbolism; the flames surrounding the coffin are those of the hope in eternal life brought by the risen Christ.

Around the altar, the light of lamps or candles, like a solar symbol, evokes the Word, *Sun of justice, light from light.*

The tradition of suspending oil lamps from small chains in the catacombs was kept during the Middle Ages for lighting the altar. An isolated lamp close to the tabernacle indicates symbolically the Real Presence of Christ.

Toward the eighth century, tripodal chandeliers were placed on the altar itself. Though their number and location varied by place and circumstance, their symbolism did not change.

A light accompanies the eucharistic celebration and the solemn proclamation of the gospel, as provided in the rubrics. The same is true for the adoration of the Blessed Sacrament and the exposition of relics or holy images.

Close to the tabernacle, a lamp also indicates the presence of the consecrated species.

Symbol of prayer, the candles burn near the altar

14. The Reserved Eucharist

The Eucharist keeps alive in the believer the life and love of Christ the Savior: *He who eats my flesh will live forever.* The faithful of the first centuries took hosts home with them in order to be able to receive Communion during the week and for the **viaticum** (nourishment for the journey) for the sick who were moving toward death.

The exhortations of the Church Fathers recommending that one fix one's gaze on the consecrated host — *each day you can see that same body which died for you* – fostered Christians' preoccupation with the **permanent eucharistic presence** of the Christ and their vow to see the host on the day that they were to die. During the Middle Ages the contemplation of the consecrated host was more appealing than the practice of Communion. Responding to this ever more assertive desire for contemplation, in 1264 Urban IV extended the feast of Corpus Christi (the Body of Christ) to the universal Church. Thus originated the procession of the Blessed Sacrament. In addition, the exposition of the Blessed Sacrament in monstrances was proposed on certain feast days. In 1534, in Milan, the "Forty Hours" of adoration were instituted.

As a reaction against the Protestant interpretation of the Last Supper, professions of faith in the *Real Presence* grew in number. Then in the seventeenth century the Brotherhoods of the *Blessed Sacrament,* of *Perpetual Adoration* and, at the entry into Lent, of *Adoration in Reparation* were formed and developed, and *Benedictions of the Blessed Sacrament* accompanied certain feast days or offices outside of Mass.

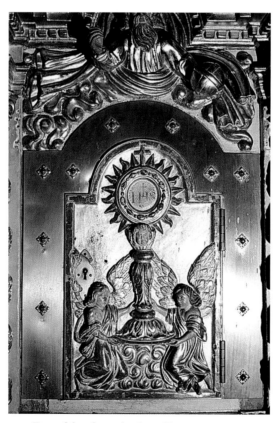

Door of the tabernacle adorned by a monstrance,
Ytassou, France

RESERVED EUCHARIST

The church is opened not only for the celebration of the sacraments. It is also a place of recollection and communal or personal prayer. The permanent presence of the Blessed Sacrament outside of Mass is an invitation to adoration and silent meditation. This presence of consecrated hosts in a small cupboard is *indicated* by a light, a valuable door, or a veil, the canopy, which recalls symbolically the tent of the Exodus tabernacle (Exod 33:7) and announces the dwelling of God amid humanity (Rev 21:3). The tabernacles of high altars from the seventeenth to nineteenth centuries often upheld a wooden or metal dais which, in certain circumstances, served as a throne for the exposition of the Blessed Sacrament.

15. Sacred Vessels for the Celebration of the Sacraments

LITURGICAL OBJECTS

The celebration of the sacraments, particularly the Eucharist, has made necessary the use of suitable objects. There is a symbolism attached to their form and their sacramental use.

ORIGIN, FORM, AND MATTER

On instituting the Eucharist, Jesus used a single dish for the bread and the common cup of wine, which he consecrated into his Body and Blood. These objects of common usage were the first sacred vessels, paten and chalice, and for a certain time remained in keeping with Jewish, Greek, and Roman table sets.

Then, in order to identify them better with the mystery celebrated, Christians singled out precious objects. Little by little these received a form adapted to the matter of the sacrament, bread and wine, as well as an appropriate decoration so that through these signs the faithful could distinguish the consecrated bread and wine from ordinary food and drink.

THEIR FORM AND MATTER

The sense of the sacred which is innate in every person, and both a fascination and a respectful fear, means that before God one does not stand, nor act nor eat just any old way. There lies the root, which cannot and must not be eradicated, of the discrepancy… between the behavior of everyday life and religious rituals. The objects of worship themselves are marked by this.

The forms of rites depend on the culture, on what is held to be noble or vulgar, precious or worthless, polite or rude, respectful or offhand… Every search for the right form for a dish (paten), a cup (chalice), an ewer (cruet), must take as point of departure the gesture to be made and the suitable way of making it, that is both functional and mean-

ingful at once: what for a given assembly can be perceived as dignified, beautiful and rich in meaning. This cannot be done without a memory of what has existed throughout the centuries, nor without a connection with the materials, industries and arts of today (Joseph Gélineau, Sacred Vessels. Chronicles of Sacred Art, no. 49).

Paten and Host

WARNING

What advantage is there in loading the table of Christ with golden vessels when he himself is dying of hunger? Start by satisfying the hunger of the starving and you will adorn your altar with what is left over. Do you make a golden cup and then not give a glass of fresh water? (Sermon of Saint John Chrysostom on the Gospel of Matthew).

ENCOURAGEMENT FOR THE USE OF PRECIOUS METALS

Let each person follow his own opinion. For my part, I declare, what seems to me proper above all, is that all that is most precious must serve first for the celebration of the holy Eucharist. If, according to the word of God and according to the ruling of the prophets, the golden cups, the golden flasks, the little golden mortars were to collect the blood of goats, calves and a red heifer, how much more proper it is to have at one's disposal golden vessels, precious stones and all that one holds precious in creation in order to receive the blood of Christ. Those who criticize us object that a holy soul, a pure spirit and an intention of faith are sufficient for this celebration. I acknowledge this; that is indeed what is most important. But I also affirm that we must serve through the outer embellishments of the sacred vessels, and more than in any other thing in the holy sacrifice, in all inner purity and all outer nobility (Suger, *On consecration*).

As early as the third century, precious materials were already stipulated for the chalice as well as the paten. Constantine offered seventy chalices of one or two pounds of gold to Saint John Lateran. In Saint Augustine's time, patens were usually made of silver and gold, crystal, gilded bronze inlaid with silver niellos and decorated with stones or else of glass gilded or painted with biblical subjects. Since the ninth century, councils have recalled the same stipulations.

**Ministerial chalice
(10th - 11th centuries).
San Marco Basilica, Venice, Italy**

PRESENT-DAY STIPULATIONS

Nowadays the requirements are more modest. *The sacred vessels are to be made of materials which are strong and which, in each region, general consensus considers noble; the bishops' conference is the ultimate judge. Preference is to be given to materials which do not break or spoil easily. The sacred vessels in metal are normally to be gilded on the inside, if they are of a metal which is likely to rust, but if they are of a metal which does not rust and is more noble than gold, it is not necessary to gild them* (Prescriptions of the Roman Missal after the Second Vatican Council, 290–94).

PATEN

The Lord used the guests' common dish – *trublion* in Greek – for the bread. *"The one who puts his hand in the dish,"* he said during the Last Supper (Matt 26:23 and Mark 14:20).

The use of a tray for the bread is noted in the *Liber Pontificalis* as standard practice at the beginning of third century. It received the round, thick loaves intended for the consecration. These trays were distinct from the *offertoria,* which became **collection plates** used for receiving the congregation's offerings during the Offertory, at first in kind, and then in money, and distinct also from the trays used for the holy chrism.

For the consecration of the hosts a fairly large paten may be used for both the priest's bread, and that of the ministers and the faithful (Prescriptions of the Roman Missal after the Second Vatican Council, 239).

CHALICE

The chalice used by Jesus at the Last Supper, called *poterion* or *calix* by Saint Paul (1 Cor 11:25; cf. Luke 22:20) was common to all the guests, symbolizing thus the unity of the Church.

Until the thirteenth century (during which the faithful ceased receiving the Precious Blood at Communion) three types of **chalices** could be distinguished: the chalice for the use of the priest *(calix)*; the ministerial chalice equipped with handles and used for the Communion of the faithful *(crater)*; a more capacious cup used to fill the ministerial chalices *(scyphus)*.

For the reception of the wine at Communion, the faithful drew it up through gold or silver tubes or **straws**, without bringing the cup to their lips.

Nowadays they can receive the Precious Blood by drinking from the chalice or by intinction (wherein the host is moistened by dipping it into the chalice).

The chalice is in itself a **symbol of the Blood of Christ.** In the Middle Ages the Breton romance of Arthur relates the story of the Grail. The *crater* of Joseph of Arimathea was said to have collected the Blood of Christ. The knights of the Round Table set out in search of it. Only a pure knight like Galahad could achieve this quest, not his father Lancelot of the Lake who was soiled by his guilty love for Guinevere.

Angels bearing chalices are sculpted on Breton calvaries. They gather the blood which flows from Christ's wounds, from his side, his hands and his feet. The chalice is also an **emblem of the priesthood.** Among statues of the apostles, Saint John can be recognized by his chalice, which he holds both in memory of his presence at the Lord's right hand at the Last Supper, and of the poisoned cup intended for the apostle. The chalice, which was placed in priests' coffins in the Middle Ages, is often engraved as a symbol on their funeral memorials.

The evolution of the sacramental rites introduced progressively the use of **other objects of worship**: ciborium, monstrances, thuribles, reliquaries, ex-voto…

CIBORIUM

Vessels were devised for keeping the eucharistic species, such as the **pyxidium,** or precious box used for hosts which were to be consecrated, and then for already consecrated hosts. They were first placed in a cupboard on the wall, an **ambrey,** whose door was of great value; then later on, in accordance with the stipulations of the Council of Trent, in a **tabernacle.** Sometimes their cover, run through with a ring, made it possible to hang them up. As early as the third and fourth centuries this gave them the shape of a dove, evoking the intervention of the Holy Spirit through whom Mary conceived in her womb the Son of God. In the light of faith, the Spirit allows us to recognize in the host the Body of Christ.

The eucharistic vessel, thus hoisted up under the *ciborium* (altar canopy), took its name of *ciborium* from this dais above the altar, at the end of the Middle Ages. A crozier or a palm tree rolled up in a scroll fixed above the main altar sometimes served to suspend the ciborium. The shape of the ciborium soon imitated that of the chalices, with a cover topped with a cross. Cases in the form of little ciboria or medallions, called **pyxes** were also used for taking Communion to the sick.

Monstrance

The exposition of the Blessed Sacrament in a *pyxidium* on a stand, in the form of a tower, dates back perhaps to the eleventh century. There is evidence of benediction with the monstrance or the eucharistic tower in the sixteenth century. The monstrance devised for this use imitated reliquaries. In 1324, Robert of Courtney bequeathed to his cathedral of Reims *a gold cross with precious stones and crystal in which to place the Body of Christ and bear it in procession on the feast of the Blessed Sacrament.*

This vessel first took the name of **monstrance** (from Latin *monstrare* = show). After its ornamentation with rays of gilded metal, it was given the name of *sun*. In the seventeenth century, the exposed host was adored by two angels fixed to the stand, in an imitation of the ark of the covenant.

Then the term **monstrance** became widespread again. The host is enclosed in its center in a *lunula* (= "little moon") made of two pieces of crystal.

Reliquary

Veneration of relics has been linked to the celebration of Mass since the age of the martyrs. Recalling the Eucharist celebrated on their tombs, relics of their bodies were enclosed in a cavity (the sepulcher) hollowed out beneath the altar or in the altar-table itself.

Besides the silver and gold plate reliquaries displayed on the altar or its steps, there was sometimes a miniature church with windows revealing the relic. The reliquaries can sometimes be in the shape of a cross for the fragments of the true cross, or a crown of thorns for a fragment of it, or yet again in the shape of a preserved limb. Then this reliquary is called a **shrine**, like the case which contains the whole body of the venerated saint.

Vessels for the Holy Oils

Special vessels or phials are used for anointing with holy oils: holy chrism (the oil containing a consecrated balsam used for baptism, confirmation, and ordination), the catechumens' oil, and the oil used for the sacrament of the sick. These are given the name **chrism vessels** from their contents.

THURIBLE OR CENSER

The thurible, *thuribulum,* is used to burn the aromatic resin, incense, according to the ancient custom which reserved it for the gods and the kings who represented them. On the altar of fragrances in the Temple, the Hebrews burned incense as a sacrifice. The Gospel of Matthew tells that the Magi from the East gave incense to Jesus, thus acknowledging his divinity (Matt 2:11). The Apocalypse depicts the adoring elders who offer golden bowls of incense (Rev 5:8).

In the fourth century, the liturgical thurible appeared, a *cassolette* in which the sweet-smelling resin burns on hot coals. The mosaics of San Vitale testify that it was used in the sixth century.

A thurifer swings this instrument, with its cover, on the end of small chains. He presents it to the celebrant who takes the incense from a receptacle in the shape of an oil lamp or a ship, the **incense holder.**

Thurifer swinging the censer during the Eastern Rite liturgy. Notre Dame de Paris, France

The rites of consecration and the Liturgy of the Eucharist make provision for the incensing of
- the evangelistary, because it contains the word of God;
- the altar, because it is the symbol of Christ;
- the offerings of bread and wine, because they are to be consecrated;
- the altar cross;
- the celebrant, a minister of Christ; and
- the assembly of the faithful, sign of the presence of the Lord among his people.

OTHER LITURGICAL ACCESSORIES

Silver instruments in the shape of a shell are still used to pour the water of baptism over the head of the baptized person.

At the beginning of the Mass, the rite of sprinkling is sometimes performed as a remembrance of baptism, which solemnizes the use of the water in the **fonts** at the entrance to the church. Aspersion pails and sprinklers *(aspergillum)* are used for this rite. The French word *goupillon* evokes the fox, formerly called a *goupil,* whose tail was used for the aspersion.

Cruets contain the wine and water for the Eucharist.

The **ewer** with dish is used for washing the hands after incensing.

The **alms-boxes** are cases fixed to the walls of churches for the collection of offerings.

THANKSGIVING PLAQUES (VOTIVE OFFERINGS) AND MEDALS

After having made a vow *(ex-voto)* in gratitude to a heavenly intercessor, the faithful offer an object such as a painting depicting the supernatural intervention or a sign linked to the saving of a life or the healing: a boat, silver arm or leg, wooden crutch, or simply a commemorative plaque. This custom dates back to pagan times.

16. Liturgical Vestments – The Study of Vestments

The vestments for worship devised during the last ten centuries for the Catholic liturgy are replete with their own symbols to which is added the play of colors.

ORIGIN OF LITURGICAL VESTMENTS

The use of liturgical vestments does not date back to the origins of the Church. At the beginning of the third century, Clement of Alexandria recommended a special dress for prayer, but Tertullian condemned it.

At the end of the fourth century Saint Jerome relied on the Old Testament and took up the position of Clement again.

However, the letters of Pope Celestine I to the bishops of Vienne and Narbonne in 428 still attest to the absence of all specific clothing. *The bishops must be distinguished by their doctrine and not by their clothing.* In their functions they wore the dress of ordinary citizens, regulated by the Roman laws of 382 to 397: a tunic, or long white robe, *linea,* and over that a *poenula* or *planeta,* the **chasuble.** In the sixth century oriental silks were used for the liturgical vestments.

The sixth-century mosaics of San Vitale illustrate that the court dress of the dignitaries of Justinian and Maximian barely differed from that of the archbishop or his clergy.

Specific insignia appeared little by little in the East from the fifth century onward: the *orarium,* the stole; the *dalmatica,* the dalmatic, an honorary outfit worn by the Roman deacons and the pope; the *mappula,* the maniple; and the *campagi,* precious shoes. In the eighth century, strict control was maintained on vestments and dress, requiring the bishops to wear a cloak, forbidding the use of battle dress and garish luxury and later on banning multicolored vestments.

Thus a liturgical wardrobe was progressively built up, departing from secular clothing and chosen toward the end of the Roman epoch according to the customs and rules of the councils.

The Congregation of Rites, born of the Council of Trent, laid down the norms on July 14, 1600, in the *Bishop's Ceremonial* of Clement VIII.

EVOLUTION OF THE FORMS

These norms concerned only the shapes. Another development was the use of brocades, orphreys, and even precious stones made of the vestments sacred ornaments, *paraments.* In the sixteenth century, the excessive decorations led to reducing the shapes of vestments for greater ease in movement. This evolution, preferring insignia to the art of clothing, did not stop until the mid-twentieth century, when a change in aesthetics was encouraged by the exhortation of the 1969 Roman Missal (V §VI, 305): *"It is advisable that the beauty and nobility of each vestment not be obtained by an abundance of superfluous adornments but by the material used and the shape of these vestments."*

SYMBOLISM OF THE LITURGICAL VESTMENT

Treatises have attached a subtle spiritual meaning to each of the components of this wardrobe. Yet the very wearing of liturgical vestments has its own symbolism and designates the officiant as a representative of the Church, not acting in his own name. Theologians specify that bishops, priests, and deacons act *in persona Christi,* taking on the role of Christ. *Their dress reminds them and others what they are and what should come to light in them,* principles which are recognized and written in canon law. Thus, liturgical vestments draw their sacred character not from their blessing but from the function they signify.

PRESENT-DAY RUBRICS

The *Bishops' Ceremonial,* the 1960 *Codex Rubricarum,* and the *Pontifical* strictly regulated liturgical vestments. From the Second Vatican Council onwards they no longer went into detail. The new Code of Canon Law simply stated, *"In order to celebrate and administrate the Eucharist priests and deacons will wear the sacred vestments prescribed in the rubrics"* (Can. 929).

The *Constitution for the Holy Liturgy,* §128, concludes thus: *"As far as the materials and forms of sacred furnishings and vestments are concerned, freedom is granted to the local bishops' conferences to make adaptations according to local needs and customs."*

The instruction *Inter Œcumenici,* §13, leaves room for contemporary art. The preliminaries of Paul VI's Roman Missal (April 3, 1969) are more explicit. In Chapter V (4.297), it is written, *"The diversity of ministries in the exercise of worship is manifested outwardly through the diversity of liturgical vestments. Consequently these must be the sign of the function proper to each minister. However, these vestments must also contribute to the beauty of the liturgical action."*

CONTEMPORARY WARDROBE

Nowadays a reduction in liturgical clothing and colors is noticeable: the relinquishment of the tunic, the maniple, the humeral veil. The alb, stole, and chasuble, and occasionally the cope are the only liturgical vestments in use. Contemporary taste for more simplicity can ultimately lead to a certain uniformity among the celebrant, the deacon, the acolytes, and even the choristers all wearing the alb, thus equalizing the ministries and the celebration itself.

The meaning of the liturgical action is better perceived through the beauty of festive vestments, the nobility of gestures, and the respect of postures. To this end, contemporary designers are concerned to design true vestments adapted to religious activity. This art of designing clothing compensates for the increasing lack of vestments.

Forms are renewed. The form of the alb is inspired by the monastic cowl: a linen or imitation linen cloth, without embellishment or embroidery, with very wide sleeves and no belt. The hood can give way to a turned-up collar which suggests the form of the cowl. The stole is superimposed as a decoration and a functional indication. The chasuble is roomy and woven in linen or wool. Artists like Matisse and Manessier created such a vestment for the choir. *Haute couture,* with Courrèges and Castelbajac, has proposed bold works in view of great assemblies.

Entrance procession of bishops

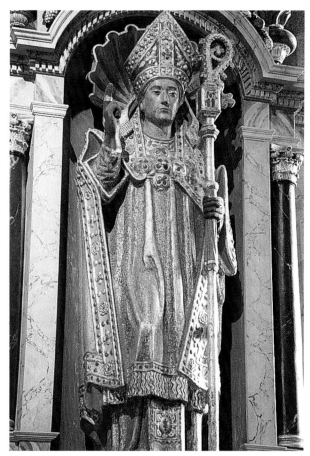

A bishop with cope, miter, crozier, and gloves and ring at the end of the fifteenth century. Statue of Saint Ronan, France

KNOWLEDGE OF EARLIER VESTMENTS

The vestments which no longer correspond to present-day liturgy and aesthetics interest historians and all those who seek to understand the paintings and sculptures on the walls of churches and who do research into the significance of vestments for worship. So it is therefore useful to retrace the evolution of ecclesiastical vestments and to recall the use and meaning of these vestments, even those which have become museum pieces.

CLERICS' DRESS IN THE CHOIR

■ Cassock

The cassock appeared in Italy in the fifteenth century under the name of *sottana* (undervestment) at first for clerics, doctors, and judges, that is, of the so-called **legal professions.** Since the seventeenth century an ankle-length cassock, closed in front by a row of buttons and sometimes caught at the waist by a belt, has been the choir robe worn by

priests. It is black for priests, purple for bishops, red for cardinals, and white for the pope. In France it became the daily dress of the clergy only at the end of the *ancien régime.*

■ Surplice, Rochet, *Cotta, Camail*

In the choir the clerics put on a surplice over the cassock, a short alb with tiny folds and wide sleeves, or the rochet, with narrow sleeves trimmed with lace. In the thirteenth century the canons of Paris protected themselves from the cold during the long winter offices by wearing this vestment over a pelisse, whence the name *superpelliceum* or surplice. Councils in the fourteenth and fifteenth centuries stipulated that it should be knee-length. The *cotta* is a surplice with short sleeves.

Furthermore, dignitaries were distinguishable by their wearing a camail, a short hooded cape over their shoulders, and, around their neck, a cordon with the medal of the coat of arms of the cathedral chapter.

The relinquishment of the cassock as ordinary wear around 1962, and soon after as a choir vestment, led to the surplice, too, falling into disuse. Even earlier was the disappearance of the bands, a collar ornament in the seventeenth century; and of the biretta, a square hat with three or four horns which had been inherited from the medieval clerics and was worn by the priests seated in their stalls.

The clothing of the clergy assisting in the choir was thenceforth the alb alone.

VESTMENTS OF THE MAIN CELEBRANTS

These vestments concern the ministers (priest, deacon, and subdeacon) of the eucharistic celebration. The following are the components of their dress, and the different stages of their evolution and relinquishment.

■ Amice

Originally a scarf protecting from the cold, the amice is mentioned among eighth-century liturgical vestments. Tapestry or silk facings decorated the border. It was a cloth square with cords which the celebrants first put on as a sort of hood and then pulled back and tightened around their neck. The prayer accompanying this clothing compared this piece of clothing to the helmet of salvation recommended by Saint Paul (Eph 6:17).

This vestige retained its function as a hood during celebrations among the Benedictines, Dominicans, and Carthusians and in the dioceses of Angers and Paris. Since then, the biretta has replaced the hood as a head-covering for the secular clergy.

■ Alb

The alb stems from the fourth-century undervestment (*tunica* then *linea talaris*) and is a long robe of white linen, fitted with sleeves and tightened at the waist by a cord or cincture. In its whiteness it is rich in biblical symbolism for purity of heart. It suggests the clothing of the transfigured Christ that glowed with light, the royal and priestly robe of the heavenly liturgy, that of the Lord of glory and all the glorified beings, angels, and saints of heaven.

From the eleventh century onward the alb was decorated on the sleeves, sometimes also at the square neck-opening and at the bottom, with a band of gold orphreys and colored silks. The art of lacework became a substitute for the orphreys in the sixteenth century, for the decoration of albs and rochets. In the nineteenth century the lower lace edging and the bands of the sleeves became more and more extensive. Nowadays the alb without embellishments is shaped in the form of a monastic cowl with wide sleeves.

■ Belt, Cincture

In order to tighten *the alb around the waist if necessary* (Roman Missal, 1969), the belt, *cingulum,* is the vestige of the pre-fourth-century common belt which came back into fashion in the form of a precious silk cord from the ninth to the thirteenth centuries. Under monastic influence, the *gospel recommendation* to the apostles to gird their loins for the road imposed a girdle or cord knotted at the waist.

■ Maniple

The maniple was a cloth made of two strips enlarged at the ends. The subdeacon, deacon, and celebrant wore it on the left forearm during Mass. Its origin is the *mappula,* a ceremonial napkin and badge of authority of the consuls who presided over the games.

In the tenth century it was a simple handkerchief and was first held in the left hand as one can see in the Bayeux Tapestry (1090). It is no longer mentioned in the 1969 Roman Missal.

Deacons carrying relics and wearing the dalmatic. Door of the cathedral of Saint-Guy, Prague, Czechoslovakia

■ Stole

The stole, a prayer scarf, *orarium,* then *stola,* appeared in the Orient, then in Spain and in Gaul, as a deacon's vestment (563), and then priest's (663). Sometimes little silver spherical bells were hung on the ends, as on the Jewish priestly robes or on the deacon's stole among the Greeks. It became a band of linen or silk fabric, adorned with embroideries, and the insignia of bishops, priests, and deacons.

The enlargement of the extremities of this vestment developed because of the rite of imposition of its ends on catechumens or during exorcisms.

Worn by the bishop, the stole around the neck fell naturally into two vertical strips. It was crossed over the priest's chest, unless he used a pastoral stole with ends linked by a cord, the crossing or the linking cord signifying the

149

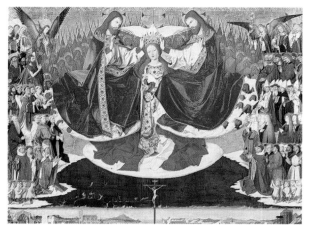

Liturgical vestments of God and of the saints

dependance of his powers of jurisdiction. Since the 1969 Roman Missal, the wearing of the stole is the same for priest and bishop. Deacons wear the stole diagonally from the shoulder, across the chest.

■ Tunic and Dalmatic

Invented in Dalmatia, the dalmatic was a luxurious tunic, superimposed on the simple tunic, which two purple stripes decorated in front and behind. This vestment became the liturgical attribute of the Roman deacons in the ninth century. Originally long and closed, it was split at the sides at first up to the knees and then up to the armpits in order to make walking easier. The sleeves became shorter and so did the robe, and then in the sixteenth century they opened up to form two flaps falling from the shoulders.

The tunic of the subdeacon, *subtile* or *tunica*, was origi-

nally more modest and was modeled on the deacon's vestment, distinguishable only by the stole across the shoulder. Formerly, when he celebrated, the bishop wore these two vestments in silk over the alb. Then the chasuble covered these. In this way he signified the fullness of the priesthood which he exercised in wearing these three insignia.

■ Chasuble

The chasuble, derived like the cope from the *paenula* or *planeta,* was worn by citizens until the fifth century. It became the overvestment of the celebrant of the Mass, originally a very roomy vestment, made of a circular cut opened with a hole in the center for the head to pass through. It enveloped those who wore it, whence the Gallic term of *casula* (little house) which gave the name chasuble. The front and back flaps could end in a point (Bishop Stignat of the Bayeux Tapestry). The celebrant freed his arms by pulling the vestment up on each side. In order to facilitate his movements these two flaps were lifted up and fixed by a hook on the shoulder, then they were cut back more and more, all

Deacon wearing the dalmatic and proclaiming the gospel

the more so for the fact that in order to satisfy the desire of the faithful to adore the host the priest had to lift his arms very high above his head. One can monitor the evolution of the chasuble in paintings between the fourteenth and seventeenth centuries. This vestment shrank to the point of becoming two rigid flaps of fabric, the front one cut back to the maximum in the shape of a violin, the back one cut in a rectangular shape and decorated with two vertical stripes or a cross. The nineteenth-century passion for all that was Gothic and the writings of Dom Guéranger, the restorer of the Order of Saint Benedict, brought the more roomy medieval vestment back into line with current tastes, and it came into general use toward the mid-twentieth century.

This vestment is indicated by the ordination rite as distinctive of the priesthood. The 1969 Missal simply states that *the vestment proper to the celebrant for the Mass and for the other sacred functions in immediate connection with the Mass is the chasuble, unless another vestment is foreseen* (Ch. IV, VI, 299).

■ Humeral Veil

Formerly the celebrant wore on his shoulders – in Latin *humerus* – a veil whose ends he could use to hold the Blessed Sacrament, the holy oils, and sacred objects.

■ Cope

Originally a raincoat, the cope cut in a demi-circumference like the Franco-Germanic imperial coat became a ceremonial vestment. What was a hood in the seventh century became a flap of fabric with folds which fell over the back, and a pure ornamentation cut in a shield, a square, and then in a semicircle. It was first the vestment of the cantors before being worn by the priest who celebrated certain offices or processions. The hook for this vestment, on the chest, instead of being a simple flap of material with fasteners, was a metal clasp or pectoral laden with precious stones.

ATTRIBUTES OF THE BISHOPS

■ Miter

Bishops have certain distinctive insignia: the ring, the pectoral cross, and the crozier. When a bishop presides on his cathedra he wears the miter. This appeared first under the name of *phrygium* as a nonliturgical headdress of the pope in the ninth–tenth centuries. It was adopted by the bishops and recognized in the twelfth century in the rite of episcopal ordination. It was then made of a circular headband topped with a conical bonnet, which slumped and divided into two points joined by a soft lining between. It grew in size from the fourth century and reached its maximum height in the Baroque period. Two lappets or narrow strips of cloth fall down from the back part. The miter is either simple or precious and is acceptable for abbots and bishops according to the degree of festivity in the celebrations.

■ Pectoral Cross, Ring, and Pastoral Staff

As a sign of their order bishops wear a pectoral cross and a pastoral ring. A gold ring was first reserved for the emperor and then adopted by spouses as a sign of the covenant between them. In the seventh century it also became a symbol of the bishop's bond with his diocese. In the thirteenth century the pope wore on his finger the fisherman's ring (thus named because of the engraving depicting Peter throwing out his net), which he used to seal his pastoral letters.

The pastoral staff mentioned around the fifth century was at first a simple traveling staff. Its straight form terminated

Bishop with miter, pectoral cross, and crozier

A bishop receives the miter at his consecration

either in a *tau*, that is, a cross like that of St. Francis and of the Irish monks, or in a knob like a royal scepter. Elsewhere the volute of the episcopal staff, treated in ivory or copper inlaid with enamel, ended with a dragon or serpent's head or even a floweret. Scenes were chiseled in the spiral in order to brace it: the Annunciation, Crucifixion, Virgin Mother, or patron saint of the diocese.

■ Shoes, Gloves, Gremial

Formerly when he celebrated the bishop wore stockings, ceremonial sandals – the *campagi* or laced-up shoes – and gloves of the right liturgical color. He also wore, when he was seated or he used the consecratory oils, the **gremial,** a silk veil of the liturgical color with which he covered his knees.

■ Pallium

The pope grants to metropolitan archbishops, and formerly did so to dignitaries, the privilege of the *pallium,* which is a narrow scarf of white wool marked with black crosses which is placed on the shoulders. S flap falls down in the middle of the chest and the back.

LITURGICAL VESTMENTS FOR THE LAITY

It is common practice for choristers and acolytes to wear a hooded alb. At their baptism catechumens are clothed in a white vestment (*alba,* whence the name alb). They wear it during the confirmation and Mass which follow. In the past those baptized at Easter kept this alb or tunic until the following Sunday, which was for this reason called *in albis*

(in white). After wearing a simple armband, a reminder of the white vestment, children making their profession of faith (the anniversary of baptism) were also offered an alb.

Special costumes formerly distinguished sacristans (a silver chain, a red robe, or black habit). Dressed as Swiss guards, lay ushers watched over the liturgical protocol in the nave or during processions.

MATERIALS AND VESTMENTS

Wool and linen were the first liturgical textiles. The colored stripes affixed to the clothing of Roman civilians as seam-covers were used to receive embroidery or additional facings. They were to become the purple decorative bands, which were more or less wide, on the chasubles, tunics, and dalmatics.

In the eleventh century, wools, silks, satins (tenth century), damasks (thirteenth century), velvets (fourteenth, fifteenth centuries) were used for outer vestments. These precious fabrics were of Persian or Hispano-Moorish origin and were enhanced with gold filigree. Orphreys (Latin *aurifrigium* = Phrygian gold) with brocade or embroidered gold or silver threads embellished the vestment. Other stripes sometimes

Thurifers wearing the alb and the cross

formed a triangle around the neck, or upside down in a lower part of the material. After the oriental decorative motifs which had no religious significance, at the end of the fourteenth century narrative embroideries depicted series of apostles or martyrs on the ends of the cope. Finally, embroidered crosses on the back of the vestments sometimes depicted in their center a monogram or a Christic or even Marian iconography.

LITURGICAL COLORS

The liturgical prescriptions conformed little by little to the symbolism of colors previously described. A code of colors appeared in the ninth century. The councils legislated before that only to forbid striped or brightly painted vestments. After having used only white, the symbol of light, the Church accepted different colors. For processions outside, dark vestments were more suitable. The Gothic sensitivity to color made the liturgical use of color more widespread.

Though the Eastern Church did not attach any particular significance to the colors of liturgical vestments, the Romans, after Innocent III (1198–1216), defined a symbolism which was fixed in the fourteenth century and recognized a particular use for five colors: white or vermeil, red, green, violet, and for a long time, black. White is linked to purity and divine light; it is the color suited to the Epiphany "because of the splendor of his star," to the vestments of the transfigured and ascending Christ, to the appearances of the angels, and to the ransomed of the Apocalypse. Thus it was to be the color of the feasts of Our Lord, of Mary, of the dedication of churches, of confessors and virgins.

Violet – "the color of the livid wounds" of Christ according to William Durandus, bishop of Mende, the commentator of Innocent III – replaced black from the thirteenth century for times of mourning and penance, vigils, and Advent and Lent.

The 1969 Missal still notes that because of the more joyful texts of the third Sunday in Advent and the fourth of Lent, the color rose can replace violet. In Lyon, ashen grey can replace violet.

Black was used for the offices of the dead, but since Vatican II it has been replaced by violet.

Red refers to the blood spilt by Christ or the martyrs. It is also the color of the flames of love and of the tongues of fire of Pentecost. Nowadays it is the color used for Passion Sunday and Good Friday, which were formerly celebrated in black.

Vermeil is a color of substitution. Gold and silver materials have stood in for white, red, or green because of their splendor.

The new deacon receives the dalmatic

Green, a color in which the "Song of Songs" bathes according to William Durandus, or to which others attach the symbolism of the Tree of Life, is the color of the ferias and the Sundays of Ordinary Time which are oriented towards the end-times and hope in the world to come.

In Spain, blue marks the feasts of Mary.

The canons have not been universally respected; the Ceremonial of Cardinal de Noailles (1703) prescribed a motif of stars on the vestments for the Epiphany. At Christmas, besides white, red was used because of the Savior's charity, and violet or black because of the self-emptying of the incarnation.

Exeter celebrated Corpus Christi in white and red in order to symbolize the bread and wine of the Eucharist.

Conclusion
The Catholic Church has emphasized the transcendence of the liturgical functions through a language of colors sensitive to the passage of time, the seasons, and the particular character of each celebration.

Each community is preceded by a cross and is recognized by its banner. Procession of the "Pardon de Notre-Dame du Folgoët," France

BANNERS AND OTHER LITURGICAL INSIGNIA

■ Form and Significance

Banners are ensigns of worship intended for liturgical processions.

At the origin of the liturgical **banner** are the ensigns of the Jewish tribes; the *labarum* of Constantine, the standards, banners, and gonfalons under which the knights rallied their troops. In the Middle Ages each town and each guild wanted to have its own ensign which bore the coat of arms and image of a protective patron saint. Still, at the festivities of the "Palio" in Siena, the standards and gonfalons bear the colors of the different neighborhoods and the image of the Virgin.

Whether it was linked to a guild or not, or assembled for prayer or charitable works, or set up by a religious order, each religious **brotherhood,** particularly after the Tridentine Reform, gave itself a rallying sign which it carried in processions. Thus one can recognize banners making known the worship of the Blessed Sacrament and the devotion to the rosary. In the nineteenth century the congregations for devotion to the Sacred Heart or to Our Lady took over the succession of these brotherhoods.

The Roman Ritual previous to Vatican II (IX c1, 5) approves the use of these processional banners, stipulating that they must bear holy images and be differentiated from military standards.

Made up of a vertical pole and a crosspiece in a *tau* with or without a cross, they consist of a piece of material adorned with embroideries, paintings, or tapestries, or gold or silver orphreys. Sometimes little bells are attached to the lower part which can be divided into two or three tails.

■ Canopy, Dais

This name is given to tapestry work or precious material forming a baldachin above the bishop's *cathedra* or the throne of the Blessed Sacrament, or suitable for being carried in procession above the celebrant holding the monstrance or the bishop during a solemn entrance.

■ A Few Hangings and Liturgical Linen

The **canopy** or tabernacle veil is a hanging placed in front of the tabernacle to recall the tent in which the Lord dwells in the consecrated species.

The **antependium** is a facing of the appropriate liturgical color fixed in front of the altar. A frontal or painted wooden panel also decorated the altar in the Romanesque era.

The **altar cloth** covers the eucharistic table as a reminder that the Eucharist is the wedding feast.

The **corporal**, a small linen cloth spread out under the chalice and the paten during the Eucharistic Prayer, takes its name from the "Body of Christ" which it receives.

The **pall** is a square piece of linen which may be embroidered and serves as a protection for the wine in the chalice.

The **manutergium** is a small towel with which the celebrant wipes his hands after the lavabo.

The **chalice veil** is a piece of fabric of the appropriate liturgical color which covers the chalice and paten before and after the celebration.

The **burse** is a case adapted to the size of the chalice veil which serves as a protection for the corporal after the celebration.

THE STONE CHURCH, A MICROCOSM

If visitors who are attracted by cultural patrimony allow themselves to be touched by the forms and the lines of the architecture and liturgical objects, they are carried beyond their original purpose by the symbolic expression.

A church expresses the world, humanity and God through its symbols.

Indeed building it, and building it to be solid, superb, in beautiful close-fitting stones was the primary and ultimate task, in order that the liturgical act might unfold in full magnificence. It is especially intended that the edifice may contain in its very body the major symbols through which the builder's art, parallel to that of the musician, strives to render perceptible the order of the universe. Through painting and sculpture one achieves only a reflection of the invisible. By contrast, the church intends to supply the most complete significance. The church building can cooperate in the revelation of the divine, like the sequences of the liturgy, like the analysis of the sacred text. It must formulate a series of symbols through which it permeates imperceptibly the hearts of those whose prayer it embraces. Its global representation of the cosmos and of this microcosm which is the human person, that is of the whole of creation, reveals the Creator, who wished to be not unlike creation.

Duby, *The Time of the Cathedrals*

But it is in the very act of the celebration of the Word and the Eucharist by the Church assembly that the meaning of the symbols of the edifice is revealed.

Adoration of the Lamb

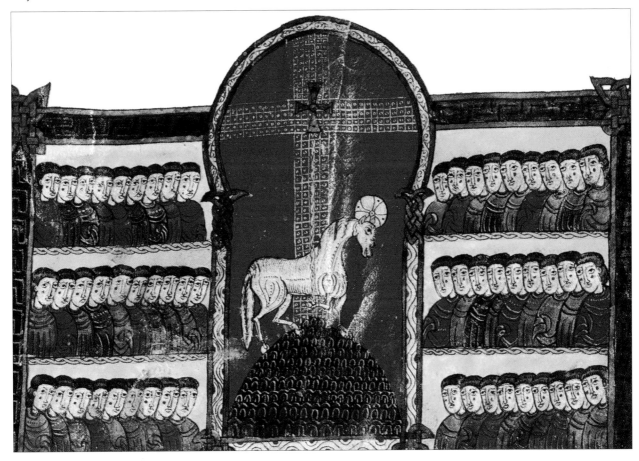

Glossaries

VOCABULARY OF SYMBOLISM

■ An **allegory** is a developed metaphor. It expresses an abstraction or concept in a vivid manner filled with images. Thus the vine and its branches are an image of the vital relationship between Jesus and his Church.

■ An **analogy** is a relationship of resemblance between two beings or two ideas, which cannot be confused, nevertheless.

■ An **apologue** is a short narrative of spiritual or moral significance.

■ An **attribute**, nowadays called a logo, is a distinctive sign proper to a person or an institution (the crown of laurels as a symbol of victory).

■ An **emblem** is a symbolic figure, an attribute adopted conventionally in order to represent an abstract notion, an institution.

■ An **image** is the being or the fact which evokes a reality because of a likeness or an analogy.

■ A **metaphor** establishes without terms of comparison (i.e., *like* or *as*) an image-filled equivalence between two things.

■ A **myth** is a fabulous account which states in a symbolic fashion a belief, an aspect of the human condition. (Ceres visits her daughter Proserpina in the underworld and comes back up to earth in spring, thus representing the time of sowing and of harvest.)

■ A **parable** is a comparison sometimes developed in a narrative and intended to make a spiritual or moral teaching understood. (The story of the "prodigal" son, his desertion of his father's house, his return to his father and the ensuing welcome represent the measureless love and forgiveness of the Father for his children.)

■ A **prefiguration** is a person-type, a precursory event of a personage or an event. (Melchizedek and Moses are prefigurations of Christ.)

■ A **symbol** is an object or a fact which evokes something else by virtue of a correspondence, or natural association of ideas, or by convention. (The flame is a symbol of love; Noah's Ark is the symbol of the Church.)

Actions can be symbolic and be presented as a mime intended to catch the imagination or as a prophecy. (Jeremiah shouldered a yoke as a sign of the future reduction to slavery of the kings of the West by the king of Babylon.)

■ **Symbology** is the science of symbols and of their meaning, or the system of symbols relating to a specific domain (the entirety of the symbols proper to churches, the liturgy, symbols used in the Romanesque style).

■ **Typology** is the concordance between the Old and the New Testament. In the former one finds figures who are types, prefigurations, a prophetic announcement of the realities of the latter. Thus, the crossing of the Red Sea and the manna in the desert are prefigurations and types of the sacraments of baptism and the Eucharist. (Adam takes on meaning only with regard to Christ, the Adam to come; he is both prefiguration and type.)

THE BIBLE: SOURCE OF THE JUDEO-CHRISTIAN SYMBOLS

The **Bible**, the Book in the highest sense of the word, is divided into two parts, the Old and the New Testaments.

Extended and clarified through the tradition of the Church, this book serves as a foundation for Christian doctrine. It is the principal source of Christian liturgical texts and iconography.

OLD TESTAMENT:

Repository of the Old Covenant, made up of forty-five books.

This collection of books, common in part to Jews and Christians, relates the covenant made between Yahweh and the chosen people in the Sinai Desert and the consequences of the covenant.

■ **Pentateuch** ("The five scrolls"): The first five books of the Bible. Genesis, Exodus, Leviticus, Numbers, and Deuteronomy make up a whole consisting of an introduction relating the creation of the world, followed by historical texts beginning with Abraham and leading up to the death of Moses, legislative texts which gained for this whole the title *Law*. Pious Jews have

symbolized their belief in the Law by the wearing on their forehead and left arm boxes or phylacteries containing verses from the Bible among which was the declaration of the first commandment (Deut 6:4-9).

Genesis: The first book of the Bible, Genesis takes its name from the first word in the book, *"In the beginning."* It relates the origins of the world and the story of the Patriarchs Abraham, Isaac, and Jacob.

Exodus: the title of the second book of the Bible (from the Greek word for *exit*). The narration of the liberation from Egypt is followed by the march towards Sinai, the covenant and ritual prescriptions.

■ **Historical Books:** also called *the books of the first prophets;* these are the books of Joshua, Judges, Ruth, Samuel, Kings, to which are added Chronicles, Esdras, Nehemiah, Tobias, Judith and Esther.

■ **Poetical and Sapiential (Wisdom) Books:** These include the books of Job, the Psalms (The 150 psalms are prayers in a poetical form, are used in the liturgy, and are of varied eras and authors although they have for the most part been attributed to David), Proverbs, Qoheleth or Ecclesiastes, The Song of Songs, Wisdom, and Ecclesiasticus, all inspired by the art of living according to wisdom.

■ **Prophetic Books** (literally, the prophet is the seer who speaks on behalf of God): *The last prophets* revealed God and his attributes. A distinction has been made, according to the importance of their oracles, between the great prophets (Isaiah, Jeremiah, Ezekiel and Daniel) and the lesser prophets (Hosea, Joel, Amos, Obadiah, Jonah, Micah, Nahum, Habakkuk, Zephaniah, Haggai, Zechariah, Malachi).

NEW TESTAMENT:

Repository of the New Covenant, made up of twenty-seven books. This second part of the Bible concerns Jesus Christ, the apostles, and the birth of the Church. It tells of God's covenant with humanity through the Son, Jesus, at the Last Supper in the presence of his disciples.

■ **Gospels (or Good News):** The Gospels are four small books bearing the names of their authors. The first three, those of *Matthew, Mark,* and *Luke* are called the **Synoptics** owing to the choice of episodes and the parallelism in their content, as compared with the Fourth Gospel, that of *John.*

■ **Acts of the Apostles:** The Acts of the Apostles are a continuation of the Third Gospel, that of Luke, and give an account of the origins of Christianity and the apostolic mission.

■ **Epistles:** The New Testament contains twenty-one letters, the epistles, addressed to Christian communities by Paul, Peter, John, James, and Jude.

■ **Apocalypse:** The word *apocalypse* means revelation and refers to several oracles of the Old Testament. The book of the New Testament with this name is attributed to John, the author of the Fourth Gospel. It is a book of revelation written to console the Christians persecuted by Nero and Domitian.

■ **Apocrypha:** The apocryphal books (literally *hidden*) are writings which the Church has not retained among the books of the Bible. Those of the Old Testament are of an apocalyptic style. Those of the New Testament relate traditions, sometimes marked by a taste for the marvelous which iconography has

LITURGICAL BOOKS AND
THE INTERPRETATION OF SACRAMENTAL SYMBOLISM

FOR THE CELEBRATION OF THE EUCHARIST

■ **Evangelistary**
Since the liturgical reform of Vatican II, the Evangelistary contains exclusively the passages of the Gospel chosen for Sundays and feast days. This compilation spreads over three years the texts of the four Gospels.

■ **Gradual**
A special book contains the psalmic refrains, the entrance, offertory, and Communion songs proper to each Sunday and feast-day Mass.
In the old days it was part of a more general collection called an antiphonary.

■ **Lectionary for Sundays and Feast Days**
The *Lectionary* spreads over three years the major texts of the Old Testament, the Apocalypse, and the Acts of the Apostles chosen as the first readings of the Sunday Mass. The second reading is drawn from the apostolic epistles, whence the name **Epistolary,** which was also given to this collection.

Finally, it contains the gospel texts.

■ **Missal**
In Western Christian antiquity, the **Sacramentary** contained the prayers specifically for the celebrant, prayers and prefaces for the feast days of the time or of the saints. A missal called "complete" appeared around the tenth century and contained songs, readings, and prayers like certain missals for the faithful. Then the **altar missal** kept only the prayers and prefaces for Sundays and feast days of the liturgical seasons and of the saints, and chiefly the Eucharistic Prayer or *canon* of the

Mass. Since the Second Vatican Council the missal contains a choice of Eucharistic Prayers adapted to different circumstances or assemblies of the faithful. The tradition of printing in red the indications for gestures and postures of the celebrant earned them the name *rubrics*.

■ Weekday Lectionary
A collection of texts for the Masses of each day of the week contains texts from the Old and the New Testaments spread over a two-year cycle, as well as gospel sequences spread over a year. Another Lectionary concerns the saints' feast days which are celebrated during the week, as well as celebrations adapted to certain circumstances.

FOR THE OTHER SACRAMENTS,
other books are in use, among them:

■ The Martyrology is a collection of short accounts of the lives of the saints, martyrs, and confessors of the faith who are commemorated every day.

■ the Pontifical and Bishops' Ceremonial, with the ordination ritual.

■ For the *celebration of the Liturgy of the Hours,* different compilations are used for the office, that of the psalmic antiphons, or Antiphonary, that of the 150 psalms or Psalter; the Breviary, to-day called the Liturgy of the Hours, which in addition contains prayers and readings for each feria and feast day. The Books of Hours are manuscripts decorated with miniatures used as unofficial anthologies of prayers and as liturgical calendars.

■ the Ritual, hereafter called the Book of Blessings, which contains, apart from the texts and the rubrics of the sacraments, the prayers for blessing or consecrating persons and things, such as a church, an altar, bells, a house, a work tool;

SACRAMENTS –
APPLICATION OF THE SYMBOLIC LANGUAGE

The word *sacrament* and the word *mystery* have a single meaning and are applied to Jesus Christ, who reveals the hidden presence of God and the divine kingdom and whose words and actions have a saving effect.

The Church has recognized the treasure received from Christ, and the term sacrament has been applied to liturgical actions, that are tangible and efficacious signs of grace, and performed in order to manifest the efficacious presence of God.

In the Middle Ages, **seven** different sacraments were declared to have been instituted by Christ for the salvation of his people. They apply to the important moments of the Christian life and coincide with the different stages of human life, bringing new birth and growth, healing, and mission.

The three sacraments of *Christian initiation* are the following:

■ Baptism, an efficacious sign of the birth to a new life, purifies from sin and incorporates baptized persons into the Church, the body of Christ, and has them participate in his priesthood.

■ Confirmation, the perfection of the baptismal grace, bestows the gifts of the Holy Spirit in order to establish the new Christians in divine filiation, incorporate them in Christ, associate them with the mission of his Church, and help them to bear witness.

■ Eucharist, the heart and zenith of the life of the Church, unites the Church and its members to the sacrifice offered by Christ to his Father and bestows on them the graces of salvation.

The sacraments of *healing* are these:

■ Penance or Reconciliation, a sign of forgiveness of sins through confession and absolution, brings conversion and draws the person back into communion with the God of mercy and with the members of the Church.

■ The Anointing of the Sick, a sign of God's presence and help given to those who suffer from illness or old age, unites them to the passion of Christ, comforts them, and grants them forgiveness.

The sacraments of *communion* and of *the mission of the faithful* are two:

■ Holy Orders (Ordination), the sacrament of the apostolic ministry, entrusts the mission of the apostles to the bishops, priests, and deacons for the service of the faithful.

■ Marriage is the sacrament of conjugal union through which a man and a woman constitute between them an intimate community of life and love, thus signifying the union between Christ and his Church.

EUCHARISTIC VOCABULARY

■ **Adoring Angels:** sculptures depicting angels kneeling on either side of the tabernacle.

■ **Altar:** according to its shape it is either called: *altar-table* (a platform on legs), an *altar-block* (parallelepiped), an altar-chest (when the table is borne up by a full base), or *altar-tomb* which is straight or with curved outlines (in the shape of a sarcophagus).

■ **Ambrey:** case on the wall serving as a tabernacle.

■ **Antependium** or frontal: front panel of the altar which is sculpted, painted, or made of embroidered material.

■ **Dove:** receptacle in the form of a dove suspended above the altar by a system of pulleys: it contains the consecrated bread in a **pyx** (a small box).

■ **Eucharist, Thanksgiving, Supper of the Lord, Breaking of the Bread, Sacrament of Bread and Wine, Mass:** these terms apply to the renewal by the Church of the celebration of the Lord's Supper.

■ **Eucharistic Tower:** a portable tabernacle.

■ **Polyptych:** Collection of paintings with shutters that open, and that sits upon an altar.

■ **Predella:** lower part of a retable consisting of panels either painted or sculpted in low relief, and which illustrate the Bible or the life of a saint.

■ **Real Presence, Blessed Sacrament, Sacred Species:** bread that has become the presence of the living Christ through the words of consecration.

■ **Reserved Eucharist:** consecrated bread kept in a ciborium in the tabernacle.

■ **Retable or Reredos:** construction erected above an altar which can be made up of a wooden or stone architectural piece with statues or painted scenes.

■ **Tabernacle:** cupboard in the form of a tent *(tabernaculum),* fixed to an altar or a console which contains consecrated bread. A sanctuary lamp indicates this presence.

Church Vocabulary - The Church in the Spirit, the Church in the Flesh, and Stone Churches

THE HEAVENLY CHURCH, THE TRIUMPHANT CHURCH, THE CHURCH OF THE SAINTS

We believe in the communion of all the faithful of Christ, of those who are pilgrims on earth, of the dead who are coming to the end of their purification, of the blessed in heaven, for all together they form one Church, and we believe that in this communion the merciful love of God and of his saints is always listening to our prayers. (Solemn profession of faith)

■ Abbot / Abbess
The monk or nun appointed to govern the community in an abbey's territory, after the fashion of the bishop in his diocese, receives the title of abbot / abbess, carries the crozier, and wears the pastoral ring. In some languages this title (from *abba* = father) is used to address secular ecclesiastics; they are universally called father.

■ Archbishop
The bishop of the see of an ecclesiastical province bears the title of archbishop.

■ Bishop
Through the sacrament of holy orders the mission entrusted by Christ to his apostles continues in the Church until the end of time. This sacrament is conferred in three stages: the diaconate, the priesthood, and the episcopate. The fullness of the priesthood falls to the bishop who has the responsibility of sanctifying, teaching, and governing. He exercises this responsibility in union with the pope and the other bishops of the world, who are members like him of the Apostolic College. His particular pastoral responsibility concerns a territory called a diocese or bishopric. For the Romans this term designated an administrative district. The word bishopric also designated the bishop's dwelling.

■ Canon
The bishop appoints canons to make up the chapter of his cathedral, ensure that the office of the psalms is recited publicly every day, and possibly serve as counselors for him.

■ Cardinal
The pope appoints a number of counselors for his government. The College of Cardinals gathers in a conclave to elect his successor to the See of Peter.

■ Catholic Action

Apostolic movement run by the laity for the evangelization of their environment.

■ Charismatic Communities

They are also called renewal movements. At their origin, they were gatherings of laypersons desirous to commune in the Holy Spirit. The members of these communities manifest unabashedly the joy they derive from their faith and seek new ways of announcing the gospel.

■ The Church on Earth, or the Church Militant

Christian, recognize your dignity. Since you participate in the divine nature, don't degenerate by returning to the decline of your past life. Remember to which Head you belong and of which Body you are a member. Remember that you have been snatched from the power of darkness in order to be transferred into the light and the kingdom of God (Leo the Great, Sermon 21,2-3).

■ Cleric

Every minister of religion is a cleric. This term is applied canonically to Christians whom the bishop welcomes as candidates for sacred orders. Before the Code of Canon Law following Vatican II, the preparation of clerics for holy orders consisted of different stages called minor orders, which were manifested in the exercise of a liturgical function: those of acolyte, exorcist, reader, to serve at the altar, carry the candles, prepare the censer for use, read the Scriptures in church, open and close the doors, and ring the bell for the offices.

■ Cloistered

This name is given to contemplatives living within the enclosure of a monastery.

■ Contemplative

The religious who dedicate their entire life to prayer are called contemplatives as distinct from the "active" orders devoted to charitable works.

■ Deacon

The bishop imposes his hands on the deacon for the service of the Church: assistance of the bishop and priest in the celebration of the Eucharist, the presence of the Church at the blessing of a marriage, preaching, presiding over funerals, and, above all, various works of charity.

■ Hermit

The term is given to a religious who withdraws into solitude in order to live a contemplative life.

■ Laity

The Second Vatican Council *(Lumen gentium)* understood by the name laity, *the whole of Christendom excepting the members of the sacred order and of the religious state recognized by the Church, that is, those Christians who are incorporated in Christ through baptism, as an integral part of the People of God, and who participate in their own manner in the priestly, prophetic, and royal function of Christ, thus exercising in the Church and in the world the mission of the entire Christian people.* They are still called the **faithful** *(united by the faith)* in order to distinguish them from the laity in the ideological (i.e., nonreligious) sense of the word.

■ Missionary

Those who devote their lives to proclaiming faith in Christ through their words and actions are associated with the mission of the Church and bear the name of "missionary" whether they are priests, religious, or laity.

■ Monk / Nun

A monk or nun lives within the clois-ter of a house called a monastery. Monks may receive holy orders in order to celebrate the Eucharist for the community.

■ Pope

The pope, Bishop of Rome and successor of Peter, Vicar of Christ and Pastor of the entire Church, *is the everlasting and visible principle and foundation of the unity which binds the bishops and the multitude of the faithful together.*

■ Priest

The priest is united to the bishop and dependent on him for the exercise of his ministry. He is consecrated in order to preach the gospel to the faithful of whom he is the pastor, to celebrate the divine mysteries with the community, and especially the Eucharist. The pastoral responsibility entrusted to him can concern a local community: a parish (in which case he is then called pastor and his assistant, curate), a sector of a diocese, a charitable, missionary, or teaching task.

■ Prior / Prioress

The superior of a monastery of religious dependent on an abbey bears the name of a prior or prioress. This monastery is called a *priory* and a church dependent on it is called a *priory church.*

■ Religious

Religious are members of institutes whose lives are contemplative or devoted to charitable activity. They pronounce publicly solemn or temporary vows, most often of poverty, chastity, and obedience, and live a in community. Various religious families often take their names either from their founders (Augustinians from Saint Augustine, the Benedictines from Saint Benedict, the Dominicans from Saint Dominic, the Franciscans from Saint Francis of Assisi)

or in reference to the foundation (Jesuits [Society of Jesus], Cistercians or Trappists [Cîteaux], Carmelites [Mount Carmel]), Carthusians from Saint Bruno, or from a characteristic of their clothing (Capuchins [hood]). They usually live in a convent, a monastery, or a house of their order.

■ Saint, Holy

God is the Holy one, the *totally other*. Creatures, either angels or men and women, are holy only in the measure of their union with God.

The early Church called all the baptized "saints" because of their membership in Christ. It began by venerating, by the gift of flowers and perfumes, the martyrs who through their faith had shared in the death and resurrection of Christ. In order to celebrate the anniversary of their death which was called *dies natalis* (birthday), the Church replaced the traditional funeral meal with the Eucharist. It linked with the celebration of Christ and the mysteries of his life, Mary, John the Baptist, and those he chose as his apostles – the Twelve, whose college was completed (after Judas' betrayal) by the election of Matthias. The name of Paul is also associated with them, as *Apostle to the Gentiles* (pagans). They all gave their lives for Christ.

Then the Church extended its veneration to the confessors of the faith, all those who underwent persecutions for their faith without spilling their blood. In the list of confessors appear bishops and pontiffs, but others were subsequently added who were not bishops: those who lived an exemplary life of fidelity, professing their faith to the end. Among these are monks and hermits who in times of peace voluntarily imitated the martyrs through voluntary asceticism and solitude in the desert. The holy doctors of the Church are about thirty men and women who have demonstrated a deep sense of the faith and an eminent art of teaching it. The same veneration was given to virgins, those women who had chosen a life of consecrated virginity, and to all the lay people whose lives were permeated with the love of Christ.

Specific churches kept a calendar of the days on which their saints died. These calendars spread to the Roman Church. From the tenth century onward the bishops wished the authority of the pope to give an official character to the recognition of the holiness of these people in an act called canonization. The rules for canonization were fixed at the Council of Trent.

■ Secular

The diocesan clergy which exercises pastoral responsibility under the authority of the bishop is called "secular," for it exercises its ministry in the world. Clergy who belong to a religious order and follow the order's Rule (Latin *regula*), are called "regular."

■ Subdeacon

Before Vatican II, entry into the major orders was preceded by a commitment to celibacy called the subdiaconate. Nowadays in the Latin Church this does not concern permanent deacons, but candidates to the priesthood.

VOCABULARY FOR BUILDINGS

■ Abbey Church

The monastic church of an abbey is the church of the local abbot or abbess, whence its name of abbey church.

■ Basilica

The title *basilica* originally referred to a type of church, then to the main churches of Rome and Jerusalem, and was then granted to certain churches as a mark of honor, usually to churches remarkable for being important places of pilgrimage. Pilgrims to basilicas may benefit from certain indulgences.

■ Cathedral

The cathedral is the church in which the bishop of a diocese gathers his faithful and worships with them. His *cathedra* is a reminder, even in his absence, that the presidency is reserved for him.

■ Chapel

The name *chapel* is given to a limited space in a church, furnished with an altar and at first reserved for the devotional exercises of sodalities. Yet a chapel can also be an independent place of worship intended for a community more restricted than that of a parish; for example, a school or a hospital.

■ Church

This edifice is generally built to provide a place of worship for a parish community. However, certain churches are built to receive pilgrims, such as those of Lourdes, Loreto, and Assisi.

■ Collegiate Church

Besides the cathedrals, certain churches called collegiate churches are at the disposition of a chapter of canons or religious who ensure the canonical Liturgy of the Hours.

■ Convent Church

The church of a convent is called a convent or priory church.

■ Oratory

A little chapel for the use of a family or a religious community. Like the chapel, the oratory can be public, semipublic, or private.

ARCHITECTURAL VOCABULARY

■ **Abutment**
Stonework pillar used to cushion the thrust of a flying buttress.

■ **Ambulatory**
Gallery prolonging the aisle by a walkway around and behind the choir.

■ **Apse**
(from the Greek *apsis,* vault, curvature). Extremity of the choir of a church shaped in the form of a semicircle or polygon.

■ **Apsidiole**
Each one of the small chapels grafted onto the apse and the east of the transept is an apsidiole.

■ **Arch**
Architectonic limb crossing a space (opening, reinforcement of a vault) by forming a curve.

■ **Arcade**
Ensemble formed by an arch and its jambs.

■ **Archivolt**
(from the Italian *archivolto*). Vertical face of an arch decorated with moldings.

■ **Atrium**
Courtyard lined with porticoes in front of the façade of certain churches.

■ **Bay**
Vertical part of an elevation marked off by consecutive supports (columns, pillars).

■ **Baldachin**
(from the Italian *baldacchino,* silk fabric from Baghdad). Tapestry work, hanging raised above a bed, throne, etc.

■ **Barrel- or Tunnel-Vault**
Vault generated by the transfer of an arch following a directrix curve. It can be a semicircular or pointed barrel-vault.

■ **Bell-Tower**
Construction (tower, wall set with openings, campanile, etc.) intended to contain bells.

■ **Buttress**
Massive stonework pillar elevated in a projection against a wall or a support in order to retain it. Sloping bank or saddle-roof summit.

■ **Canopy, Dais**
(from the Latin *discus,* disk). Work (in cloth, carved wood, etc.) suspended or sustained by uprights above a throne, an altar, a statue; sometimes mobile, notably in religious processions.

■ **Capital**
An element interposed between the column and that which it supports (from the Latin *caput, capitis*).
Corinthian: enlarged element which forms the summit of a column or a pillar and is made up of a quarter round *(echinus)* or of a basket topped with an abacus.
Doric: The most ancient of the architectural orders of ancient Greece, characterized by a sharp-edged, fluted column with no base, a naked quarter round capital, and an entablature whose triglyphs and metopes are arranged alternately.
Ionic: Greek architectural order which appeared around 560 B.C.E., characterized by a slender, fluted column placed on a molded base and by a capital whose quarter round decorated with an eggs-and-darts pattern is flanked by two volutes.

■ **Chapels**
On either side of the choir, or all along the ambulatory or the naves, secondary sanctuaries are often fitted out for private celebrations.

■ **Chevet**
Extremity of a church behind the choir. It can be flat, semicircular, or have cut-off angles.

■ **Chief Rafter**
Sloping part of a roof-truss fastened at the summit to the king post and at the base to the extremity of the tie-beam.

■ **Choir**
Part of the church consisting of the sanctuary and the space reserved for the clergy, which originally received the cantors.

■ **Ciborium**
Baldachin over an altar in medieval churches.

■ **Corbel**
Block of stone jutting out on the facing of a wall in order to sustain the springing of an arch or a cornice. A succession of corbels makes possible an exuberant construction called a corbelled-out construction.

■ **Cornice**
Decorative ensemble at the junction of a wall and the base of a roof. It consists of a shelf sustained by modillions or corbels.

■ **Cross-Ribbed Vault**
Vault resting or seeming to rest on the intersecting of two diagonal arches. (In this vault, which is characteristic of Gothic buildings, the diagonal ribs are in general rounded arches, the framing joists or formerets being pointed arches.)

■ **Crypt**

(from the Greek *kryptos* = hidden). Place of celebration and worship ordinarily intended for the exposition of relics and set up in the basement of certain churches.

■ **Cupola (Dome)**

Form of vault in a semisphere elevated on a square, circular, or octagonal design. Squinches or pendentives are architectural arrangements which make it possible to pass from the square design to the cupola.

■ **Demi-Cupola Vault**

Vault shaped in a demi-cupola.

■ **Diagonal Rib**

Diagonal supporting arch keyed up under the Gothic vault, whose construction it facilitates and whose thrust it transfers towards the corners.

■ **Diaphragm Arch**

(from the Greek *diaphragma,* partition). Arch with a diameter inferior to the vault and designed to support a pinnacle.

■ **Dome**

Rounded roof of centered design with an unbroken hemispheric or cut-off angled slope which surmounts certain edifices.

■ **Flamboyant Arch**

Arch of the late Gothic period, i.e., from the end of the fourteenth century, which had a liking for decoration with curves and jointed counter-curves, notably with bellow shapes or outer fillets and forming as it were dancing flames (window tracery, gables, etc.).

■ **Flying Buttress**

Stonework elevated in an arc on the outside of an edifice in order to support a wall by transferring the thrust of the vaults onto an abutment.

■ **Formeret**

Lateral arch of a bay of groined or ribbed vaults, parallel to the general axis of the vaults.

■ **Gable**

Decorative pyramidal surface with pitches decorated with moldings which crowns certain arches (Gothic portals, etc.).

■ **Groined Vault**

Vault composed of the intersection at right-angles of barrel-vaults in curvilinear triangles.

■ **Horseshoe Arch**

Arch extended beyond the semicircle.

■ **Impost**

Stone or other element, generally jutting out, which crowns the jamb of an arcade and upholds the springing of the arch.

■ **Jamb**

Vertical lateral components which support the base of a vault or arch. Lateral uprights of an opening.

■ **Joist**

Arch separating two vaults or reinforcing a barrel vault.

■ **Keystone**

Upper archstone of an arch or a vault.

■ **Lierne**

Longitudinal rib which links the keystones and perpendicular rib linking the summit of the lateral formerets or joists.

■ **Lintel**

Horizontal elongated component above an opening, transferring the burden of the upper parts onto the sides of this opening.

■ **Mullions**

Each one of the fixed uprights dividing an opening into compartments, notably in medieval and Renaissance architecture. (They can be intersected by horizontal cross-pieces.)

■ **Narthex**

Closed vestibule at the entrance to certain churches, where formerly the catechumens and penitents stood.

■ **Nave**

By analogy with the ship, the main part of a church which holds the faithful between the portal and the transept or the choir takes the name nave. It can be divided into a principal nave and lateral, aisle, or side-aisle naves.

■ **Oblong Vault**

Vault whose longest side is presented frontally and is in general perpendicular to the axis of the building. It establishes a rectangular bay.

■ **Opening**

Opening made in a wall for a door or window. It consists of a double splay.

■ **Pediment**

Top (of a façade, an opening, or a piece of furniture) in a triangular or arched form on a horizontal base, wider than it is high and made of a tympanum which surrounds a frame decorated with moldings.

■ **Pier**

Central pillar dividing the portal of a church into two.

■ **Pillar**

A support or pillar of isolated stonework, of any cross-section, and

raised up in view of receiving a burden. When the pillar is cylindrical it is called a column. A pillar is sometimes cantoned with small columns.

■ Pilaster

Vertical limb formed by a slight bearing out of a wall, generally fitted with a base and a capital similar to those of the column. A series of pilasters joined by a succession of round arches forms a decoration typical of Romanesque architecture called a pilaster strip.

■ Pinnacle

Slender end ornament terminating in a tapering pyramid shape, ordinarily erected on the top of an abutment in Gothic architecture.

■ Pointed Arch

An arch in which an equilateral triangle is inscribed or in which the centers of the segments divide the chord into three equal parts.

■ Porch

Covered space, within or outside the main building, in front of one or more entrance doors of a church.

■ Recessed Order of an Arch

Small vaults above the embrasure of an opening.

■ Roof Framework

Assembly of pieces of wood, metal, or reinforced concrete making up or supporting the various parts of a construction.

■ Roof-Truss

Assembly of triangular pieces of wood placed at intervals in order to support the slopes of a roof.

■ Round-Window

(Oculus). Circular opening.

■ Round Arch

Inner curve in a semicircle of an arch or of a vault with a circular curve.

■ Sanctuary

Raised part of the church in which liturgical activity takes place around the altar.

■ Segment of a Ribbed Vault

Compartment of a vault between the ribs.

■ Spire

Regular pyramidal structure crowning a church tower.

■ Three-Centered Arch

Surbased arch in a semioval whose reach is that of the greatest diameter of the oval.

■ Tie-Beam

Horizontal piece at the base of the triangle formed by the roof-truss, to which the chief rafters and king past are fastened.

■ Tower

Body of a building raised above or either side of the western portal and overlooking a church and intended to accommodate its bells. The tower which tops the transept-crossing is called a lantern tower.

■ Transept

Transverse nave running at right angles to the principal nave and having the same height as this.

■ Trefoil

Arch with three foils (leaves), or which has the shape of a clover. Name also given to the design of the choir of a church with three rounded apses.

■ Tribunes

Above the lateral naves or at the far end of the principal nave galleries can be built which make it possible to take part in the celebration from on high.

■ Triforium

Passage with arcatures fitted into the thickness of the wall above the principal nave.

■ Triumphal Arch

Commemorative monument forming a great arcade decorated with low-reliefs, inscriptions, etc.

■ Tympanum

Surface contained between the lintel and the two pitches or the arch of a pediment; partition which encloses the arch of Romanesque and Gothic portals.

■ Vault

(from the Latin *volvita,* from *volvere,* turn). Arched stonework covering a space between breast walls and made up of an assemblage of tapering or wedge-shaped voussoirs which support one another; work of the same shape in concrete, wood, etc.

REFERENCES

Le Monde des Symboles
G. de Champeaux, D.S. Sterckx - Zodiaque
Les Symboles chrétiens primitifs
Daniélou - Seuil
Le Langage de l'image au Moyen Âge
F. Garnier - Le Léopard d'or
Iconographie de l'art chrétien I
Louis Réau - P.U.F.
Dictionnaire des Symboles
J. Chevalier, A. Gheerbrant- Seghers
Le Sacré et le Profane
Mircéa Eliade - Folio
Mircéa Eliade et le Phénomène religieux
Douglas Allen - Payot
Signes, Symboles et Mythes
L. Benoist - Que Sais-je ? P.U.F.
La Symbolique
O. Beigreder - Que Sais-je ? - P.U.F.

Initiation à la symbolique romane
M. Davy - Flammarion
Du Symbolique au Symbole. Essai sur les Sacrements
L.-M. Chauvet - Le Cerf
Introduction à la Liturgie
Martimort - Desclée & Cie., Paris, 1961
Liturgia
R. Aigrain : Bloud et Gay, Paris, 1935
Mobilier, Vases, Objets et Vêtements liturgiques
D. Duret - Paris, 1932
L'Orfèvrerie religieuse en Bretagne
P.M. Auzas - Picard, Paris, 1955.
Dictionnaire encyclopédique du christianisme ancien
Le Cerf, 1990
Dictionnaire de liturgie

Dom R. Le Gall - Chambray-lès-Tours, 1982
Art sacré
Le Cerf, (1945-68)
Espace (1977-1983)
Chambray-lès-Tours
Chroniques d'Art Sacré. (1985-1997)
Chambray-les-Tours
Die liturgischen Paramente in Gegenwart und vergargenheit
Joseph Braun - Herder, Fribourg, 1924
Abbaye de Fontevraud - Catalogue expo 1986
Guy Le Goff
Paramentica - Tissus lyonnais et Art sacré 1800-1940,
Catalogue du musée de Fourvières - Lyon
Encyclopédie - THEO

ILLUSTRATIONS

INDEX